Catawba Indian Pottery

CONTEMPORARY AMERICAN INDIAN STUDIES
J. Anthony Paredes, Series Editor

Catawba Indian Pottery

The Survival of a Folk Tradition

Thomas John Blumer
With a Foreword by William Harris


THE UNIVERSITY OF ALABAMA PRESS

Tuscaloosa and London

Copyright © 2004
Thomas John Blumer
All rights reserved
Published by The University of Alabama Press
Tuscaloosa, Alabama 35487-0380
Manufactured in the United States of America

Typeface: Trump Mediaeval

∞

The paper on which this book is printed meets the minimum requirements of American National Standard for Information Science–Permanence of Paper for Printed Library Materials, ANSI Z39.48-1984.

Library of Congress Cataloging-in-Publication Data

Blumer, Thomas J., 1937–
 Catawba Indian pottery : the survival of a folk tradition / Thomas John Blumer ; with a foreword by William Harris.
 p. cm. — (Contemporary American Indian Studies)
 Includes bibliographical references and index.
 ISBN 0-8173-1383-4 (cloth : alk. paper) — ISBN 0-8173-5061-6 (pbk. : alk. paper)
 1. Catawba pottery—Themes, motives. 2. Catawba Indians—Industries. 3. Pottery craft—South Carolina. I. Title. II. Series.
 E99.C24 B58 2004
 738'.089'9752—dc21

 2003012348

British Library Cataloguing-in-Publication Data available

The Catawba tradition has entered the third millennium with a tremendous strength. The transition is being accomplished by a large number of master potters. Foremost in this long list are

Earl Robbins
Viola Robbins
Margaret Tucker
Cheryl Sanders
Brian Sanders
Marcus Sanders

Catawba Indian Pottery: The Survival of a Folk Tradition is dedicated to them.

Contents

Figures

Foreword

My grandmother was Georgia Harris, one of the greatest Catawba Indian potters. Before she died in 1996 at the age of 91, she asked her closest friend, Dr. Thomas Blumer, to deliver her eulogy. To those who didn't know Dr. Blumer, it may have seemed strange that a white scholar from the Library of Congress in Washington, D.C., eulogized an elderly Indian woman who had spent most of her life on or near the Catawba Indian Reservation in South Carolina. But Dr. Blumer is not simply a historian with more than 200 publications regarding the Catawba to his credit. Through his selfless dedication to the people and the pottery of the Catawba, he has become our cherished friend.

I heard about Dr. Blumer before I had the opportunity to meet him. Nearly 30 years ago, my grandmother told me about a young man who had visited her to ask questions about her pottery and the traditions of the Catawba potters. I sat in her kitchen and listened to her tell the story of the young man from the University of South Carolina who had "discovered" a wonderful art form, Catawba pottery.

Dr. Blumer became a frequent visitor to my grandmother's house, and his curiosity about Catawba pottery became almost an obsession, consuming his thoughts and most of his time. His genuine appreciation of the beauty, grace, and simplicity of Catawba pottery created a bridge between him and the usually reticent Catawba. Before long he was spending every spare moment on the Catawba Reservation, record-

ing conversations with not only the potters but other tribal members as well. With the limited funds of a doctoral candidate, with no grants or donations to help him, he dedicated himself to recording the history and art of the Catawba. And always he worked against a ticking clock, knowing that his most important resources were the elderly potters of the Catawba Nation.

Interestingly, Dr. Blumer's discriminating appreciation of Catawba pottery inspired my grandmother to produce her best work. She had learned to make pottery from her mother Margaret Harris, and from her grandmother Martha Jane Harris, who is considered to be the best of the Catawba potters. Following the example of such accomplished potters, my grandmother made pottery that was consistently excellent. Nonetheless, I can remember, as I helped her fire pots in a shallow pit in her back yard, her excitement when a pot "burned" particularly well. Her respect for Dr. Blumer's knowledge of Catawba pottery was such that she would often point to her best piece and say, "I'll bet Dr. Blumer will buy that one." And he often did, even when buying a pot meant making a choice between owning that pot and having enough food to eat the next week. He understood that each piece of pottery was unique, that it never would be duplicated by the artist or by the fire. One piece of pottery at a time, he carefully and lovingly built a collection of Catawba pottery that is unsurpassed.

When the Catawba Nation sued the state of South Carolina to settle a 150-year-old land claim, Dr. Blumer provided support in the form of historical research, and when the Catawba Nation was awarded a $50 million settlement in 1993, no one was happier for the Catawba than Dr. Blumer.

That tangible support is typical of Dr. Blumer's relationship with the Catawba. During his early visits to the reservation, Dr. Blumer found that the Catawba traditionally learned pottery making at the knee of a family elder. His concern that too few of the younger tribal members were taking up the craft led him to encourage the older potters to teach pottery-making classes. Thanks to his efforts, a revival of interest in the making of pottery followed, and many of today's Catawba potters can look back to those classes and remember their own beginnings as potters.

Dr. Blumer's knowledge of the Catawba traditions and his love of Catawba pottery made him the perfect ambassador for the Catawba Nation. He never refused any request for information about Catawba pottery, and he never passed up an opportunity to make others aware of the treasure to be found in northern South Carolina. He graciously accepted the title of Catawba Tribal Historian and continued to donate his time to the promotion of Catawba pottery. It was through his ef-

forts that my grandmother was awarded posthumously the National Endowment for the Arts "Folk Heritage Award" in 1996. It would be difficult indeed to find a Catawba potter who has not benefited from his encouragement and patronage.

And now, with this book, Thomas Blumer benefits not only the Catawba but also anyone interested in our history or our art. It can truthfully be said that no one knows more about the history of the Catawba people than Thomas Blumer. And certainly no one knows more about our pottery. *Catawba Indian Pottery: The Survival of a Folk Tradition* organizes and disseminates his unique knowledge of every aspect of Catawba Indian pottery. It brings together the experience and knowledge of countless Catawba potters, many of whose voices have been silenced over the last 30 years. Dr. Blumer's decades of academic research complements those voices by giving depth and perspective to the personal recollections of contemporary Catawba.

Through his life's work with the Catawba Indian Nation of South Carolina, Thomas Blumer has become something of a Catawba treasure himself. Future generations will be indebted to Dr. Blumer for his lifelong dedication to understanding and recording the art and history of the "People of the River."

William Harris
Catawba Indian Nation

Preface

This volume has been too long in the making. Aside from my own distractions coming from those wanting Catawba information from me, the task of examining issues connected to Catawba history and culture is enormous. The documentation is vast and scattered. The tradition is of great antiquity and certainly deserved the attention. Also, although the Catawba survived the eighteenth and nineteenth centuries, the most critical period in their history, they slipped into obscurity. As a result, it took far too long for the American academic community to discover this artistically lonely pottery-making community. In 1884, the U.S. Bureau of Ethnology sent Edward Palmer, a field anthropologist, to the reservation. As a result, the Smithsonian's Catawba collection dates from Palmer's field trip. It is, therefore, the oldest in the United States. George P. Merrell, John R. Swanson, and James Mooney, to name the major contributors, made additions to the collection. Then, in 1888, a South Carolina writer and would-be ethnologist, MacDonald Furman, took an interest in the Catawba and wrote about them in the local press. He alone sparked interest in South Carolina. As a result of his efforts, the University of South Carolina collection was begun early in the twentieth century. Major additions have been made in recent years by the University's McKissick Museum.

Palmer and Furman were followed by M. R. Harrington (1908), who

produced the first published examination of the Catawba tradition. V. Fewkes came next in 1944 with his longer study. Since 1944 no attempts have been made to discuss the Catawba tradition in a comprehensive way. It is, however, impossible to discuss the Catawba for very long and not touch upon the pottery made by the Indians. Nearly every scholar who has done any work on the Catawba has made some effort to bring the tradition into focus. In spite of over a century of scholarly attention, no comprehensive study of the Catawba tradition has ever been written from the Catawba perspective. *Catawba Indian Pottery: The Survival of a Folk Tradition* hopefully fills this need. At long last the Catawba themselves have a chance to speak at length about their ancestral tradition. What they have to say will help scholars move closer to a full recognition of the historical importance of the Catawba contribution. The world beyond the Catawba has much to gain as this small Nation is recognized for the cultural, artistic, and technological bridge it offers between our times and the little understood prehistory of the region.

The first thank you for standing by me in the making of this study goes to my longtime friend Brent L. Kendrick. He accompanied me on my first visits to the Catawba Reservation. Although his professional desires took him in the direction of American Literature, he never left off encouraging me during my long Catawba saga. He has been my editor and has always believed in my work among the Catawba. Over the years he has believed in the value of my study, *Catawba Indian Pottery: The Survival of a Folk Tradition.* He has always told me that, though my approach to Catawba studies came with its difficulties, my approach of dealing directly with my primary source was the key to my success. He was right, and I thank him.

Those Catawba Indians and individuals allied to the Nation who have always stood by me as mentors include: Deborah Harris Crisco, Jayne Marks Harris, William Harris, Judy Canty Martin, Billie Anne Canty McKellar, Steve McKellar, Della Harris Oxendine, Earl Robbins, Viola Harris Robbins, E. Fred Sanders, Marcus Sanders, Frances Canty Wade, and Cynthia Walsh. I owe them many thanks for years of friendship and support. Although they passed away long ago, this study is a dream come true for Georgia Harris and Doris Blue.

A huge number of Catawba have supported my work over the years and these include: Cindy Allen (potter); Hazel (Foxx) Ayers (potter); Sara Lee Harris Sanders Ayers (master potter); Richard Bailey (Sanders family); Helen Canty Beck (master potter, major history informant); Lula Blue Beck (master potter, major history informant); Major Beck (fiddler, major history informant); Roderick Beck (potters' support network); Ronnie Beck (potter, dancer); Sallie Brown Beck (master potter);

Samuel Beck (secretary/treasurer, mentor); Lillian Harris Blue Black-
welder (potter); Betty Harris Blue (potter); Brian Blue (potter); Doris
Wheelock Blue (master potter, major history informant, mentor); Eva
George Blue (potter); Gilbert Blue (chief); LeRoy Blue (major history
informant); Mildred Blue (master potter); Travis Blue (potter); Anna
Brown Branham (potter, master bead worker, language revival); William
(Monty) Branham (master potter, music composer); Ellen Canty Bridges
(gourd worker); Jennie Canty Harris Sanders Brindle (potter, major his-
tory informant); Keith Brown (master potter, spiritual leader); Larry
Brown (potter, bead worker); Roy Brown (potters' support network);
Blanche Harris Bryson (potter, major history informant); Louise Beck
Bryson (master potter, major history informant); Mohave Sanders Bry-
son (potter); Marsha Ferrell Byrd (potter); Edwin Campbell (master pot-
ter); Nola Harris Campbell (master potter, major history informant,
mentor); Catherine Sanders Canty (master potter, major history in-
formant); Dean Canty (dancer); Jack Canty (traditionalist leader, assis-
tant chief); Jerum Canty; Ronald Canty (potter); Paige Childress (potter);
Deborah Harris Crisco (traditionalist leader, mentor); Alberta Canty
Ferrell (master potter); Betty Blue Garcia; Guy Garcia (major history
informant, drummer); Beckee Simmers Garris (potter, dancer); Charles
George (flint knapper); Cindy Ayers George (bead worker); Elsie Blue
George (potter, major history informant); Evans (Buck) George (assist-
ant chief, history informant); Evelyn Brown George (master potter,
major history informant); Phillip George (wood carver); Isabelle Harris
Harris George (potter); Kristen George (potter); Landrum George (major
history informant); Mandy George (potter); Marvin George (potter, ma-
jor history informant); Susan George (potter); Wayne George; Cheryl
Gordon (potter); Faye George Greiner (potter, basket maker); Alice Har-
ris; Bertha George Harris (master potter, major history informant);
Beulah Thomas Harris (master potter, major history informant); Curtis
Harris (potter); Donald Harris (master pipe maker); George Furman
Harris (major history informant); Georgia Harris Harris (master potter,
major history informant, mentor); Grady Harris (major history infor-
mant); Ida Harris (potter); Little Leon Harris; Melvin Harris (major his-
tory informant); Minnie Harris Sanders Harris (potter); Peggy Thatcher
Harris (potter); Reola Harris Harris (potter); Richard Harris (major his-
tory informant); Walter Harris (potter); Wesley Harris (potters' support
network); Wilburn Harris (major history informant); William Douglas
Harris (wood carver, potter, traditionalist leader, chief); Gail Blue Jones
(potter); Brandon Leach (potter); Miranda Leach (potter); Trisha Leach
(potter); Faye Robbins Bodiford Lear (potter, spiritual leader, major his-
tory informant); Billie Anne McKellar (master potter, mentor); Ann
Sanders Morris (potter); Denise Ferrell Nichols (potter); Dawn McKel-

lar Osborn (potter); Sherry Wade Osborn (potter); Della Harris Oxen-
dine (master potter); Donnie Plyler (potter); Elizabeth Plyler (master
potter); Olin Plyler (wood carver); Big Bradley Robbins (potter sup-
port network); Earl Robbins (master potter, mentor); Flint Robbins (pot-
ter support network); Frank Robbins (potter support network); Little
Bradley Robbins (potter); Viola Harris Robbins (master potter, mentor);
Albert Sanders (chief, major history informant); Brian Sanders (master
potter); Caroleen Sanders (master potter); Cheryl Harris Sanders (mas-
ter potter); Clark Sanders (potter); E. Fred Sanders (potter, major history
informant, traditionalist leader, mentor, councilman); Freddie Sanders
(master potter); Marcus Sanders (master potter, traditionalist leader);
Randall Sanders (potter); Verdie Harris Sanders (potter); Willie Sanders
(major history informant); Jimmy Simmers (potter); Shelly Simmers
(dancer); Pearly Ayers Harris Strickland (potter, major history infor-
mant); Virginia Blue Trimnal (major history informant); Roger Trim-
nal (major history informant, traditionalist leader); Margaret Robbins
Tucker (master potter); Matthew Tucker (potter); Shane Tucker (potter);
Ruby Ayers Brown Vincent (potter); Florence Harris Wade (potter);
Frances Canty Wade (potter, major history informant, mentor); Gary
Wade (major history informant); Sallie Harris Wade (potter, major his-
tory informant); Clifford Watts (major history informant); Eber White
(major history informant); Charlie Whitesides (potter); Velma Brown
Whitesides (arts and crafts authority); and Clara Sanders Wilson (tradi-
tionalist leader).

Those who are allied to the Catawba Nation through marriage and
contributed to the success of my work include: Eddie Allen (flute
maker); Mae Bodiford Blue (potter); Dennis Bryson (potters' support);
Willie Campbell (potters' support); Jayne Marks Harris (artist, potters'
support); Judy Leaming (support of traditionalist faction); Steve McKel-
lar (artist, potters' support).

A large number of institutions have always stood ready to assist me
in my research needs. These include Carolinian Library, University of
South Carolina, Columbia; Catawba Nation Archives, Catawba Na-
tion, Rock Hill, South Carolina; Chester County Museum, Chester,
South Carolina; Children's Museum, Charlotte, South Carolina; Dacus
Library, Winthrop University, Rock Hill, South Carolina; Katawba Val-
ley Land Trust, Lancaster, South Carolina; Library of Congress, Wash-
ington, D.C.; McKissick Museum, University of South Carolina, Co-
lumbia; Mint Museum, Charlotte, North Carolina; Museum of the
American Indian, Heye Foundation, Washington, D.C.; Museum of
Charleston, South Carolina; Museum of York County, Rock Hill, South
Carolina; Qualla Cooperative, Cherokee, North Carolina; Schiele Mu-
seum of Natural History, Gastonia, North Carolina; Smithsonian In-

stitution, Washington, D.C.; South Carolina Department of Archives and History, Columbia; University Museum, University of Pennsylvania, Philadelphia; University of North Carolina, Department of Anthropology and Archaeology, Chapel Hill; Valentine Museum, Richmond, Virginia; York County Library, Rock Hill, South Carolina.

A growing number of scholars have taken an interest in the Catawba and the following have generously given me their time and expertise: Ruth Byers, York County Library, Rock Hill, South Carolina; Tommy Charles, University of South Carolina, Columbia; Joffre L. Coe, University of North Carolina, Chapel Hill; R. P. Stephen Davis Jr., University of North Carolina, Chapel Hill; Michael Eldredge, Schiele Museum of Natural History, Gastonia, North Carolina; Barbara Frost, Cinebar Productions, Newport News, Virginia; Tom Johnson, Caroliniana Library, University of South Carolina, Columbia; Rita Kenion, Archaeologist; Mary Mallaney, York County Library, Rock Hill, South Carolina; Robert Mackintosh, South Carolina Department of Archives and History, Columbia; Alan May, Schiele Museum of Natural History, Gastonia, North Carolina; Phil Moody, Winthrop University, Rock Hill, South Carolina; Lindsay Pettus, Katawba Valley Land Trust, Lancaster, South Carolina; Louise Pettus, local historian, Rock Hill, South Carolina; Brett H. Riggs, University of North Carolina, Chapel Hill; Blair Rudes, University of North Carolina at Charlotte; Tom Stanley, Winthrop University, Rock Hill, South Carolina; Sherry Staples, Cinebar Productions, Newport News, Virginia; Ann Tippitt, Schiele Museum of Natural History, Gastonia, North Carolina; Gene Waddell, College of Charleston, South Carolina; Steve Watts, Catawba Village Exhibit, Schiele Museum of Natural History, Gastonia, North Carolina; Terry Zug, University of North Carolina, Chapel Hill.

Catawba Indian Pottery

1 Discovering the Catawba

The Catawba Indian Nation of South Carolina occupies a 640-acre reservation eight miles east of Rock Hill, South Carolina. About 2,200 Indians are listed on the tribal roll (U.S. Department of the Interior 2000). Perhaps another 1,000 Catawba descendants are located outside of South Carolina in Oklahoma, Colorado, and other places. From the time of the American Revolution to the end of the nineteenth century, the tribe was dangerously close to extinction. During this period they lost most of their culture.

The tribal government's powers rest in a general council of unknown inception. Daily business is conducted by an elected chief and an executive committee consisting of an assistant chief, secretary/treasurer, and two councilmen (Catawba Nation 1975). Even though the language officially died in 1952 with the death of Sallie Brown Gordon, some knowledge of the language remained, and today the tribe is experiencing a language revival of sorts (Anna Brown Branham, personal communication, 1999–2002). In the area of religion, the "old way" survives only in the belief in minor woodland deities called the *yehasuri,* or the wild Indians (Blumer Collection, Edinburg, Virginia, [BC] 1985). In the realm of arts and crafts, an occasional blow gun is made. Catawba songs are often mere melodies containing words that lost their meaning to most tribal members long ago. Catawba still know their herbs, but their non-Indian neighbors are apt to use the same remedies. Their once complete culinary art has been reduced to a simple recipe for ash cakes. Some beadwork is produced, but it is of a pan-Indian variety. A few men make walking sticks and burn designs into them and other wooden objects. The triumph of the Catawba Nation rests in its pottery tradition, which is a cultural treasure of tremendous worth. Of all the tribes east of the Pueblo only the Catawba have preserved their aboriginal pottery-making tradition. At the least, the pottery tradition represents an unbroken line between generations from the Woodland to the present. At the most, it represents a much older time.

The Catawba aboriginal technology is not only intact but shows signs of continuing resilience. Today approximately 75 adults and 25 children make pottery. The majority of the adult artisans have contributed to this study and have helped make it a comprehensive Catawba statement. Other tribal members, including non-Indian spouses, who cannot or do not make pottery actively supported this study and the potters' efforts by digging clay, gathering wood, burning pottery, and helping with sales.

The survival of the Catawba and the Catawba pottery tradition is complicated. While forces beyond the Indians' control had their impact, the Catawba owe no outsiders any gratitude for the survival of their pottery tradition. All tributes go to a long line of Catawba potters, both male and female, who stubbornly followed their ancient craft. For nearly two centuries of great economic and cultural stress, roughly from 1776 to 1945, pottery was often the only means of subsistence. Yet, even during this period ironies abound. Making and selling Indian pottery is a difficult way to earn a living. If Catawba pottery had been an avenue leading to at least economic comfort, those who unwittingly contributed to the demise of the Catawba Nation would have copied the Indian potters. Instead, low proceeds protected the Indians; the tradition was not worth emulating. Today we are the benefactors of this complicated set of circumstances as we appreciate and purchase fine examples of Catawba pottery. And, more importantly, the Catawba owe their survival as a people to their pottery. Without pottery there would be no Catawba Nation today. Pottery is the key to the strong cultural revival among the Catawba, for the potters lead the way.

Although the Catawba survived through the eighteenth and nineteenth centuries, the most critical period of their history, they slipped into obscurity. It took American academics a long time to discover this isolated Indian pottery-making community. In 1884, the United States Bureau of Ethnology sent Edward Palmer, a field anthropologist, to the reservation (Holmes 1903:55). Today, the Smithsonian's Catawba collection dates from Palmer's field trip and is the oldest in the United States. Then in 1888 a South Carolina writer and would-be ethnologist, MacDonald Furman, took an interest in the Catawba and wrote about them in the local press (Furman 1888). He alone sparked South Carolina's interest in the Catawba.

My great adventure with the Catawba Indians began in June 1970. I was a Ph.D. candidate at the University of South Carolina, and my task at hand was to write a term paper on an obscure South Carolina writer. The temperature outside was in the high 90s and the relative humidity about the same. Inside Caroliniana Library the atmosphere

was similar but made almost tolerable by a few little rotating fans placed on the readers' desks. At that moment, I was not happy physically or intellectually. I needed a break.

Finally I could no longer handle the stress and thought to myself, "I wonder if there are any Indians in this state?" I had recently been introduced to the Pamunkey Indians of Virginia by a friend, Ed Bottoms. As a result I owned a collection of about five brightly painted, glazed, and kiln-fired Pamunkey vessels.

The card catalog stood about 10 feet away, seemingly tempting me to stray from my assignment. Surrendering to my impulse, I flipped through the cards and discovered the topic, "Indians of South Carolina." Within minutes I had learned that South Carolina was home to the Catawba Indians. Little did I suspect that the theme for the rest of my professional life had been found.

To my delight, I learned from my fetched pamphletlike source that the Catawba made flat-bottomed pots by the coil method and that one of the last potters was Doris Blue. The information presented in the pamphlet, if I remember correctly, was obtained in part from an interview with this potter. I jotted her name down and returned to my term paper refreshed by my brief interruption. That night, back in my dorm room, I wrote a short letter to Mrs. Blue. I requested a price list. I innocently addressed my note to Mrs. Doris Blue, Catawba, South Carolina. I had no idea there was a four-mile geographic distance between the reservation and the town of Catawba.

A few days later, I saluted the United States Postal Service. The poorly addressed letter actually found its way to Doris Blue's door. She responded with a short price list including those vessels she had on hand (D. Blue to T. Blumer, letter, 11 July 1970, BC). I purchased my first Catawba pieces from Doris: one comb pipe, one hatchet pipe, one Indian head pipe, and one plain elbow pipe. The total bill came to eight dollars. More importantly, I had made a friend. Doris Blue was a very generous lady who eventually became one of several Catawba mentors. She began the long process of introducing me to her people's ancient artistic heritage by opening reservation doors for me and urging me to study her people beyond the pottery tradition. This book is in part the result of a long process initiated by Mrs. Blue and continued by other tribal members. My collection began with those four pipes and today has grown to over 1,000 vessels. These pieces, which cover over a century of Catawba pottery making, are also the basis of this study. It has been my invaluable study collection from the very beginning.

To say the Catawba Indians of South Carolina possess a cultural treasure of tremendous worth is a great understatement. Few of the

original Native American communities have survived the kind of holocaust that began for the Catawba in 1521. Few of the surviving communities can boast much in the way of material culture such as pottery making. This sorrowful and shameful blot on our history has hardly ended in our time. From the Indian perspective, forces are still busy working to eradicate American Indian culture in this country. For many reasons, the Catawba Nation has survived nearly five centuries of contact with an alien culture. Most of their amazing success story belongs to their beloved pottery tradition. Hopefully this study will make some of their story clear. I do not intend that this effort be the last word on the Catawba pottery tradition. Much work remains to be done.

It did not take me long to discover that Doris Blue enjoyed incising her vessels with very carefully drawn motifs. As I added more potters to my list of friends, I learned they too used such markings. Mrs. Georgia Harris, who was to join the ranks of my tribal mentors and whom I came to call my Professor of Catawba History and Culture, used the same patterns slightly modified by personal style. The designs themselves, as simple as they are, provide us with a major echo of the Southern Cult, which gave the region's Indians a full religious cycle of tremendous complexity (Howard 1968). Most Catawba motifs reflect the sun circle or the sacred fire, alluding to the antiquity of the Catawba tradition.

Part of the Catawba's resurgence of interest in their pottery tradition is linked to economics. It is true that love and pride are and always have been basic ingredients in the making of a Catawba pot. Many of the potters can be heard to declare with great sincerity: "I just love to get my hands in my clay to build something"; "I am drawn to my clay"; "I feel in touch with our ancestors when I work in clay." At the other end of the spectrum, however, is the crass topic of financial gain. Part of today's success story can be seen in the four pipes that Doris Blue sold to me in 1970 for eight dollars. Today the same pipes would bring between 40 and 50 dollars each. If they are mounted on a decorated reed stem, the price can go to over 100 dollars for the same pipe. Money talks. The Catawba potters have long been attuned to and acted on the economics of their tradition. Today, due to the efforts of many, it is cost effective for the Catawba to work in clay. Catawba pottery has been linked to the economic situation the Catawba faced for so long it is impossible to separate the two.

According to the Bible, clay is the stuff from which God made mankind. Clay has the same role in Catawba belief, but the Indians give it a different twist:

One day the Creator decided to make a man. He took some clay and molded one and put the figure in the fire to burn. When the Creator thought the man was baked enough, he took him from the fire. He was hardly burned at all and was a pale color. Dissatisfied, God took the man and threw him across the sea. He became the white man. The Creator did not despair but decided to try again. So he took up his clay and molded another figure and put it in the fire to burn. This time He let the fire burn longer. When the Creator thought the man was baked enough, he took the man from the fire. To His dismay, the man was burned black. Dissatisfied again, God took the man and threw him across the ocean. This man became the Negro. The Creator decided to try one more time. He took up his clay and molded another figure and placed it in the fire. He watched the fire more carefully this time and took the man out at just the right moment. The man was burned nice and red. The Creator did not throw this man away but kept him. This perfect man was the first Catawba Indian. (Field Notes, Susannah Harris Owl, 1977, BC)

It took me a long time to get to see the clay holes. Every time I visited a potter, I saw clay in various stages of preparation, but actually seeing the clay holes was another matter. The Indians are cautious about who visits their clay sources. In 1976, I was given permission to go and I met with William Oliver Nisbet, who owned the portion of the Waxhaw Old Fields that contains the clay long held sacred by the Catawba. As I stood with Mr. Nisbet and surveyed a rich expanse of bottoms planted in corn, he told me he had no idea why the Indians were so insistent on digging clay on his land. They came in family groups, asked permission to trespass, dug their clay, and carefully filled in the holes. Years passed before I discovered the full import of the Nisbet Bottoms in its relation to Catawba history, culture, and spirituality. The secrets hidden under layers of Catawba history take time to unearth.

The Catawba pottery-making kit is filled with an odd assortment of ancient and modern tools. The rubbing rocks are the most important link with a rich past going back in time for many centuries. Doris Blue was the first potter to show me her tools and tell the story behind each one. Her rubbing rocks came from her great-grandmother Rhoda George Harris, who probably obtained her tools from her elders. Today these tools are in the hands of a potter of the sixth generation descended from Rhoda Harris. Modelers can be kitchen spoons, jar lids, shells purchased or found at the beach, and an assortment of heirloom and new knives. For digging clay, the Indians use a common garden shovel. Earl

Robbins uses a posthole digger. The shift from beating the clay to straining it through window wire to remove impurities was made early in this century. Each and every step in the long Catawba pottery manufacturing process is accompanied by a fascinating story.

Building a Catawba pot is not an easy matter. Each of the more than 100 shapes follows a fixed construction method a new potter must learn before the title of "Master Potter" is earned. For instance, appendages including legs and handles on pots are never merely stuck onto the sides or bottom of a vessel. The potters measure exactly where an appendage should go and bore holes so it may be firmly inserted through the vessel's walls. There is only one way to make a turtle effigy, and all the potters use the same method with very little variation. Even Catawba pots of the most primitive workmanship, such as those built hastily for the North Carolina mountain trade (1925–1960), display ancient construction methods.

When one looks at any group of say 25 or 30 Catawba pots in a museum storage area or on a sales table, one may in all probability see the entire historical range of Catawba pottery from the most basic pre-Columbian shapes to the Catawba vessels that innocently resemble Colono ware of Spanish and English influence. Tourist vessels once made for the North Carolina mountain trade are still produced. Some of the most magnificent contemporary vessels are made by today's young master potters who are intent on studying the old styles and reviving them in all their glory. These young potters also like to approach the serious collector and museum acquisition officers.

Academics are often confused by some of the more modern tourist-type items, most of which originated in the North Carolina mountain trade. Those who come upon Catawba pottery but do not study it have a tendency to see a Catawba turtle effigy pencil holder and declare the tradition tainted by tacky commercialism. They often fail to recognize the heritage behind such tourist gimmicks and miss seeing a great aboriginal pottery tradition at its best. The truth of the matter is the Catawba potters have preserved an art form of great antiquity. But the potters also stand on two legs: one placed firmly in the modern period and the other anchored in the past. The newer shapes are made for those who want something Indian but have no idea what that means. The highly critical Catawba potters respect the ability to make a graceful water jug, cooking pot, snake pot, or a peace pipe. These are the old standards by which a potter's skills are tested today.

Pipe making among the Catawba is nearly as old as growing and using tobacco in the Americas. Today the Indians make pipes by two time-honored methods. First, they "bend" pipes by hand following the most ancient construction methods. Such pipes often resemble those

found in archaeological digs. The second method uses squeeze molds. Moravian potters seemingly introduced these interesting tools to the Catawba in the eighteenth century. The ability to make such molds died out in the 1930s and was successfully revived by Earl Robbins in the 1990s. Today, a number of the young master potters make squeeze molds and use them in their pipe production.

Burning a load of Catawba pottery is a dramatic event, particularly if the fire is witnessed at night when the pots glow like hot coals. My first fire occurred in daylight. It was a wonderful experience and a total surprise. The year was 1976. The first formal pottery-making class, that of 1976, was ending. The coordinator, Mrs. Frances Wade, told me that two young potters, Louise Bryson and Anne Morris, were at the old school burning their pottery in the fireplace. When Mrs. Wade suggested that I go to the school to watch I jumped in my car and rushed to see the burning process. On entering the building, I found the two ladies red-faced from the tremendous heat generated by the pottery. What impressed me immediately was the joy that was painted on Louise Bryson's face. As I entered the room, she was removing her pottery from the fire with an iron poker. Realizing she had an audience, Louise fetched an odd object from the coals and held it up for me to see. She declared, "I made this clay hat for my daddy." This was my introduction to one of the most enthusiastic Catawba potters I have ever known. Later that year Louise and her husband Dennis invited me to come to their home in the middle of the night to witness my second fire. The three of us sat around a 50-gallon steel drum and watched pottery glow as red coals. To me it was akin to standing on the edge of a volcano crater watching the lava bubble up at my feet. I shall never forget the hours I spent with Louise and Dennis as we guarded that fire so many years ago.

Teaching the craft of Catawba pottery making is crucial to the tradition's survival. One can rightfully say the Indians are very good at it, for they have been successful over a span of centuries. Catawba pottery is so uniform that archaeologists are constantly finding vessels on digs in the Carolinas that look very much like twentieth-century vessels. The Catawba do, however, have a tribal law, today backed up by federal law, that outsiders are not to be taught to make Catawba pottery (Public Law 101–644). In times of great economic stress, however, this rule has been broken to allow non-Indian spouses to make pottery and sell it.

The Catawba rationalize pottery-making demonstrations by saying the viewer is not allowed to handle the clay and actually make something. Those Indians who work with schoolchildren who do make little objects are always on the defensive with their fellow potters. Catawba

clay is far too valuable for such demonstration purposes, and the use of commercial clay often gives the potter some room for rationalization.

In 1977, the potters demonstrated their craft at Winthrop College in front of academics and art students who understood clay. The Winthrop demonstrations became events of great pride. Doris Blue, one of the senior potters at the time, proudly announced that at one time the Indians were only allowed to sit at Winthrop's gate. "Now we are invited to go inside to teach our tradition to the students." Most recently, Mint Museum employees spent a day with Miranda Leach, a teenager, to film a video of her working in clay. The video also captured Miranda's mother, Cheryl Sanders, teaching her daughter in the traditional tutorial method: within a family a young person merely watches the elders.

Today one might be tempted to think that peddling pottery was a twentieth-century outgrowth of the North Carolina mountain trade. Again, little in the Catawba tradition is recent. When the potters set out in their poorly maintained cars to sell in North Carolina, they were doing exactly what the Indians of previous generations had done before them, by canoe, on foot, or even by covered wagon. The Catawba peddling tradition was first documented in 1540 when a youthful Indian merchant guided Hernando de Soto into Cofitachiqui (Robertson 1993:74). The youth, by virtue of his taking trade items into Cofitachiqui, claimed to know the territory well. Then in 1709 John Lawson recorded that the Indians traded pipes with those who had none (Lawson 1714). William Gilmore Simms made note of this tradition in the mid–nineteenth century (Simms 1859). At the beginning of the twentieth century the *Herald* of Rock Hill noted that a group of Catawba were peddling pottery by wagon in Gastonia, North Carolina (*Rock Hill Herald*, 15 August 1905a:1). Even the methods of barter were astonishingly fixed into the twentieth century. Today the Indians do very little peddling. Most sales transactions happen over the telephone and with occasional visitors to the potters' homes. In recent years, the Catawba Cultural Preservation Project, in opposition to tradition, has tried to corner the Catawba pottery market. The potters have resisted such interference and remain fiercely independent in their business dealings.

One of the most interesting things that happened in the twentieth century was a rise in professionalism among the potters. At the beginning of the century only one or two potters signed their work. By the 1970s the Indians began to sign and date everything they made. Today it is rare to find a contemporary piece that is not signed. Even children who dabble in clay know the importance of signing their work. The

potters are quite aware when they scratch their name and the words "Catawba Indian" on the bottom of a vessel they are making history. Today some of the young master potters even number their vessels in the hope of increasing the value for the buyer.

This tendency to appreciate Catawba pottery in a professional way provided the original idea for this study. Although I met Doris Blue in 1970 and became ever more familiar with a growing list of potters (most of them retired), I had not really done anything formal with them. Then in August 1976, I obtained a one-semester appointment as an instructor in English at Winthrop College, today Winthrop University. During this period, my visits to the potters became more frequent. Eventually I made daily trips to the reservation. During one of these visits, I decided to try to convince the retired potters, 21 in number, to make pottery for a small show/sale in the Winthrop Art Department. In the process of writing a short handout to go with the show, I interviewed retired potter Sallie Harris Wade in Mrs. Frances Wade's living room. As Sallie Wade talked about her pottery-making days, I realized the complexity of the story they had to tell.

The movement toward a professional approach to making and selling pottery has continued to develop and be refined. Following the formation of the Catawba Cultural Preservation Project, a number of the potters began to have business cards printed. I have produced fliers for a number of the potters. Some of these have been professionally printed on colored paper and illustrated with photographs. Today master potter Caroleen Sanders has her own Website. The Preservation Project also has its own Website. Some of the potters have cell phones so they will not miss a customer's call and also provide a telephone answering machine message in both Catawba and English with a background of tribal music. The practice of demonstrating pottery has become a given for these potters. They look for opportunities to gain this kind of exposure. They constantly search for ways to promote their wares. Indeed, the concept of "peddling" has been replaced by that of "promotion."

It is no secret that the Catawba pottery tradition is linked to the archaeological record. Archaeologists have long been drawn to the Catawba Reservation because pottery fragments and entire vessels of great interest are occasionally found there (Fred Sanders, interview, 6 March 1988, BC). For instance, in 1977 when Edna Brown was working in her garden she uncovered a nearly complete axe pipe (Edna Brown, interview, spring 1977, BC). It was apparently made with a squeeze mold and exhibits some fine traditional Catawba incised designs. Such a find might be a cause for surprise in any other place but

not on the Catawba Reservation. Edna Brown felt she had immediately solved a would-be mystery—who had made the pipe?—and declared that it was probably the work of Susannah Owl. The Smithsonian collection fortunately contains vessels made by Susannah Owl, and a comparison to them adds credence to Edna Brown's proclamation. The house Edna Brown occupied had been constructed by Susannah's husband, Sampson Owl, in the 1870s. As this nineteenth-century potter burned her wares, she apparently discarded broken pieces in the yard. Over a century later, Edna Brown simply uncovered the pipe while gardening.

During the summer of 1977, the Catawba Indian Potters' Association cleared a plot of ground in preparation for the construction of a pottery shop. The workmen found a small broken pitcher attributed to Mary Brown Plyler. This piece was made as recently as the 1930s when the Plyler family lived at this location. The house had been abandoned and torn down many years before 1977. All those who saw the pitcher declared it to be the work of Mary Plyler (Doris Blue and Frances Wade, interview, Spring 1977, BC). Although the vessel is badly damaged, its style and workmanship parallels that of the heirloom pieces Mary Plyler's descendents treasure. More recently, Anna Branham was walking in her yard after a rain. She found a squirrel effigy that predates the site's occupation by the Plyler family. The squirrel is almost a duplicate of one in the Museum of the American Indian collection of the Smithsonian Institution, (Anna Branham, interview, 2000, BC).

In 1994, the family of Martin Harris obtained a tribal land allotment in an area near where Sallie Wade once lived. She discarded damaged vessels at the edge of the yard in a way similar to that done by Susannah Owl a century earlier. All the broken vessels unearthed appear to be the work of Sallie Wade (Ronald Harris and Edwin Campbell, interview, October 1994, BC). During this same period, Steve McKellar found part of a fanciful pipe in his yard. Although it was found at the site of David Adam Harris's house site, it appears to come from the nineteenth century or earlier (Steve McKellar, letters, November 1994 and January 1995, BC).

The Catawba Archaeological Survey also located some interesting pottery fragments in its preliminary work conducted immediately after the Settlement of 1993 (Rita Kenion, interview, January 1995, BC). In recent years many young Catawba families returned to the reservation. Bobby and Betty Blue were among them. The house site they received from the Executive Committee had been abandoned by the Head family when they migrated to Colorado in the early 1880s. In 1907, James and Margaret Harris had claimed the place and built a frame

house there. This structure was abandoned and torn down by Floyd Harris in the late 1950s. The Blue family occupied the site in 1981. The Blues first began to find pottery fragments in 1984 when the yard was extended into the woods behind the house (Georgia Harris, interview, 17 September 1989; Betty Blue, interview, 17 September 1989, BC). As in other cases, the pottery represented surface finds. While the shards are historically important, to date they seem to reflect broken pieces discarded by the Head and Harris families between the 1860s and the 1930s. Of particular importance are several mold fragments, the oldest of which is apparently the work of Martha or Robert Head. No museum collection has yet yielded a pipe attributed to this mold. Other and more recent mold fragments are definitely the work of Martha Jane Harris, a celebrated mold maker. Another interesting piece, a bookend fragment decorated with an Indian head, was most likely made for the North Carolina mountain trade. This piece is perhaps the work of Margaret Harris who used molds made by her mother, Martha Jane Harris.

These fragments, obviously taken from Martha Jane Harris's molds, illustrate a common dilemma faced by those who wish to date or attribute work to a given potter. In this case, three potters of superlative talent must be considered. First, Martha Jane Harris had access to the site from 1912 to 1930. Second, Margaret Harris raised a family at the site from about 1912 to her death in 1924. Third, Georgia Harris lived there and worked in clay there from around 1920 to the 1940s (Georgia Harris, interview, 17 September 1989, BC). These dates must be considered. Then it is doubtful that Martha Jane Harris ever made anything as commercial as a bookend. Margaret Harris may have taken an interest in bookends. At the same time, the bookends might be the work of Georgia Harris. All one can safely say is that the piece was made with molds made by Martha Jane Harris. All three potters used the same molds.

In 1990, a broken turtle pipe and a small pitcher with the word "INIAN" incised on the bottom were found at this same location (Betty Blue, interview, 1991, BC). The Blues continue to find pottery fragments and are always alert to the possibility of an exciting find on their allotment.

The Catawba potters have entered the third millennium with great hopes. Counting adults and children, there are more Catawba potters today than there were Catawba Indians at the end of the nineteenth century. The potters have entered a period where they appreciate the professional aspects of their craft. Indeed, many are busy taking Catawba pottery into the realm of art. They have made the adjustment

from peddling their wares house to house to making telephone contacts. The number of master potters is large. The young are taking an interest and learning to make traditional Catawba pottery. Sales are no problem. The difficulty is keeping up with the demand. From the looks of today's situation, Catawba pottery will be crafted and purchased for a long time to come.

2 A Family Economy Based on Pottery

With the coming of the white man the Catawba faced immediate economic disaster based first on disease. When Hernando De Soto visited the Nation in 1540, contagion had already begun a catastrophic population decline (Robertson 1993:83). Most of the epidemics the Catawba Nation endured are barely recorded (Dobyns 1983), but we do know that in the smallpox visitation of 1759, the Catawba lost half their population. Periodic disasters began in 1539 before de Soto's arrival at Cofitachiqui and ended with the influenza epidemic of 1918 (*South Carolina Gazette*, 15 December 1760:1; *Record*, 7 October 1918:5; *Evening Herald*, 10 October 1918:3). Children were orphaned and women were left to raise families alone. Peter Harris's family fell victim to the 1759 epidemic and he was taken in and raised by the Spratt family (Spratt n.d.:64). Other examples of this sort abounded but went unrecorded as families struggled to care for their own as best they could.

By the time the Catawba in the eighteenth century first visited the Virginia Colony to settle a business deal, their fate had already been long sealed. Yet, even though the Indians had endured much in the way of tragedy, the European settlers met confident men (Passport 1715). Although greatly reduced in number by the introduction of European disease, the Catawba still possessed a culture that satisfied all their basic needs. Their huge land holdings included much of the territory from South Carolina through Central North Carolina into Southern Virginia in the area around modern Danville. The Catawba Nation staved off attacks from their Native American neighbors but they had undoubtedly heard that strife also occurred between the Powhatan Confederation and the English. Potential struggles aside, eagerness to improve their material culture led the Catawba to journey north to trade for a wondrous new commodity—iron (Richter 2001:41–63).

A business deal was soon made between the Virginians and the Ca-
tawba Nation (Brown 1966:48–58), and the fate of the Catawba was
sealed. The Catawba had little that the Europeans wanted and a truly
equitable balance in trade was never established. The woodland re-
sources the Indians offered, mainly animal skins, were soon depleted.
A second resource that came into full play was the trade in Indian
slaves. This traffic had a devastating effect on the Catawba and their
neighbors. The Native American population was quickly decimated be-
yond the losses suffered from 1521 to 1690. The erosive forces of the
slave trade were combined with repeated epidemics and the demoral-
izing effects of another new commodity, alcohol. In time, the Catawba
men were left unemployed, and a profound feeling of hopelessness set
in. Despair intensified when the Indian wars began to reach genocidal
proportions. This was especially true when the Catawba faced the fury
of the Iroquois (Brown 1966:262 ff), when, for the first time in Catawba
history, the Catawba defenses were inadequate. The destruction of
the Nation's confidence was nearly complete when the unemployed
Catawba men were occupied in the ignoble pursuit of runaway Negro
slaves for cash (*Gazette of the State of Georgia,* 10 May 1787:2).

As the Native American economy was destroyed, it was replaced by
a European emphasis on money and production (Richter 2001:41–53).
At the end of the French and Indian War, the land of the Catawba Na-
tion was surrounded by settlers (Hewatt 1961). In a valiant attempt to
save their resources, the Catawba signed the Treaty of Pine Tree Hill
in 1760 and the Treaty of Augusta in 1763. The Indians surrendered
millions of acres to the Europeans, but they retained their ancient
hunting rights to all of South Carolina. They naively thought their
economy was safe, and that they could manage with their 144,000-
acre reserve. The eighteenth-century record is replete with accounts
of white farmers attacking Catawba hunting parties (Bull, A Proclama-
tion . . . , 1770; Bull, A Proclamation . . . , 1771). The Indians were
beaten, their forest products destroyed or stolen. As a result, the Ca-
tawba could no longer follow their old occupation of hunting. Fishing
took up some of the slack, but the Catawba had long depended on a
mixed hunting and gathering economy supplemented by some farming.
The traditional Indian farming methods could not compete with the
young and hearty plantation system. So dismal was the situation that
many Catawba despaired of farming. The Catawba slipped into a long
economic decline.

Fortunately for the survival of the Catawba as a people, the prag-
matic potters learned, probably during the eighteenth century, that
their smoothly burnished and incised ware was attractive to the settlers

(Simms 1859). When all else failed, a market was found for something totally Indian in both manufacture and character, and between 1780 and 1940, pottery dominated the Catawba economy. Other occupations such as farm day labor played a role in sustaining the economy; for instance, during the proper season, the men cut cordwood, did day labor, and some became skilled enough in European farming methods to sharecrop. Also, from the 1830s to 1959, at least one family was sustained by providing ferry service on the Catawba River (*Evening Herald*, 18 March 1963:2). After the Treaty of 1840, South Carolina also provided some financial assistance through an annual appropriation necessitated by the loss of rent money from Catawba leases. These appropriations began in 1841 and were repealed in 1951 (Act 2831 1842). Then, from the first decade of the twentieth century to World War II, a few of the Indians were employed in the local cotton mills (U.S. Congress 1931). The number employed in this manner was never sufficient to have an effect on the total tribal economy though because most mill owners refused to employ Catawba (U.S. Congress 1931). Pottery always provided a subsistence living throughout these years of economic confusion.

Clay was free to those who wanted to dig it. The required tools were easily obtained. Wood used in burning pottery was always stacked up in the yard, and more could be gathered from reservation land. While a man was out cutting firewood for 50 cents or less a cord, his wife could match his wages by making pipes. At the turn of the century, for instance, a dozen Catawba pipes went at wholesale for $1.25 (Georgia Harris, interview, 1 March 1977, BC). When not doing day labor, the men also worked in clay. Everyone from the age of 10 on was employed in clay. When an individual visited another's home, that person customarily became involved in the pottery tasks at hand.

Those who have studied the Catawba have noted the complexity of their poverty-stricken situation. In 1907, M. R. Harrington observed the poor quality of the reservation farmland (Harrington 1908:339). Some 23 years later, a U.S. Senate Committee visited the reservation. Its members were appalled at the meager resources on which the Catawba were forced to sustain themselves (U.S. Congress 1931). Today some of the Indians joke that a federal Farm Program official tested the reservation soil and found that the rutted roads contained more nutrients than the gardens worked by the struggling Catawba (Willie Sanders, interview, 1 March 1987, BC).

Soon after ethnologists took an interest in the Catawba, the potters began to leave written records of the prices they expected to receive for their pottery. In 1921, Nettie Owl provided Frank G. Speck with a

number of her vessels. In one of several letters to the anthropologist, she provided an inventory/price list for a shipment (N. Owl to F. G. Speck, 1921, American Philosophical Society, Philadelphia):

4 vases	$5.00
1 pot	2.00
pipe of peace	1.25
5 pipes	1.25

Low prices did not discourage the Indians. Work in clay continued to be an economic necessity, and for a woman like Nettie Owl pottery was often the only recourse. Fortunately, she was a master potter of exceptional skill.

Margaret Brown made pottery throughout her life. Her granddaughter, Lula Beck, recalled her efforts: "She made Indian pottery as far back as I can remember. I can never remember her doing anything else. She would make big pieces. She'd make the peace pipe. That's about the smallest pottery she made" (Lula Beck, interview, 13 May 1987, BC). Another potter who continuously worked in clay was Rachel Brown, the wife of John Brown. At the time the Browns generously assisted Harrington in his research they depended on income from pottery and from running a ferry on the river. When John Brown died in 1927 (*Evening Herald*, 21 June 1927:1), Rachel Brown continued to make pottery until shortly before her death in 1960 (*Evening Herald*, 21 September 1960:2). Nearly all the senior tribal members remember Granny Wysie, as she is still fondly called. "The pottery was all she had, and she'd go [to town] every week with those pottery. She made beautiful pots. She made flowerpots. She made a lot of flowerpots and sold them" (Catherine Canty, interview, 3 March 1981, BC).

Many Catawba potters were never able to produce and market a large volume of pottery. These individuals preferred to follow a mixed economy. Edith Brown had a large family to support, and pottery played some role in her household budget until approximately five years before her death (Edith Brown, interview, 14 June 1985, BC). In her younger years she made pottery after finishing her farm work. Whenever possible she found work hoeing and picking cotton for others (Georgia Harris, interview, 22 March 1980, BC). The same was true for Margaret Harris, the widowed mother of Georgia Harris who also raised a large family alone. "She worked hard. Like I told you, she worked on the farm—rented the farm out for half . . . so she could raise her family. She did that; and, she'd make some pottery after she'd get through the crop" (Georgia Harris, interview, 22 March 1980, BC).

Mildred Blue provided a key to understanding the importance of pot-

tery. In talking about her grandmother, Rosie Wheelock, Mildred Blue declared: "Then that was about the only way they had to make any money, extra money for living expenses" (Mildred Blue, interview, 24 March 1983, BC). It was often the only way the Indians had of obtaining cash. Even then pottery sometimes brought an exchange of farm produce rather than cash money.

The Catawba had certain advantages. The reservation was a haven where renting homes was rare, and houses were traded for nominal fees or for goods of little value. For instance, Bill Sanders traded his family's reservation home for a gun (Willie Sanders, interview, 20 March 1983, BC). Most families farmed in the reservation's river bottomland and kept garden plots as well. If the Indians wanted extras or ready cash, pottery provided a way. While work in the public sector was not a certainty, the clay supply was inexhaustible.

So strong was the tradition and so difficult was public work to find that those who left the reservation often continued to make pottery. Such was the case with Theodore and Artemis Harris when they moved to the village of York about 30 miles from the reservation in the 1930s (Garfield Harris, "My Story," autobiographical sketch, BC). Theodore was a sharecropper and was never certain his crop would make enough to support his large family. The pottery built and sold by Artemis pulled up the slack and often put food on the table.

A few Catawba families have always made an adequate living from clay. The John Brown family often managed from clay alone (*Evening Herald*, 1 May 1909:1). Nettie Harris Owl was estranged from her Cherokee husband, Lloyd Owl, for much of her married life and was able to make a living from her pottery (Lula Owl Gloyne, interview, 1979, BC). She also sent her children to Indian schools. All of them had professional careers either in the Indian service or in the public sector (Records of the Owl Family).

The Gordons are perhaps the best-known family to have subsisted on pottery before World War II. The backbone for the business was Sallie Gordon, a skilled and prolific master potter. Sallie was always so busy working in clay that she depended on her son Ervin to sell her wares for her. Ervin Gordon, for the most part, only sold pottery (Lula Beck, interview, 13 May 1987, BC). At first he sold his mother's work. Then after Ervin Gordon and Eliza Harris married, Sallie and Eliza worked together. Ervin gathered the wood and burned the pottery. The Gordons also kept a sign on the road in front of their home and shared the proceeds from the sales of their work (Georgia Harris, interview, 19 March 1980, BC). They also made periodic trips to the mountains and the Cherokee Reservation, and they always attended fairs. On occasion they sold at Winthrop College. Ervin and Eliza Gordon also

spent a couple summers demonstrating and selling pottery in Tanners-
ville, Pennsylvania (Georgia Harris, interview, 19 March 1980, BC).

During the last quarter of the twentieth century, the most successful
commercial efforts were those of Sara Lee and Foxx Ayers, and the Earl
Robbins family. Although the Ayers family lived in West Columbia,
South Carolina, far from the reservation, they did a brisk trade in pot-
tery for many years. In the 1980s, their work was found in galleries and
museum shops such as Gallery IV in Irmo, South Carolina; shops at
the local airport terminal in Columbia, South Carolina; the Bureau of
Indian Affairs Indian Shop in Washington, D.C.; the York County Mu-
seum in Rock Hill; the Schiele Museum of Natural History Gift Shop
in Gastonia, North Carolina; the gift shop at the Charlotte Nature Mu-
seum (now the Discovery Place) in Charlotte, North Carolina; and the
gift shop of the Heye Foundation at the Museum of the American In-
dian in New York.

Today, the work of Earl and Viola Robbins, and the work of their
daughter Margaret Tucker, appears in numerous shops. Cheryl and
Brian Sanders like to concentrate specifically on museum shop sales.
These two families are adept at working up a deal that is to their ad-
vantage. They do not, however, peddle their wares but prefer to wait
for the particular shop or museum to contact them.

Frank and Henry Canty did not make pottery but sold vessels ob-
tained from others. Both were homeless men who supported them-
selves as best they could by doing odd jobs for sympathetic Catawba
families. Many years later, Bertha Harris recalled their method of ob-
taining some of life's necessities:

Well, one thing Frank used to do—I reckon Henry did it too—is get
pottery from different ones. He'd go cut and carry wood for them and
they'd give him pottery, and he'd take it to Rock Hill and get his liquor
to drink. That's the way—I know Frank got his like that. . . . He got
pottery from his mother like that, carrying wood up—go out and cut
and carry wood. Pile it up in the yard and get his pottery and go around
to different ones like that. He asked if he could. I know he never got
paid, but I don't know how he got rid of the pottery up there. He had
to sell it kind of cheap. I don't know how much he got for it, but he
done things like that. (Bertha Harris, interview, 2 March 1981, BC)

A family crisis often initiated a tremendous production of pottery.
Such was the case when ex-chief Raymond Harris passed away leaving
his young wife with a large family to raise (*Evening Herald*, 24 Janu-
ary 1952:2). Nola Harris joined forces with other family members and
made pottery. She and Georgia Harris worked together. Nola's brother,

Douglas Harris, carried their handiwork to the mountains. The proceeds were divided in the following fashion:

> Well, I made pottery during the first year we lived over there cause Georgia came down and we made pots together and took them to the mountains—her and my brother. . . . No, they got a little more than 10 cents for them. Yes, they got more than that for them, but it wasn't all that much. . . . I didn't have any furniture in the living room, and the whole living room floor was covered with pots, and she and I rubbed them and fixed them up, and they took them to the mountains and give me half of it, and she got half. I think I got around $60 out of my share, and she had the other half. (Nola Campbell, interview, 16 June 1985, BC)

Since these hard times, the economic place pottery held among the Catawba changed considerably (*Evening Herald*, 26 March 1942:1). As the Indians found stable public sector work during World War II, nearly all the potters abandoned working in clay full-time. A few tried to balance public work with pottery. Eliza Gordon, for instance, worked in a cotton mill and made pottery, too (Willie Sanders, interview, 20 March 1983, BC). Most potters, content with their mill salaries, had discontinued making pottery by the 1960s. Elsie George's husband, Landrum, worked in the mills and served in World War II. For Elsie, pottery was never crucial to putting food on the table. "I never made many pieces. Just small ones. I did make some in the 1930s, and I was married in 1932. Then the war came along, and Landrum was in the army. We did not need the money" (Elsie George, interview, 22 March 1977, BC).

Bertha Harris followed a similar pattern. She stopped working in clay in 1948 and did not resume pottery-making activities until the last part of the twentieth century. Her 28 years away from the craft were only broken in 1971 when she demonstrated for the Mormon Church in Rock Hill. She resumed pursuing her craft again when she was asked to teach pottery making in 1976. Mrs. Harris was working in clay on a more or less regular basis throughout the 1980s. Her pottery, however, did not play a major role in her family's economy. Her work brought good prices and gave her a great sense of satisfaction (Bertha Harris, interview, 1 March 1977, BC).

Between 1930 and 1960, the Catawba pottery prices actually fell, mostly as a direct result of the North Carolina mountain trade and the mass production it demanded of the potters. Other problems caused by this market are discussed in chapter 3, on the peddling tradition.

Hand-in-hand with the economic competition of public sector work

went misdirected pride. During the 1940s and 1950s, it was not un-
common for male family members to balk at seeing the craft practiced;
they linked pottery making to a time of a great economic depression.
Once the Indians found jobs in the mills or in some other public sector,
they felt that pottery was neither necessary nor desirable. When asked
about his wife's pottery, Richard Harris was reluctant to talk about it
and said, "She [October Harris] sold it or gave it away or something"
(Richard Harris, interview, 2 August 1982, BC). In other words, Octo-
ber did not have to work, as had her mother and grandmother. Richard
Harris's family had outgrown the making of pottery and did much bet-
ter on the labors of a male breadwinner. Georgia Harris elaborates on
this attitude: "I love to [make pottery]. My son and my husband used
to fuss at me. That's the reason I quit making pots. They said, 'Quit
making them. You don't get nothing for them, and they are too hard
to make. Quit making them.' They'd just fuss. Course my husband
made good money. I didn't have to make them. I just loved to fool with
them" (Georgia Harris, interview, 22 March 1980, BC).

The revival of the tradition is directly linked to contemporary pric-
ing. Catawba pottery prices did not begin to become competitive with
hourly wages until early in the 1970s. A look at Doris Blue's price
list from this period helps illustrate the rapid rise in pottery prices.
Though small, her vessels were among the best produced by any Catawba
potter in the twentieth century. Contemporary potters are hard pressed
to equal the quality of Doris Blue's work. It is significant that Doris
felt she was charging enough for her pieces that she did not have to
charge for postage and handling (D. Blue to T. J. Blumer, letter, 1970, BC):

Indian head pipe	$2.00
Tomahawk pipe	2.00
Hatchet pipe	2.00
Plain pipe	1.00
Canoe, turtle, duck or ashtray	2.00

While Doris Blue's prices were still low, 20 years earlier the same pipes
brought 10 to 25 cents each in the mountains of North Carolina. These
prices can also be compared with Nettie Owl's price list in 1921. By
1973, Doris Blue's prices had risen to $2.50 for small effigies and $3.50
for each pipe (Price List 1979a BC).

The economic scales tipped in favor of the potters in 1973 when
Steven Baker organized a Catawba exhibit/sale at the Columbia Mu-
seum of Art (Baker 1973). The work of four master potters was in-
cluded in this important event: Sara Lee Ayers, Doris Blue, Georgia

Harris, and Arzada Sanders. Of these, sales of the pottery of Sara Lee Ayers and Arzada Sanders provided their households with a major economic contribution. Doris Blue and Georgia Harris produced a limited quantity of pottery, and their economic dependence on pottery was minimal. Overriding the objections of Sara Lee Ayers, Arzada Sanders, and Doris Blue, Steve Baker insisted that the potters raise their prices comparable to the art sold at the Museum at that time.

At this 1973 exhibition, the Catawba were for the first time exposed to a market not only interested in fine examples of Catawba wares but also willing to pay appropriate prices for them. It will always remain to Steve Baker's credit that he correctly assessed the value of the pottery. The success of this exhibit rippled through the Catawba community. The Indians found it hard to imagine that a Catawba pot could be sold at prices that ranged from 25 dollars to 100 dollars (Doris Blue, interview, 1974, BC). Before this event, the top Catawba price was about 15 dollars. Baker also tried to convince the potters they were making art, not just the pottery of their elders and ancestors. This idea eventually caught on but it took time.

The new market ushered in by Steve Baker would speak to the new Catawba economy, which was often based on the minimum wage. All the Indians could profit from such fair prices depending on the quality of the work. Young and energetic potters found it entirely possible to make far more than the minimum wage in this traditional craft.

Another look at the prices charged by Doris Blue reveals that prices continued to climb. Her price list of October 1978 reveals the trend started by Baker (Field Notes 1978 BC):

Indian head pot	$90.00
Snake pot	90.00
Bowl	30.00
Pitcher 10″	60.00
Peace pipe	12.00
Pipes, ornate	8.00
Plain pipes	5.00

It must be remembered that Doris Blue, master potter, only produced pottery of museum quality.

In 1979, the fledgling Catawba Arts and Crafts Association sponsored an exhibit/sale at the Smithsonian's Renwick Gallery. By this time confusion reigned supreme among the potters concerning what they considered fair prices. Some potters who were still aspiring to trade-ware quality pieces wanted museum prices for two reasons: the

Smithsonian was a museum and the people in Washington had much
more money than South Carolinians and would pay more for examples
of Catawba wares. Other potters felt fortunate to send their work to
Washington and just wanted their work to sell. The Renwick price list
is interesting. The potter, quality, and size of the vessels offered is un-
known:

Gypsy pot	$104.00
Jar with pointed handles	40.00
Open bowl	22.50
Pitcher	59.00
Bowl with ruffled rim	72.50
Bowl with four legs	40.00
Indian head pipe	16.00
Pitcher	27.00
Indian head pot	144.00
Snake pot	132.50
Duck pot	64.00
Indian head jar	136.00
Indian head jar	120.00
Basket bowl	40.00
Peace pipe	22.50
Jar	48.00
Rebecca pitcher	27.25
Pitcher	59.00
Axe pipe	9.75
Jar with handles	59.25
Duck pot	14.50
Bowl with holes on rim	22.50
Comb pipe	13.00
Comb pipe	13.00
Snake pot	144.00
Candle sticks	27.25
Pitcher	27.00
Plain pipe	11.25
Jar with square handles	56.50
Peace pipe	19.25
Pitcher	136.00
Pitcher	48.00
Jar	12.75
Axe pipe	16.00
Jar	128.00
Basket bowl	12.75

Wedding jug	50.00
Pitcher	12.75
Rebecca pitcher	27.25
Jar with pointed handles	160.00

(Renwick Notes 1979b BC)

During this same period, Edna Brown's trade-ware quality work had risen to a fifteen-dollar minimum per vessel. She sold small toy effigies at much lower prices. Edith Brown, whose work hovered between museum quality and trade-ware quality depending on the vessel, used the following price list (Price List 1979a BC):

Small footed bowl	$35.00
Medium footed bowl	40.00
Pitcher	50.00
Bowl with handles	35.00

Today, several Catawba potters are asking from 300 to 1,600 dollars for large museum pieces, and they sell the vessels. When a large vessel of this quality is safely ushered through the fire, it is sold within minutes. All of these potters, new generation master potters, have other incomes. It is difficult to say what role pottery plays in their economies. For such potters and those who want to follow their example, Catawba pottery has come a long way.

FAMILY INTERACTION

The Catawba tradition is firmly linked to the family. It is a cottage industry. All members of a given family are involved at different points in the long process from the clay holes to the fire. Younger members begin by playing in the clay or watching the fire and gathering wood. Older siblings may be trusted to rub pots. Serious building is always wisely left to the oldest and best potters. On occasion men join the family effort and scrape and rub pots. Some men have always been considered master potters in their own right. Such was the case with Billy George and Epp Harris, circa 1900. Today, Earl Robbins is probably the best-known but not the only male potter. The men have always helped in the strenuous task of digging the clay. Seldom, however, is a man who is not a potter left with the responsibility of choosing suitable clay. This task is reserved for the potters, and master potters are naturally more particular about their clay than others. All family members take part in producing traditional Catawba pottery.

In 1908, Harrington illustrated this interaction in his study of the

Brown family. John Brown and his sons dug the clay. Rachel Brown selected the clay to build pots. John Brown and his children scraped the vessels, and everyone rubbed. Rachel Brown supervised the entire process from digging the clay to peddling their wares in nearby towns and hamlets (Harrington 1908).

The situation has changed somewhat today. The modern Catawba family is far more affluent than were those families who worked in clay before 1960. Today's Catawba have suffered from the same disintegration of the family as the rest of society, but this trend has been modified by tribalism, a strong force in the Nation. Until recently, the Catawba were somewhat protected by their rural location and the stability of the local population. Today the reservation seems to be part of the sprawl of bedroom communities that surround Charlotte, North Carolina. While conversion by many to Mormonism has helped maintain the family structure, the automobile, television, a rich array of entertainments, and work off the reservation have all helped alter family interaction during the last 50 years. Today the average Catawba home has added a computer and Internet access to the other electronic gadgets enjoyed by the family.

The Catawba family structure has made the work of historians, ethnologists, anthropologists, and folklorists difficult. Few of these scholars, and there have been many, have had the time to approach the various families to discover how they function together. As a rule, studies have been restricted to a single family or even a single potter, and time has always been limited. Harrington, for instance, spent several days with the Browns (Harrington 1908:399). Speck lengthened his study period and widened the scope of his contacts, but he mostly concentrated on Margaret Brown's extended family (Speck 1934). Today, as a rule, scholars restrict their first-hand Catawba contacts to a quick tour of the reservation.

A census of the contemporary potters has never been compiled. It is doubtful that even the most knowledgeable tribal members can give an accurate estimate of the community's scope. The potters themselves complicate the situation. Some, as part of a sales pitch, leave the impression that the craft is dying. This deception, and this is the correct term, is fortified by the long-standing notion that the Catawba are on the verge of extinction. When the Catawba founded their potters' association in 1977, a proposed name for the group was the Vanishing Catawba Arts and Crafts Association. The implication is that there would soon be no Catawba Indians and hence no pottery. This approach helps sales. It is, however, not true.

It is also difficult for reservation visitors to see that the tradition is

family based. No Catawba potter works alone, but this may appear to be the case. All of the Indians enjoy working with others. During the 1980s, Georgia Harris was frequently joined by her sisters-in-law Nola Campbell and Bertha Harris, and by Earl Robbins. They often built the same pieces. The tedious task of rubbing pottery is less burdensome when accompanied by conversation. Mrs. Harris also worked with her grandchildren: William and Jayne Harris, Dean Harris, Curtis Harris, and Shelli Harris, to name a few. This list of work contacts is not complete. Before her retirement in 1993, this highly respected potter was visited by a large number of Indians who were inspired by her productivity and superlative skills.

Today at least 75 Catawba make pottery, and still more dabble in the tradition. Probably more than 100 others assist in some of the more remedial or strenuous tasks. It may be assumed that some of these 100 persons also occasionally make pottery. When the late Louise Bryson was very active in the mid-1970s, her husband Dennis Bryson often tried his hand at making pots. Few of these occasional helpers ever seek recognition as potters. This is especially true of non-Indian spouses. Today a federal injunction also attempts to protect Native American artisans and their work (Public Law 101–644). Others have no intention of building pots but take pleasure in helping in some way. Each potter can and will seek help from family members in times of need.

For instance, Edith Brown's sons and grandsons dug her clay. She picked and mixed it herself and built her own vessels. When it was time to burn pottery, family members were nearby to assist her in the process that requires an open fire and can be dangerous for the elderly (Edith Brown, interview, 1 March 1977, BC). Customers, scholars included, who visited her home seldom met any of these people. Edith Brown was not reluctant to acknowledge their assistance. If such comments were made, they often went unnoticed. Visitors came to buy her signed vessels. They had little interest in who dug the clay or helped in the process. These facts are true of nearly all the many collectors who hunt pots on the reservation.

Today the Catawba family comes together most often when it is time to dig clay. While clay is found on the reservation, the best is from Nisbet Bottoms (the Waxhaw Old Fields), a short distance away in Lancaster County. Several families come together, pool their resources, take several vehicles, and make the project a major outing. Enough clay is dug to last several months or even a full season. Such cooperation exists but does not follow any pattern. The potter's husband may help pick the clay and do other chores (Dennis Bryson, in-

terview, 1 May 1977, BC). The potter, however, will take the credit and the money earned, as has always been the case. In recalling her child-hood years in a family renowned for its pottery, Edna Brown declared, "Mother, Doris, and I worked together for years. Mother and Doris built. I rubbed and burned and gathered the wood. I cannot make pots now because I never made pots until I was too old" (Edna Brown, in-terview, 22 January 1977, BC). Georgia Harris also worked under simi-lar conditions with her mother and grandmother. Other family mem-bers were present and at times would take up some clay and contribute to the work. Today Nola Campbell talks of the time she spent with Georgia Harris. One memory concerns a large canoe Mrs. Harris built and young Nola rubbed. The vessel was so large it had to be laid down during the rubbing process (Nola Campbell, interview, 1 March 1977, BC). There was no original intention that Nola Campbell would do this task. She just visited at the right time and was willing to pitch in and help. Evelyn George describes a similar situation in her family circle: "I had nothing to do. I had one baby, and I lived in my mother's house, and Fannie [Canty] lived in the old house where Frances Wade now lives. I'd go over Fannie's and just work along. We worked outside. We didn't normally work inside the house. When I made for Fanny, I helped her to rub her pots. She made small pieces, not too large. She worked in clay constantly. I also made for my mother in the 1930s" (Evelyn George, interview, 25 March 1977, BC).

An interesting aspect of the Catawba economy and the way the family cooperates is the custom of working for halvers, which may have origi-nated in sharecropping practices. According to this work method, the landowner provides both the land and the seeds for the year's crop. The sharecropper provides the labor, and the end product is shared. Catawba who work in clay for halvers do the same thing. One Indian provides the clay, and the other builds the vessels that are shared between the two. For instance, Elsie George had such an arrangement with Nancy (October) Harris who had trouble obtaining clay. "October was good at making big pots, and she kept half the pots. She really got a bargain because getting the clay worked up is the hard part. It's a long process and takes time" (Elsie George, interview, 22 March 1977, BC).

Providing for the North Carolina mountain trade, which unfortu-nately relied on quantity, demanded the making of pottery for halvers. Under the worst conditions, the potters had large orders for only one particular vessel (Mae Blue, interview, 21 April 1977, BC). To keep up with these orders, the assistance of others was needed, but the potters seldom could pay cash for such labor. Halvers was the solution.

The making of a number of new and technically complicated shapes

including the so-called loving cup and the pan-Indian wedding jar also required the practice. Some of the potters could make these pieces and gladly worked for halvers to obtain them. For instance, Louisa Blue could not make peace pipes. She had others build them for her, and she paid by providing enough clay to make an equal number of vessels. Mae Blue described the custom as she experienced it and provides some valuable insights: "I'd give the clay and I'd get half of the pots made from that clay. For instance, I cannot make a wedding jug. Sallie Beck could make them, and she would make them for me. Nola Campbell can also make the wedding jug, and we would do the same thing. But I never made for anyone else. They could all make better than me, but I'd finish them up good. I've seen them try to fill in rock holes after the pot was built, and it would leave a dent in the pot. Mine were done carefully, but I could not make good—could not make loving cups" (Mae Blue, interview, 21 April 1977, BC).

Since they work in clay to make money, it is only natural that cash is occasionally exchanged between potters. According to Georgia Harris, Rachel Brown's pottery business was often based on large orders. When this happened, Rachel turned to Martha Jane Harris and gladly paid her cash. "My grandmother often made pots for John Brown. They would have a big order, and Rachel wouldn't be able to keep up. Martha Jane would go down there and stay a day and night and make pots. She went several times that I know of. She was fast and took no time when she was younger. She had big hands and that helps. . . . My grandma was a perfectionist" (Georgia Harris, interview, 1 May 1977, BC).

In the 1980s, one potter, Martin Harris, gave the custom of halvers a new twist. Minnie Harris and Freddie Rodgers assisted Martin when he had large orders. Minnie built ashtrays, wall pockets, pitchers, and bowls with loop handles and was paid cash. Freddie Rodgers rubbed the vessels after they were built and scraped; her payment was having her hair fixed (Martin Harris, interview, 5 May 1977, BC).

The following 1995 Price List is only a rough guide for commonly made vessels, and this list does not cover the full range of vessels made:

Cooking pot	$15.00–$150.00
Large vase	$50.00–$100.00
Miniatures	$5.00–$45.00
Canoe	$10.00–$50.00
Tooth pick holder	$10.00
Plain smoking pipe	$10.00
Snake pot	$25.00 and up
Smoking pipes	$25.00–$35.00

Rebecca pitcher	$25.00–$100.00
Peace pipe	$25.00–$50.00
Indian head vase	$125.00 and up
Horse pot	$75.00–$125.00
Wedding jug	$50.00–$250.00
Animal effigies	$15.00–$75.00

(Price List 1995 BC)

3 Peddling Pottery

The Catawba potters draw from a peddling tradition with deep roots and excel at using their forefathers' bartering techniques when trading (Merrell 1989:31). The Catawba have probably always dealt in pottery. As mentioned, John Lawson noted their eighteenth-century trade in pipes. The Catawba claimed a trade network that covered the entire 55,000 square miles occupied by Catawban speakers and beyond to nations with which they maintained friendly relations. Clearly, the Indians had other viable trade alternatives than pottery, for they took full advantage of these when the Europeans came upon the scene. Unfortunately, the Catawba methods of trade and land exploitation could not match European appetites for trade goods. During the Colonial period the Catawba sold their last Indian captives, took their last load of animal skins to Pine Tree Hill, and fought their last profitable war.

By the end of the eighteenth century, the Nation was totally dependent on European trade goods and had little to barter with to attain them (Baker 1972). At the end of the American Revolution, chronic unemployment set in for the men who had spent their time at war. For uncountable generations, the Catawba had labored as both hunters and soldiers. Left behind when the American frontier moved west, the Catawba had to fend for themselves while surrounded by an alien European culture. Trade in pottery saved the Nation from extinction.

In the mid–nineteenth century, William Gilmore Simms observed the Catawba on their yearly treks to Charleston and noted that they camped at known clay deposits along their route and made pottery. The Indians sold and bartered their wares until local needs were met, and then they moved on. Charleston's most discriminating cooks considered the traditional Catawba cooking pot as essential for certain dishes (Simms 1859).

Phillip E. Porcher of St. Stephen's Parish left an account of early Catawba peddling practices: "They would camp until a section was supplied, then move on, till finally Charleston was reached. He said their

ware was decorated with colored sealing wax and was in great demand, for it was before the days of cheap tin and enamel ware" (Gregorie 1925).

By the nineteenth century the Catawba trade concentrated on a large market area that originally fanned out in an easterly direction from the Nation. They traveled by way of the rivers, but as roads were cut through from town to hamlet, the pragmatic Catawba took advantage of this new transportation system, and the potters set out on foot carrying their wares on their backs.

The work of archaeologists complements the work of historians. As Colonial settlements are explored and excavated, Catawba-style pottery is frequently unearthed throughout the Nation area. The earlier the period, the wider the range of these wares. Into the more recent period, as the Nation began to shrink and the Catawba population fell from thousands to below a hundred, the trade area diminished too, but never completely disappeared.

We study this process today in the testimonies of twentieth-century Catawba potters who participated in the Catawba peddling tradition. Peddling pottery remained an integral part of Catawba life until quite recently, and even today some Catawba potters occasionally peddle their wares. The Catawba often talk of their grandparents' peddling experiences as well as their own. Nearly all the contemporary senior potters have peddled pottery by foot, wagon, or automobile.

Some of the most colorful tales date from the mid–nineteenth century. A story told by Lula Beck probably dates from the Civil War period.

Lucinda Harris went out and sold with my grandma [Margaret Brown], and they would trade for flour and food. They went through Van Wyck walking from house to house. They came to one place and they were attacked by a bulldog, and you know how that kind of a dog can tear you up. Well, Lucinda stuck her fist right down that dog's throat, right up past the wrist, and that dog backed up and went back to the house. The farmer wanted to know why the dog was acting so odd and why he had not bitten one of them.

They went on from there and found a swarm of bees, and grandma said that she wished that she could have the bees and take them home, but she had no way to get them. Lucinda promptly took her slip off and caught the bees in it and gave them to grandma. They brought them back home that way. When they went pot trading, they were often gone for two or three days at a time. (Lula Beck, interview, 22 March 1977, BC)

During the time Lucinda Harris was peddling pottery, the Catawba population was at its lowest, and the Indians could hardly maintain a wide trading area on foot or by wagon. They were, however, willing to go great distances to sell their wares. When one considers how few pots could be carried on one's back, it is astonishing that the Indians would cover such distances to make a few pennies. "Some [Martha Jane Harris] would walk to Columbia. Just the women would go. Grandma told me that they'd put the pottery on their backs and went on. She said Polly Ottis went to a saloon, and the barman would give her a bottle of whiskey, not for the pottery but for the road" (Furman Harris, interview, 19 April 1977, BC).

The attitudes of those who speak of them today may reflect how the Catawba felt as they set out on long peddling trips loaded down with pottery:

> Sarah Jane Harris made big pots, gypsy pots, big ones. She carried them in the country on her back. People knew her all over. She was a midwife and the whites would come and get her. The folks on Route 31 knew her well. The Barbers, they bought pots. . . . [She] went way up the river on one-day walks. We just rambled. She wrapped them in something or other and tied up a cloth and carried them on her back. I guess she had a lot of flour sacks to wrap them in. Flowerpots could be stacked inside each other, and they were not so hard on her back. (Edith Brown, interview, 21 April 1977, BC)

The number of tales such as this is sizeable. In spite of the small Catawba population, many towns and hamlets are included in the twentieth-century trading zone including virtually all communities within a 70-mile radius of the Nation.

It is almost as though time and change had refused to touch the Catawba. In 1900, the older Indians continued to peddle their wares as their grandparents had done before them; for instance, the bartering methods and acceptable trade items remained fixed. In 1686, Bushnell visited a Virginia Indian village on the Rappahannock River. He wrote that the Indians "also make pots and vases and fill them up with Indian corn and that is the price" (Baker 1972:4; Bushnell 1920:39–42). John Lawson also made note of the Indians' way of measuring goods (Merrell 1989:31; Pargellis 1959:231). Among the Catawba, when Sarah Jane Harris peddled her pottery, she commonly filled the vessel three times with corn meal to ascertain a fair swap. If the farmer offered wheat flour, the vessel was filled twice. The meal was measured right on the spot. The Indians also accepted eggs, chickens, and meat (Edith Brown,

interview, 21 April 1977, BC). Lula Beck recalls that her grandmother, Margaret Brown, followed the same process. She often preferred corn meal, flour, or food over money (Lula Beck, interview, 22 March 1977, BC) and obtained virtually all of her groceries through this barter system. Other commodities included syrup (LeRoy Blue, interview, 21 April 1977, BC), peas, corn, beans, and cured meat (Wesley Harris, interview, 10 May 1977, BC). Doris Blue's family seldom purchased clothing but relied on bartering pottery to fulfill their clothing needs. "Way back when I was small people hardly ever had to buy clothes. They would trade this pottery for clothing. They would go to a home, and they would bring out clothes and trade them for so many pieces of pottery, for a garment or something, and they would get clothes like that" (Doris Blue, interview, 24 March 1980, BC). It was only natural that some people would try to take advantage and offer the Indians rags rather than usable garments. Georgia Harris recalls her grandmother's indignation: "I got enough rags at home. I don't need no more rags" (Georgia Harris, interview, 20 October 1984, BC).

While a perceptive and proud woman like Martha Jane Harris stubbornly followed her mother's footsteps, she was also aware that change was coming to the old peddling tradition. By 1900 the Catawba Indian School was well established (*Rock Hill Herald*, 5 December 1896:2) and several children were attending Carlisle Indian Industrial in Pennsylvania (Adams 1995; C. Harris). It was doubtful that the younger generation would consider peddling loads of pottery by foot as a possible occupation. The generation gap is obvious in Georgia Harris's recollections of peddling pipes with Martha Jane Harris:

> I went with her one time, and I never will forget that as long as I live. . . . She made her a bunch of pipes. You could always sell them around the grocery store. She said, "I'm going to go over to Van Wyck one day, and I think I'll come back by Catawba Junction," and I said, "Can I go with you?" She said, "If you want to and you think you can walk it." I was about 16 years old. . . . After she burned her pipes and got them ready, we got Jesse to put us across [the river] right below her house, and we walked from there to Van Wyck. I know that's seven or eight miles across there. . . . She sold some pipes over there, and she said, "Well, we'll go over on the railroad and go across the river and go to Catawba Junction." You know that's a long walk. And we walked all the way from Van Wyck to Catawba Junction across the trestle over the river. There wasn't no bridge down there then. We had to walk across it. I said to my grandma, "You reckon a train is going to come along?" She said, "No, not right now. Ain't time of day for one to come along." I said, "Well, I hope we make it." And she said, "We will." And we

walked that trestle all the way across the Catawba River. . . . I don't know if I was afraid I'd fall or not. We walked all that way across and came down to Catawba Junction. Well, we did. I done got tired by then, and she said, "We'll sit down and rest a while." She sold some pipes to that man. I knew him good. Mr. Simpson ran the store down there, and she went in and bought us some cookies and a drink. And we sat down and ate the cookies and the drink and some cheese. I believe she got some cheese. . . . She sat there with me. She knew I was tired. She said, "About ready to go?" And I said, "I guess so." After I got something to eat, I felt better, but we got ready and we walked all the way from Catawba Junction then back home, and that's a good four or five miles. I bet we made 15 or 20 miles that day. She just walked a certain pace, and it was kind of fast. When we got home I was so give in I could have fallen apart. . . . She laughed at me. She said, "Well, I brought her home, but she's about give out." And I really was. I sat down in a chair. I remember, I plopped in a chair. (Georgia Harris, interview, 19 March 1980, BC)

Obviously, Georgia Harris never considered peddling pottery an option; the physical endurance this way of life required was not to her liking. She had already spent several years attending the Catawba Indian School and was nearing graduation from the Cherokee Boarding School. Her education gave her advantages no one else in her family had ever dreamed possible. She would, however, go on to become a master potter and match her grandmother's skills. Georgia Harris felt that peddling pottery was a thing of the past, but she took the opportunity to pay tribute to her grandmother's strength whenever possible.

While peddling on foot was being abandoned by many Indians, the practice continued to survive into the mid–twentieth century through economic need and short-term hard luck. For instance, Mary (Dovie) Harris, who died in 1969, peddled pottery for most of her life. She usually recruited younger potters to accompany her on her ramblings through nearby communities. Dovie Harris was often accompanied by Maggie Harris and her children:

Aunt Dovie, well her name was Mary Harris, and Mama and Ruthie, Reola, Viola, and myself all went way out here towards Leslie and way down towards Bowater, back in that way trading pots several times. Now we'd walk all day long and trade. We got canned goods and different things for pots. [We'd] just knock on doors and ask them if they'd like, if they had anything they'd like to trade for some pots or something or other like that. Mama and Aunt Dovie done this. Us children didn't do it, but I can remember that. . . . They'd have a snack [in a]

croaker sack. . . . They carried their pots tied up in a big old bag and that
[was held] across their shoulder. (Nola Campbell, interview, 2 March
1981, BC)

Although many contemporary Catawba still speak of these outings,
it is difficult today to find non-Indians who actually recall the Indi-
ans peddling pottery. A few individuals can make general statements
such as "they were always in town on Saturday. They would ring the
bell and stand back and wait for someone to answer" (Anne Brock, in-
terview, 19 April 1977, BC). In fact, during those days, answering the
door to peddlers was a common occurrence and was seldom note-
worthy. However, Ruth Meacham of Fort Mill, a woman interested in
all things, was fascinated by the Catawba. She had vivid recollections
of their visits to her home. Catawba vessels were used as flowerpots in
the Meacham household. When the pot deteriorated from the dampness
and acidic soil, it was thrown away. A new pot was easily obtained from
the next Catawba peddler:

Recently I had a large Catawba pot that I had kept a fern in. It was out
in the tool shed, and I got tired of seeing it there and tossed it out. I just
pitched it out. We have always taken the pottery for granted.

I always paid the Indians in some way. Once a woman came and
asked for food. She was very tired and hungry. I told her that I would
feed her, but that I did not want any pottery as I had enough. The
woman insisted that I take a pot and would not take the food unless
she paid with a pot. Eventually she offered me this broken pot and said,
"Please take this one. It is broken and I can't sell it." I took the pot and
gave her three things to eat: a sandwich, a piece of fruit, and a piece of
cake. She went over on the corner and ate it right out in the street. She
must have been very hungry. The Indians were always proud and would
never take anything without paying for it.

Another woman came [here] a number of years ago. Not very long
ago. And she had a little girl with her. I did not want any pottery, but
the little girl looked so eager that someone would buy a pot that I took
a small wedding jar from her. (Ruth Meacham, interview, 12 February
1977, BC)

Pottery making was and remains a business for the Catawba, and
over the years, the Indians took advantage of any form of transportation
available to them in order to peddle. In the early Colonial days they
followed familiar river routes, then when roads were cut through the
forests, they pragmatically used them, on foot or horseback. When they
could, the Indians rode mules and wagons.

The first documented use of a covered wagon for peddling was in 1905. A large party of Catawba, including Margaret Brown, John and Rachel Brown, their children and Henry Canty, and Fred Nelson Blue, went to Gastonia. They traveled in two wagons covered with home-spun. Upon entering incorporated towns, they obtained a peddler's permit and sold pottery from house to house (*Rock Hill Herald*, 15 August 1905a:1). Most likely this was not their first or their last visit to the Gastonia area. A similar venture was recalled by Sallie Beck who accompanied her parents to Great Falls by wagon to peddle pottery. Jesse Harris also had fond recollections of his family traveling by wagon to Spartanburg to peddle pottery:

> When I was a boy, we went to Spartanburg in a wagon with a cover on it. I just drove the wagon, and they did the selling. Martha Jane Harris and Margaret Harris would sleep in the wagon, and I slept on the ground.
>
> We packed the pots in boxes—in straw and shavings. We took 100 to 150 pieces, whatever they had made. We never packed food. We only packed pottery. It took two nights to go to Spartanburg. We always asked a farmer for permission to stay in his yard. Wouldn't charge nothing. We would buy dinner and breakfast and would pay with pottery or with money. Sometimes we would build a fire and cook some bacon or ham, whatever we wanted. On the road to Spartanburg we sold in any small towns between here and there. We would stop in Chester. Lots of time we would sell all before we reached Spartanburg. Whenever we reached a place, we always went to the courthouse to get permission to sell. In Spartanburg we went to different houses and stayed there one or two nights. The YMCA would buy from us and help us make sales too. Many times the YMCA would buy the pottery and resell it. (Jesse Harris, interview, 14 April 1977, BC)

The Harris family followed an old pattern of operation; they knew the route. The Indians knew where to stay and what procedures and laws to follow. They were so confident of sales they did not carry food supplies. Sallie Wade recalled a circuit that included the towns of York, Chester, Charlotte, and Lancaster, a total of about 100 miles. Occasionally they would sell all their wares on the first day out and return home ahead of schedule leaving young Sallie disappointed (Sallie Wade, interview, 18 January 1977, BC).

Richard Harris had vivid recollections of a party that consisted of Sarah Jane Harris, Davis Ayers, and Fannie Harris. They borrowed a wagon from another Indian and set out for Lancaster and Camden, a total of about 120 miles round trip. They crossed the river at Cureton Ferry and got caught in a violent rainstorm. The surrounding creeks

were flooded, and the Indians were left stranded. While they waited for the waters to recede, they took shelter in an abandoned house (Richard Harris, interview, 14 April 1977, BC). Bertha Harris also recalls her father, Moroni George, taking wagons full of pottery to Great Falls, a total of about 40 miles round trip. These trips would take one or two days. At night they hung a kerosene lantern on the wagon for a light (Bertha Harris, interview, 2 March 1981, BC). One can imagine these trips were wonderful experiences for children who seldom had an opportunity to leave the reservation.

The automobile opened new peddling horizons for the Catawba. John Brown was the first to own a car. Doris Blue remembered the effect this purchase had on the Brown family's peddling efforts: "[John Brown's] wife made pottery all the time; and after he had his car, he would take her further to sell her pottery. Before they could just go around in the area, when they could go in a wagon in a day's time and get back home. After he got his car—why then they would venture out a little further and further from town" (Doris Blue, interview, 20 March 1980, BC). Trips that once took days could be made in hours (Edith Brown, interview, 21 April 1977, BC). As more Catawba families purchased automobiles, they expanded their peddling activities. Furman Harris visited the tourist shops in North Carolina (Furman Harris, interview, 3 March 1981, BC), and Willie Sanders recalled taking an old Model-T to Charlotte and peddling there (Willie Sanders, interview, 21 March 1983, BC). Henry Canty drove his mother, Emma Brown, to such places as Chester, Great Falls, Fort Mill, and Rock Hill (Henry Canty, interview, 15 October 1984, BC). When Jennie Brindle obtained a car, she sold all over South Carolina and as far away as Jacksonville, Florida, and Moundville, Alabama (Jennie Brindle, interview, 11 August 1982, BC). Arzada Sanders returned to towns her family had not visited in decades (Arzada Sanders, interview, 25 January 1977, BC).

The Indians were willing to go from house to house and peddle, but they were always looking for better outlets for their wares, also. For instance, Martha Jane Harris could expect regular sales in Van Wyck and Catawba Junction. Ida Harris regularly swapped her pottery for groceries at Massey's Store in Van Wyck. "I would get my groceries in Van Wyck from Mr. Massey. He would run my groceries for the year, and I would owe him money and make pottery for him. I also sold to a man in Rock Hill. I don't remember his name, but he sold sandwiches downtown, and he bought pipes from my mother—lots of pipes" (Ida Harris, interview, 7 April 1977, BC; Frances Wade, interview, 6 April 1977, BC). Nettie Harris Owl sold at Friedman's, a dry goods store in Rock Hill (Frell Owl, interview, 15 May 1979, BC). Another local out-

let was Jack Glasscock's store located within easy walking distance of the reservation. Glasscock allowed the Indians to swap groceries for pottery. On occasion they traded a pot for enough money to catch a bus to Rock Hill (Jack Glasscock, interview, 3 February 1977, BC; Ruby Boyd, interview, 3 February 1977, BC). Margaret Brown often met the trains at Catawba Junction and sold pottery to passengers (Garfield Harris, interview, 15 April 1977, BC).

In recent years, the potters turned to more sophisticated outlets for their work. Sara Lee Ayers marketed her wares in gift shops, airport terminal shops, museums, and Indian arts and crafts shops throughout the South. For a time, Earl Robbins sold his pottery at the Bureau of Indian Affairs Arts and Crafts Shops in Washington. Alberta Ferrell sold her pottery through Bee's Book Store in Rock Hill (Alberta Ferrell, interview, 22 February 1977, BC). Having these outlets reduced the need to peddle.

For more than 50 years, the potters brought their wares to the gates of Winthrop College in Rock Hill. They spread blankets on the ground, arranged their wares, and waited for the students to make purchases (Reed 1959; Blumer and Harris 1988). Students and faculty came from every part of South Carolina, and most had never seen an Indian. Bessie Garrison recalled that at first the girls were scared to death of the Catawba (Bessie Garrison, interview, 27 January 1977, BC). Capitalizing on the students' growing enthusiasm, the Indians set up shop at the campus gates Saturday after Saturday. During bad weather, they displayed their wares in a nearby passageway between buildings (Carrie Garrison, interview, 27 January 1977, BC).

The barter system also dominated Winthrop sales. Few of the students had money and the only commodity many could regularly offer was clothing; many a uniform was swapped for pottery. Students who purchased Catawba pottery sent it to people throughout South Carolina as gifts for every occasion. Margaret Tolbert recalled that most of the pottery she bought was given to family members in Laurens, South Carolina (Margaret Tolbert, interview, 6 February 1977, BC).

Many of the Catawba remember spending hours at Winthrop College with their elders. Some accompanied their mothers or grandmothers. In time, these young potters sold their own work. Edith Brown, for instance, sold her first batch of pottery there (Edith Brown, interview, 21 April 1977, BC). Isabelle George recalls offering smaller pieces, things she knew the students would find attractive and could afford (Isabelle George, interview, 1 March 1977, BC).

Arzada Sanders recalled that very little money was exchanged. Fifty cents was a good price, but most of the time clothing was swapped (Arzada Sanders, interview, 25 January 1977, BC). A matched pair of

loving cups brought a dollar. Pipes went for 15 cents each. Sallie Wade declared that the students were usually broke. In addition to clothing, they offered finger rings, bracelets, shoes, and even brand new dresses. To handle the money situation, the Indians usually decided on their sales strategy for the day. "[We] would decide who was to take only money and who would swap clothes. Those who needed the money most of all would get the money and the others would swap clothes" (Sallie Wade, interview, 18 January 1977, BC).

During the winter of 1976–1977, while the potters were preparing for a pottery exhibition/sale at Winthrop College, Doris Blue declared proudly, "At first we sold at the gates and later moved inside the gates under a tree. Now they will let us sell our pottery inside the college building. It has taken us a long time to get in the door" (Doris Blue, interview, 21 January 1977, BC).

THE CHEROKEE TRADE

After World War I, Americans became infatuated with the automobile. As the number of cars increased, the roads were improved, and the grid of our modern highway system began to take shape. It was not long before adventurous tourists began to straggle into the Great Smoky Mountains to visit the Cherokee Indians. Naturally, these individuals wanted mementos of Indian country. As the number of visitors grew, the enterprising Cherokee were quick to recognize and develop a market for arts and crafts. Numerous Cherokee made baskets and carvings in wood and stone that were eagerly snapped up by tourists (Blumer 1987b:153–173). The Cherokee, however, had no potters. The Cherokee pottery tradition had ended when the last of the Katalstas stopped making pottery around 1900 (Blumer 1987b:153–173). Fortunately, two master Catawba potters, Nettie Owl and Susannah Owl, who had married into the Cherokee tribe, were living at Cherokee. These two women endeavored to fill the early tourist needs at Cherokee.

The first shop to offer Indian arts and crafts to tourists was opened by Sampson Owl, Susannah Owl's husband, around 1920 (Blumer 1987b: 153–173). The efforts of these two women to fill tourist demands for pottery were short lived. Nettie Owl died in 1923 (*The Record*, 12 March 1923:1), and as Susannah Owl advanced in years, she found it increasingly difficult to keep her husband's shop stocked with pottery. Sampson Owl turned to Susannah's Catawba relatives to fill growing orders for Indian pottery. The first Catawba potters to benefit from the North Carolina mountain trade included Martha Jane Harris, Margaret Harris, and Rosie Wheelock. Beginning in 1925, Sampson Owl made regular trips to the Catawba Nation to purchase pottery. When Margaret

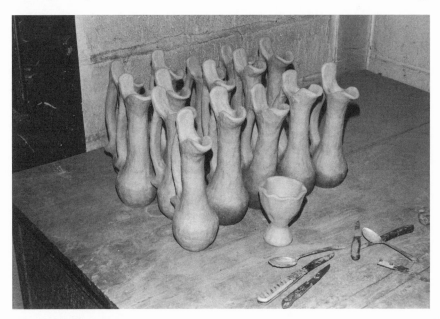

Figure 1. North Carolina trade ware made by Reola Harris for sale at Chero-
kee. (Photo by Thomas J. Blumer, 1977)

Harris died in 1926, he purchased the last pottery she had made (Georgia
Harris, interviews, 20 March 1980; 24 March 1980, BC).

Sampson Owl was soon totally dependent on Catawba pottery, and
he sought other potters to work for him (Doris Blue, interview, 24 March
1980, BC). In time, he developed a routine of driving his Model-T Ford
to South Carolina where he packed the car to the hilt with Catawba
wares. It was not long before other Cherokee opened up shops to handle
the needs of tourists, not only at Cherokee, but also throughout the
mountains of both North Carolina and Tennessee.

Soon the Catawba started to go to Cherokee on their own. Ervin and
Eliza Gordon took advantage of the Cherokee trade early on (Furman
Harris, interview, 1 March 1981, BC). They made the trip so frequently
that this trade became their major source of income (Fewkes 1944:102).
Soon nearly all the Catawba were trading with the tourist shops in the
mountains. By trading in Cherokee, the Catawba earned income and
also renewed old family alliances (Mae Blue, interview, 1982, BC). Yet,
it was not long before enterprising Cherokee began to eye the Catawba
tradition as something to copy (Blumer 1987b:153–173).

At first, the wholesale prices offered by the merchants were fair, and
the Catawba worked to provide the best pottery they could (Doris Blue,
interview, 24 March 1980, BC). Doris Blue occasionally went to Chero-

kee to visit family there and always carried a load of pottery to a shop
owner named Duncan. Georgia Harris filled orders for another shop
near Cherokee:

> If we wanted to go to the mountains, we'd ride. And that's how we got
> started. I sold my pots just after we got a car. . . . We found a place over
> here on, next to Hendersonville across the river. I found this woman,
> Mrs. Reed, and she bought from me all the time. Well, I didn't have to
> go all over the place selling pots. I'd just make them and carry them to
> her, and she'd take them. She bought just practically everything, what-
> ever I'd make. She would buy all of it. Everything I would take. Once I
> made a set of dishes, the whole thing. She'd always—she had big ideas.
> She'd always ask me, "Can you make that?" And then I'd always have
> to make everything she wanted. (Georgia Harris, interview, 20 March
> 1980, BC)

In general, the Catawba would visit all the tourist shops between
the Nation and the mountains. Often their pottery was sold before they
reached Cherokee. As the shops built up their inventories, the potters
who went frequently had difficulty selling their wares. Jennie Brindle
recalled the situation: "The shop owners would buy by the lot, and we
could start selling as soon as we got to the mountains. Sometimes
we would have to go over to Gatlinburg to get it all sold, depending on
who [which Catawba potter] had been over there before us" (Jennie
Brindle, interview, 12 April 1977, BC). The partial list of places Jennie
Brindle visited to peddle her wares is impressive: Greenville, Saluda,
Tryon, Fletcher, Chimney Rock, Black Mountain, Bryson City, and
Grandfather Mountain. Florence Wade remembers accompanying Jennie
on these trips: "When I went with Jennie, she talked. She didn't have
any problems getting rid of them, I guarantee you" (Florence Wade, in-
terview, 15 March 1977, BC).

As the number of Catawba potters making vessels for this market
increased, the shopkeepers began to take advantage of the Indians.
Around 1960, Nola Campbell took what she estimated was 200 dol-
lars worth of her pottery to Cherokee. This master potter of great
skill was offered the meager price of 10 cents for each item. Knowing
that she was producing museum quality vessels, she indignantly de-
clared, "I didn't need to sell them that bad" (Nola Campbell, interview,
1 March 1977, BC). The shop owners easily and quickly offended the
best Catawba potters. Three of the best potters, Doris Blue, Georgia
Harris, and Nola Campbell refused to take their work to Cherokee:

> They [the shop owners] wanted me to give [my pottery] to them, and I
> wouldn't. I worked too hard to make pots and give them away, and I

didn't sell them. I brought mine back home. I went up there one time to try and sell pottery, but I couldn't sell mine, not for what they wanted to give for them. So I brought mine back home. I set out a big pile there, and they would say, "I'll give you so and so for that big pile," and it would be maybe five cents apiece, and I'd have big pieces in there. . . . That's the way they were. . . . I said, "No way." I just packed them up and brought them back home. (Georgia Harris, interview, 19 March 1980, BC)

In effect, the merchants were caught in a price war between the best Catawba potters and those who put little pride in their work. Not terribly concerned with quality, the merchants sought the lowest prices from the less talented potters. The overall quality of the Catawba wares sold in the mountain trade dropped. Unfortunately, too, some Catawba lowered their prices to make a sale ahead of another potter or tried to reach the best dealers first. "I remember Idle [Sanders] used to try to cheese in on me. He wanted to sell to [Mrs. Reed] so bad because he knew she was a good customer because she'd take what I sold her, and he'd go by there and try to sell to her. She'd take four or five dollars worth, but then she would say, 'Well, I got some coming, Miss Harris is going to bring me some and I can't.' And she would buy it from me" (Georgia Harris, interview, 19 March 1980, BC). So common was this practice that Wesley Harris referred to it as "peddling in front" of the other person (Wesley Harris, interview, 10 May 1977, BC). To make their efforts cost effective, some Catawba potters only made small vessels. This way, Bertha Harris was able to sell hers at 15 cents each (Furman Harris, interview, 19 April 1977, BC). Naturally the prices declined. Discouraged by low prices, fewer Catawba peddled in the mountains of North Carolina. During this same period, public sector work became more available and many of the Indians abandoned pottery (Florence Wade, interview, 15 March 1977, BC).

The problems the Catawba faced were not all related to prices. Distance was a very real concern. The potters drove cars in poor repair over bad roads with few available services. In general, they had little money for a trip and depended on immediate sales for their food and other expenses. Today the Indians laugh about incidents that approached tragedy at the time they occurred. A classic among such tales was told by Louise Bryson. On the occasion she relates, it took the Beck family a week to drive from the reservation to Cherokee, a mere 190 miles:

One time, well he [Major Beck] used to like to go to the fair, that Cherokee fair. . . . And I mean he'd go in the morning and we'd stay 'til that thing was over at night—all day long. So we started this one time. Mama had a load of pots, and we started having flat tires here in York.

And at that time they didn't have any service stations. He didn't have a jack, and he didn't have a spare tire. So we had a flat tire between stations. It took us a solid week to get from here to Cherokee. We were going to the Fair, and we met it coming this way before we got there. And we stayed on the road so long, Mama had to trade our pots. We didn't have anything. They did that! We didn't have no money or anything, and they'd go to Cherokee. [They'd] get gas here. They'd go to Cherokee and [had] pots for us to come back on. Now if they didn't sell those pots I wonder how they expected to get back? I wondered about that now. But we went. It took us one solid week, and Daddy had the pink eyes. You know what the pink eye is? Your eyes just get real pink and red, and you can't see, and they just lead over. And he had a pair of shoes that he had got from the relief. And poor old fellow, his feet wouldn't go in them. They set up on the spur apiece. There he had that pink eye and his shoes was too little, and he'd have to go to [Cherokee]. When he'd have a flat tire, he'd take the tire off, and bat it to a service station. He'd never know, and we got up in the mountains and there it went down. So he said, "Well, I'll just go early in the morning and have that thing fixed, and we'll sleep here on the road tonight." Next morning he got up and took that thing. Way—it was almost dark and we seen him coming way over yonder, a little dot batting that tire. He got almost there and that thing went off the mountain. Got away from him [and] went down in a gorge in there. He came onto the car and said that thing got away from him and that Buddy could go down in there the next morning and get it out. So the next morning at daylight, he got them up and went down there and got that tire up. When they got it up, there it was flat again. It went flat over night. Same thing. He had to do that again that day. We stayed on the road so long they hollered and told us to get off the road. Yes, they said, "Get off the road." But they didn't say it like that you know.

We done without food. Then when we got to a little town, Mama traded the pots for something to eat. She'd go around to the houses and trade. Traded all her pots away before we got to Cherokee. I've often told this story. I put a little more to it sometimes, but Daddy had an old Model-A, and there wasn't any room in one of those things. Sam and Buddy was in the back with the pots, and there was me and Mama and Daddy in the front. Well, I had to lay curled up around that gear. It was on the floor, and if I moved this way, Mama slapped me. And if I moved this way Daddy would pinch me, and there I lay, and when I'd get up the next morning, I'd be all drawn up. I kind of added a little bit to that. I got out of there, and they said, "Oh, look at that poor little girl. Looks like she's deformed." Well, . . . we stayed on the road a week, and I laid in that position every night.

But that's where the police told her. We stopped somewhere and the police came over there and asked Daddy and said, "What are you doing parked here?" And Daddy said, "Well, I'm resting," and said, "We're just laying here sleeping." So he went back and told the police in another car, said, "That man said he's laying here resting," but said, "He's got a woman laying up in that car and she's snoring like a damn hog." And Daddy got mad at Mama. Said, "Wake up fool here. That police here talking about you." Said, "You're snoring like a damn hog." So he cranked the car up and drove on down the road a little piece further and stopped and said, "Now don't snore so loud this time."

We went on to Cherokee. He got a tire off something up there, and we was about a week or two. Then he come around through Wahalla cause he had a brother living there, and we was there for about a week. But we was just like a bunch of gypsies. We'd just pack up and go, and we got up there and it started raining. Well, Mama, she done got tired. She was wanting to come home, and the river was just a flowing, running over the bridges—those little old bridges. And Daddy got so mad. Both of them got mad at each other, and Daddy said, "Well, get in that car, and I'll take you home." And we come to the river where the bridge was flooded, and he didn't stop. He just tore right on across there. The bridge could have been washed away, but luckily it wasn't. And Mama was back telling him we ought to turn around and go back. He said, "No, I'm going to take you home now." Then we come on home, and we went through a big bridge there, and the water was just up level with that big bridge, and they asked you not to go across. You could go across at your own risk. You know Daddy just paddled across that thing.

I don't think we went back to the mountains again for a long time after that. (Louise Bryson, interview, 16 June 1985, BC)

The problems experienced by Major Beck and others were traumatic. In retrospect, however, the Catawba had more good luck than bad. Even today with far better tires, excellent highways and services, every traveler can tell tales of road trip happenings. Later, after the passage of time, the anguish is turned into humor. The emphasis is on ingenuity and a willingness to endure. The story of Major Beck's trip to Cherokee is a classic among the Catawba.

The Indians began to face the problem of deteriorating quality in the pottery. Some raced to fill larger orders. They lost pride in their work. The repetitiveness of making the same vessel over and over again did not help. Declining prices demanded less time per vessel. Corners were cut in every possible step in the long Catawba process. For instance, encouraged by the shopkeepers' greed, some potters did not complete the burning process (Bertha Harris, interview, 3 February 1977, BC).

But then the merchants stopped buying the pottery when its quality reached a level so low it could not be sold. One documented victim of this circumstance was a shopkeeper named Duncan. Unfortunately, he displayed his Catawba wares out of doors. "One man said he didn't want to fool with it any more because they left theirs outside in a rain storm, and when they went out to get it, the pottery had melted. [The potter] hadn't burned it. So that ruined sales from this place. Good bye" (Doris Blue, interview, 24 March 1980, BC).

In recent years, the Catawba have shown a revived interest in returning to Cherokee to sell pottery. Low prices remain a problem. A 1979 survey of several dozen shops on the Cherokee reservation only revealed some substandard vessels made by Jennie Brindle. These vessels were being sold for $3.98. This same craft shop also carried examples of wares made by several Cherokee potters. From 1989 to 1990 Sara Lee and Foxx Ayers were reportedly selling through the Cherokee Qualla Cooperative.

Today the Catawba are more interested in sales to museum shops and collectors who visit the reservation. There are indications that some wholesaling is being done, but the shopkeepers usually visit the potters' homes where the advantages seem to tip in favor of the Indians. Few if any Catawba potters look to the mountains of North Carolina for sales opportunities.

NORTH CAROLINA MOUNTAIN TRADE WARE SHAPES

This trade ware, centered on the Cherokee Indian Reservation, resulted in the production of a number of forms made to satisfy the local merchants. These shapes were encouraged by the traders. They felt such things were Indian enough in appearance to attract tourists. Some popular nineteenth-century shapes such as the canoe and bookends were encouraged by the merchants.

 1. cup/mug
 2. candlestick
 3. candlestick with Indian head
 4. candle holder
 5. bookends
 6. bookends with Indian heads
 7. toothpick holder
 8. turtle pencil holder
 9. turtle ashtray
10. ashtray
11. dog ashtray

12. club playing card ashtray
13. spade playing card ashtray
14. diamond playing card ashtray
15. heart playing card ashtray
16. paper weight
17. plain wall pocket
18. Indian head wall pocket
19. canoe
20. canoe ashtray
21. canoe with Indian head lugs (pipe)
22. canoe with flat Indian heads
23. tepee tents

4 The Indian Circuit

The Catawba potters have long seen the wisdom of capitalizing on their Indianness. Young and old are well aware of their historical importance. When fairs and expositions became popular at the end of the nineteenth century, the Catawba embraced this opportunity to market their wares. The tradition of attending public events to market their wares is old among the potters.

In 1895, MacDonald Furman fostered the idea of exhibiting Catawba pottery at the Cotton States International Exposition in Atlanta, and he contacted the local papers and the governor:

> Now I want to speak of another matter. I enclose a clipping which you may not have seen, but I feel sure you will approve of my suggestion. I speak in words of praise in the article of what you have done in regard to the Atlanta Exposition exhibit from South Carolina. I now request that if you can do anything in an official capacity to have the exhibit of Catawba wares that you will do it. I have written to Capt. A. E. Smith [the Catawba agent], commissioners Roddey and Brice and Chief Harris, of the tribe, stating that if the exhibit is gotten up, I will contribute one dollar towards paying its expenses. I take a keen interest in the Catawba and am very anxious for this exhibit to be gotten up. (*Rock Hill Herald*, 6 March 1895; Furman to John Gray Evans, 25 March 1895, MacDonald Furman Papers, Caroliniana Library, University of South Carolina, Columbia)

Beyond Furman's efforts, nothing is known about Catawba participation in this fair. However, the Catawba speak of other such events from the beginning of the twentieth century.

More is known about the South Carolina Inter-State and West Indian Exposition of 1901 held in Charleston (*Rock Hill Herald*, 17 July 1901:3). As early as July 1901, two commissioners from York County negotiated with the Catawba Tribal Council. The goal was to recruit

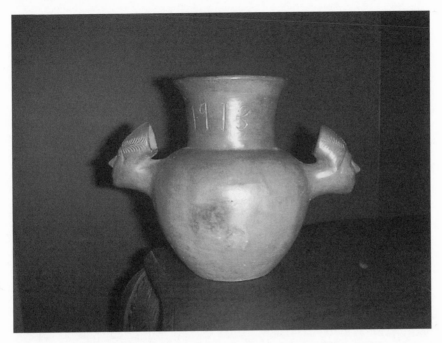

Figure 2. Indian head jar attributed to Robert Lee Harris. Origin, the 1913 Corn Show in Columbia, South Carolina. From the Blumer Collection. (Photo by Brent L. Kendrick)

20 to 25 Catawba Indians, preferably "healthy purebloods," to populate a demonstration village. The Exposition officials offered transportation and a "remote location" in the fairgrounds. It is difficult to say if the location was a Catawba idea or chosen according to the wishes of the Exposition organizers. The result was that the Indians were housed away from the core exhibitions. During their stay, the Catawba were to support themselves from pottery sales. Of those who might have gone, only Epp Harris left a record. Georgia Harris recalls seeing a photograph of him taken at the Exposition. He was in full Indian regalia (Georgia Harris, interview, 12 August 1980, BC). This and other photographs documenting the event have yet to be located.

In 1913, similar arrangements were made for the Corn Show in Columbia. The documentation here is stronger. The Corn Show may provide insights regarding earlier fairs the Catawba attended. Excitement ran high among those non-Indians who attended the fair. The Catawba purpose, of course, was to sell pottery. Other attractions the Indians offered included the making of Indian corn bread (ash bread) and bows and arrows (*Evening Herald*, 25 January 1913:1). The party of 22 included men, women, and children. Richard Harris recalled that they

gathered in Rock Hill the night before and caught the morning train. Although Doris Blue was a young girl, she was able to provide a partial list of those who participated in the Corn Exposition: John and Rachel Brown and children; Archie and Rosie Wheelock and children; Lewis and Sallie Gordon; Benjamin and Mary (Dovie) Harris; and Epp and Martha Jane Harris (Doris Blue, interview, 24 March 1980, BC).

This time the Catawba were provided a demonstration area in the main exposition building rather than a remote area (*State*, 27 January 1913a:9). Doris Blue recalled the excitement of living away from home and being with a crowd of strangers. "I remember going, and I remember all of these Indians. There was a bunch of them went, and they gave us this long tin building to put our exhibit in. We stayed and lived in there—slept in there. But that is about all [I remember]" (Doris Blue, interview 24 March 1980, BC).

The Catawba Exhibit proved to be a major attraction. Every day, people flocked to see their first Indians (*Evening Herald*, 25 January 1913:1). The pottery quickly sold out. Daily demonstrations of pottery making held viewers' interest high. Indian dances were performed before large crowds (*Record*, 12 February 1913:12; *State*, 3 February 1913b:12). Robert Lee Harris (Red Cloud), a former member of the Daniel Boone Troop, led the Catawba in the Fox Chase, Bear, Wild Goose, and War Dances. Spectators were fascinated by Catawba rattles. Some were made from cow horns filled with buckshot. In a faint recollection of the Busk, which the Catawba had not celebrated for many years, the women dancers wore traditional turtle-shell rattles tied to their ankles.

The Indians were so pleased with the Corn Show that they returned to Columbia for the State Fair for many years. Furman Harris recalls selling pottery there with Joe Sanders. The two men stayed a week and slept in Joe Sanders's car. During this same period, Eva Blue attended the State Fair as part of a large Catawba delegation. The group included her husband Guy Blue, Rosie Wheelock, Lucy Starnes, Emma Brown, and Early Brown (Eva Blue, interview, 20 April 1977, BC).

The Indians began attending so many fairs they ended up not being able to distinguish one from another. Consequently, it is difficult to find recollections of one particular fair. Mildred Blue had a childhood memory of her family taking her grandmother, Rosie Wheelock, to the State Fair in Columbia: "We'd go . . . to the State Fair and spend a week down there. . . . You'd have to have your own transportation and take your pottery and your material. They'd furnish a booth to put your pottery in—a little stand like. We'd take my grandmother down there and leave her there, and then we'd go back on the weekend when the fair closed and bring her home" (Mildred Blue, interview, 24 March

1983, BC). Many times the potters recall things that have little to do with the pottery tradition. This is the case with Jennie Brindle, who had vivid recollections of a fair held at Grier, South Carolina, around 1930. "They had a hog calling. Put a dollar on a greased pole, and we watched men try to climb the pole, and they had a greased pig too. Lula Beck went and so did Ervin and Eliza Gordon and some others. We stayed right there and sold all we took and had a lot of fun too" (Jennie Brindle, interview, 12 April 1977, BC).

When York County began its own annual fair, the Catawba were always given space for a booth. Prizes were awarded for the best pottery, and some of these awards appeared in the newspaper. In 1952, Georgia Harris took first prize. Nola Campbell, who took second prize, recalls the event: "I took pottery to the fair. We set up a booth, and I can remember winning second prize. Georgia got first. She got 10 dollars and I got five. I can't recall what I made then, but it might have been a small pitcher. I got in free because I had pottery on exhibit. I did that only that one year" (Nola Campbell, interview, 15 March 1977, BC).

In 1938, the tribe organized its own fair. The first event went unnoticed by the local papers, but the second annual Catawba Indian Fair received some publicity. The first, second, and third pottery prizes were awarded to Georgia Harris, Doris Blue, and Sallie Beck in that order (*Evening Herald*, 22 September 1939:5). This fair was held again in 1940 and 1941 (*Evening Herald*, 18 October 1940c:15; *Evening Herald*, 4 September 1941:1).

The Catawba potters also attended a large number of historical events during the last century, such as the centennial celebration at King's Mountain. "In October 1930, they had a centennial up at King's Mountain Park. We went and sold pottery and camped out. Ervin and Eliza Gordon, Betsy Estridge, and Georgia and Douglas [Harris] went. We sold a lot. We had an Indian dance. One day the president came, and I saw Herbert Hoover as he passed by on the road. He didn't stop to look at our pottery. We got 75 cents for a plain pot, and if it had handles we got a dollar" (Furman Harris, interviews, 19 April 1977; 1 March 1981, BC). A similar market was provided by the summer's events at Camp Steere in North Carolina. Rosie Wheelock and Mae Blue frequently sold pipes to the Boy Scouts who gathered there (Doris Blue, interview, 15 March 1977, BC; Mae Blue, interview, 21 April 1977, BC).

One of the most ambitious Catawba efforts to use historical celebrations as venues for selling pottery began in 1935 at the Schoenbrun Village State Memorial in Ohio. Schoenbrun is a reconstructed late-eighteenth-century Moravian Mission to the American Indians (Weinland 1928). Interest in restoring the site of the mission and the Gnadenhutten Massacre of 1782, where nearly 100 Christian Indians were

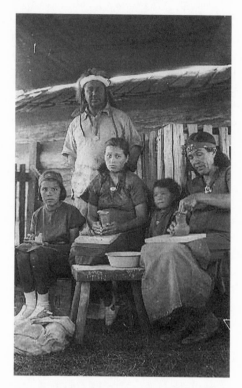

Figure 3. Postcard photograph of the
Early Brown family working at Schoen-
brun Village, Ohio. *Back row:* Early
Brown. *Front row, left to right:* Joanne
George, Evelyn Brown George, Faye
George, and Emma Harris Brown.
(Blumer Collection)

murdered, began in the early 1920s. Over time, land was purchased,
the settlement was planned, and the first building was meticulously
reconstructed in 1927. Soon after the Memorial opened, Schoenbrun
officials contacted two Catawba potters of reputation: Early and Emma
Brown. They were to provide the park with an Indian presence through
pottery-making demonstrations. According to the agreement, the Ca-
tawba were provided with transportation and lodging. Once at Schoen-
brun, the potters were to make and sell pottery and thus support them-
selves. "A man, Mr. G. C. Tyler, came with a truck and got a load of
clay. He was from the museum. We did not let him see the clay holes,
but he took the truck to a place near the clay holes and waited for
us. We got enough clay for the summer" (Evelyn George, interview,

25 March 1977, BC). Those who eventually participated in this effort included:

Ethel Beck	Catherine Canty
Samuel Beck	Henry Canty
Early Brown	Sadie Canty
Elizabeth Brown	Evelyn George
Emma Brown	Faye George (Greiner)
William (Pete) Brown	Howard George
Alberta Canty (Ferrell)	Joanne George (Brauer)
Billy Canty	Marvin George

(Evelyn George, interview, 25 March 1977, BC;
Catherine Canty, interview, 17 February 1977;
Alberta Ferrell, interview, 22 February 1977, BC).

Samuel Beck, who drove the first group to Ohio, provided a vivid recollection:

In 1935, in the early part of 1935, I can't remember who made contact with Early about going up there and making pottery. We were in a park up there, and I guess maybe it was historical. Somebody made contact with him. So they decided to go up there and demonstrate making pottery and also for the sales of the pottery that they made. I hadn't been driving a car too long, but I had been driving enough so that I had some experience. Of course there wasn't as many cars on the highway as there are now, and he had a 29 A Model Ford—what we called a touring car at that particular time. It had a top on it, and you'd have to put curtains up in it. They didn't have glass [in the windows]. . . .

He asked me to help drive to go up there, so I did. Well, we had to move quite a bit. We were really loaded. We had to take Early and Emma, Marvin and Evelyn, and me and William Brown and all in that car plus all of our luggage and the clay and everything. All of our things that we carried. And I'll never forget, when we were going through Charleston, West Virginia, I wasn't driving then and Uncle Early wanted to bypass town, and I said No, we'd be going out of the way if we had to bypass town at that particular time. It wasn't like having super highways now, but I said, "No, it's a straight shot. We are going to go through town." And so he said, "Well, you'll have to drive through town." And I had to drive through Charleston, but it wasn't like it is now. It was pretty hard to drive through then.

And when we got up there they had cabins in the park, and they assigned us to some of the cabins that they didn't have on exhibit. They

had the other things that they had on exhibit in the area for visitors to visit, and I stayed I guess three months or longer, but that was my reason for going with them, to help him drive up there. [They] made pottery, and we helped to beat the clay. I didn't do any rubbing or making any pottery, but we did help them get the clay ready for Emma and to burn the pottery, and we got a lot of publicity out of it. There was a lot of people that visited the park and everything, and they had good sales for the pottery, and it continued for a number of years. I don't know how many years that they made . . . pottery, and they went back a number of times after that, but I didn't go but the one time. (Samuel Beck, interview, 3 May 1987, BC)

The potters were provided living quarters in a nearby Civilian Conservation Corps camp (Catherine Canty, interview, 2 March 1981, BC). The working situation appeared more like a factory than a Catawba family at work. According to Catherine Canty, they were divided into teams:

Ethel Beck and Elizabeth Brown [Plyler] went along to rub pots for us. One went to rub for Emma and one went to rub for me. Billy [Canty] scraped my pottery. I made them, and then when they dried, Billy would scrape them, and Elizabeth would rub them. Ethel Beck did the same thing for Uncle Early and Emma.

The building we worked in had a porch on it and had a fence around it. We sat on the porch during the daytime and built. If it didn't rain too hard we could set out there. I built, Billy scraped, and Elizabeth rubbed. (Catherine Canty, interview, 2 March 1981, BC)

According to Evelyn George, who participated in the demonstrations at Schoenbrun for several years, working conditions were even more regimented than described by Catherine Canty:

We made everything by the dozen. If we made peace pipes, we made a dozen of them. We worked all day like in a factory. I wore an Indian dress, moccasins, beads, and a headpiece. People crowded all around us so we could hardly breathe, and once the kids got gone. Emma thought they got kidnapped. They would ask questions about the pottery. They wanted to know if we lived in tepees, if we made beadwork, and wanted to know if we could speak Indian. One woman offered to buy my little girl, Faye. She offered me thousands. After we left Ohio, the lady sent things for Faye for Christmas. One day we would make pots all day, and the next day we would scrape the pots. (Evelyn George, interview, 20 March 1980, BC)

During this same period, Ervin and Eliza Gordon made similar arrangements to demonstrate and sell pottery in Tannersville, Pennsylvania. The object was to give Pocono Mountain visitors an opportunity to see Indian pottery being made. Although the Gordons always took a number of finished pieces with them, most of the pottery made at Tannersville was built and burned at the resort (Georgia Harris, interview, 20 March 1980, BC). Eliza Gordon built and scraped the pottery and her daughter Gladys rubbed (Georgia Harris, interview 11 May 1977). Eventually Edith Brown joined the Gordons. Georgia Harris, assisted by Gladys Gordon, also held weeklong demonstrations in Winston-Salem, North Carolina (Georgia Harris, interview, 20 March 1977, BC).

When the Cherokee began their yearly fair, the Catawba potters were invited to participate. In 1951, Georgia Harris took first prize. Second and third prizes were awarded to Nola Campbell and Lula Beck (Laurence 1952).

This practice of attending fairs, expositions, and historical events continues. In 1974, Doris Blue began a long and congenial relationship with the Schiele Museum in Gastonia, North Carolina (Hamilton 1994). Then in 1979, Sara Lee and Foxx Ayers joined what had evolved into a yearly Catawba Festival (D. Blue to T. Blumer, Letters: 15 October and 15 November 1979, BC; Doris Blue, interviews, 20 March and 24 March 1980, BC). The Schiele's effort to bring the American Indian story to its visitors was given a tremendous boost in 1984 when its permanent "Catawba Village Exhibit" opened. The Schiele has since become a mecca for students of Catawba history and culture (Burrell 1984). The students who gather there participate in a wide range of programs through the Schiele's Southeastern Native American Studies Program. In 1989, its annual Catawba Festival was attended by 13 Catawba potters. The tenth anniversary of Schiele-sponsored festivals was held in 1994. Today this tradition is continued during the September celebration of Heritage Day.

DEMONSTRATIONS

The Catawba have demonstrated pottery making for about a century. The practice is directly linked to scholarly interest. Most likely, the first non-Catawba to be treated to a close examination of the potters' skills was Edward Palmer in 1884, but his field notes have been lost. An incomplete list of these scholars in chronological order includes Edward Palmer, Albert Gatschet, MacDonald Furman, M. R. Harrington, Truman Michaelson, and Frank G. Speck. More recently, the studies of Vladimir J. Fewkes, Joffre L. Coe, Chapman Milling,

Charles M. Hudson, Jr., and D. S. Brown have benefited from demonstrations (Fewkes 1944; Coe 1952; Milling, interview, 1977, BC).

Harrington's photographs provide the most insight into the earliest pottery demonstrations (Harrington 1908). The Brown family staged each step in the pottery-making process for the camera. In effect, Harrington, though he was a scholar from one of our most prestigious learning institutions, became a student. He listened and watched intently as John and Rachel Brown, his instructors, taught him. Looking back nearly a century after this historic event, it is difficult to assess its initial impact. Were the Browns doing something approved of by the other potters? Did Harrington approach other potters only to be denied access? Were the Browns the only Catawba who welcomed Harrington to witness the craft as it was practiced in 1907? Did the Browns become the point of envy within the community? Did those not photographed feel left out and ignored? Catawba oral tradition is nearly mute on these issues.

There are some indications that the Browns did something revolutionary when they welcomed Harrington into their home and shared their skills with him. Even today some Catawba will not demonstrate pottery making. Jennie Brindle approached the topic in 1977: "The people in Cherokee wanted me to come up and demonstrate pottery making all summer. They even offered to give us a place in a local motel, and they would have bought all of my pottery just so the people there could have seen me make it. I said, 'Floyd, I wouldn't stand it, them seeing me make that pottery. They'd worry me to death.' I'm too backwards to demonstrate. I have too much Indian blood" (Jennie Brindle, interview, 12 April 1977, BC).

Earlier in this century, Susannah Owl felt the same way. If she was working in clay and some strangers approached her home, she customarily put her work away (Cora Wahetah, interview, 1979, BC). Susannah Owl and Jennie Brindle were highly successful in the business of selling pottery, and neither potter was reluctant to meet strangers and talk about their history and culture.

Carrie Garrison, a Winthrop graduate and later a teacher in Rock Hill, understood the shift in the Catawba tradition toward demonstrations. Early in the twentieth century, she purchased a large Indian head bowl from Martha Sanders. At the time, people in Rock Hill noted that Martha Sanders was the first Catawba potter who permitted outsiders to watch her work in clay (Carrie Garrison, interview, 27 January 1977, BC). The Garrison family still treasures the vessel.

Documentation of demonstrations remains a problem. Many potters visit schools and museums for demonstrations, and these events tend to merge in the Indians' minds. Seldom does a local newspaper give

space to such activities presented before a first- or second-grade class. This tendency to blend the various demonstrations into one singular memory was definitely the case with Arzada Sanders, who was present when her parents demonstrated for Harrington. Demonstrations were an important part of her long career as a potter. In 1977, her son Fred Sanders provided an outline of her most recent demonstrations. The list included numerous schools in both Carolinas. Much the same can be said of other potters. Invitations are frequent once a willingness to demonstrate is declared. Today, Florence Wade is in great demand as a demonstrator; Faye Greiner has a growing list of schools that call on her. Cheryl and Brian Sanders demonstrate for the South Carolina Arts Commission's artist-in-residence program. Their work carries them to every part of South Carolina.

Although demonstrations are rarely the object of publicity, when the press does record the event, the resulting documentation is usually not what students of Catawba pottery need. Such was the case in 1940 when demonstrations in Confederate Park in Rock Hill were given much fanfare (*Evening Herald*, 8 August 1940b:5). The resulting news article emphasized a made-up wedding dance and an equally made-up Indian wedding. No mention was made of the use of a wedding jug in the ceremony. In any case, the so-called wedding jug is an import from the Pueblo potters through the Cherokee of North Carolina (Blumer 1980).

The memories of non-Indians often help balance the picture, but the information provided is usually not very pointed. For instance, Anne Brock of Rock Hill recalled that schoolchildren often visited the Nation, and that such groups watched pottery demonstrations (Anne Brock, interview, 19 April 1977, BC). But those who gave the demonstrations are not much more informative. For instance, when Bertha Harris was interviewed in 1977, she merely recalled that she, Connie Collins, and Arzada Sanders had demonstrated the year before in Freedom Park in Charlotte, North Carolina (Bertha Harris, interview, 3 February 1977, BC). In order to go beyond these cursory recollections, one must attend demonstrations and take notes. Few scholars have had an opportunity to witness the Catawba at work with a large group of students.

In April 1977, several Catawba potters provided demonstrations for the Winthrop College Art Department in conjunction with an exhibition/ sale held there. Frances Wade, Connie Collins, and Billie Anne McKellar conducted the first session. Most of those in attendance were students and faculty. The group gathered around a large worktable and extra chairs were fetched from nearby classrooms. Mrs. Wade described her experience in detail:

First, I made a bowl with rolls and added a top and fluted it in and out to show the possibilities the clay would permit. Then I made a plain bowl. Then I made a candlestick and a basket, just whatever I felt like doing at the moment. The students were upset when I smashed the pieces and made others. I also took my big pitcher without the head to show them the pieces which are not burned properly can be detected by the dull thud. And I told them about burning pots.

I took my big pot with the handles and explained that I had worked too fast, and I discussed the problems of straightness. That pot is irregular, but they failed to see the flaws until I pointed them out and explained that I had worked on the piece for two days, and it should have been a much longer process.

I also showed them my rubbing rocks and explained that the rocks are money and the way I guarded my rubbing rocks. I took the two clays, both sifted and raw, so they could see both in both states. I took some raw pipe clay so they could see that too.

Then I made a canoe and told them about the clay holes and the way we guard them from outsiders. In the old days, we crossed the river in boats and used a wagon to haul the clay from the river bottoms to the reservation. Today we go in cars.

Billie Anne showed them how to scrape a pot, and Connie Collins made a pipe and a turtle.

I also took a canoe along which was filled with air holes to show them bad clay. I told them it would be discarded when I got home, and they were distressed. I also told them about the decline of the art and money problems that the Indians could not get good money for the pottery and the craft declined. The Catawba want to return to the clay, but it is hard work, not easy. There are problems with the clay, problems with the weather, wood, etc.

The students were surprised by the terminology when I told them about burning pots. They were overwhelmed by the softness of the clay. They liked it, but I could not tell them the origin of the clay. (Blumer 1977)

From Mrs. Wade's comments, it becomes obvious that demonstrations usually include unprepared statements. Planning is minimal; however, the more experienced potters usually develop a set routine through repeated experience. For instance, as a rule, Arzada Sanders made two dozen pots and then gave each child, if she was working in an elementary school, a bit of clay to play with (Fred Sanders, interview, 8 February 1977, BC). Those Indians who are gregarious by nature conduct the best demonstrations. Such was the case with Louise

Bryson, who took the lead at the second set of demonstrations at the Winthrop art department:

Louise Bryson: "It's lots of work, nasty. I might just as well tell it like it is. Most of the young people do not know how to make pots. You get tired of it when you have to make a living in the clay, and now it is something new for them. They don't need to work in clay anymore."

Then Louise Bryson told about her grandmother's rubbing rocks and passed the only one she had around the room so the students could feel it.

Bertha Harris then made some rolls and made a base for a pot, working a crimp up on the outer rim of the base and then placing a roll inside the crimped-up rim. In a matter of seconds, she had built a perfectly round bowl, which she promptly destroyed to provide clay for the next piece.

Louise Bryson then described her turtle bowl—how she conceived the idea. She had one with her, but it had not been burned. "I just made a bowl and thought I'd put legs on it, and I thought I'd put four instead of three, and it looked funny so I put a head and a tail on it, and it turned out the way it is. She then talked about problems of finding bits of rock in the clay and trying to rub such a vessel. Bertha Harris talked about digging the clay and going deep enough to get good clean clay and that the hole had to be filled in again. She emphasized the work involved. The clay must be mixed, strained, and put to dry before it could be worked up. Then the clay is ready to build pots.

The students wanted to know about glazes, and Bertha Harris explained that none are used: "It turns out the colors it wants to turn out. We usually use oak wood as the base burning wood, just old black jack oak."

Louise Bryson: "We heat it in the oven first. I burn it in a tub in the yard. I get a hot fire in the tub first and then put the pots in and let the fire burn down twice. I put chips in the tub, and I heat the pots all day in the stove. Then I leave them in the fire for two hours. I start the fire with wood chips, then dry pine, and then oak wood. Oak burns longer and hotter. I temper them with pine wood."

Bertha Harris then explained the old method of burning them in the fireplace.

Louise Bryson: "The sad part is taking them out because some of them might be cracked."

Louise Bryson brought two pots to scrape, and she let two students rub a couple of pipes. One of these pipes was left with a potter in the Art Department so it could be burned in an electric kiln. She was asked

about the designs on her pipes, and she explained that her husband carves the designs. She used an inner coil of a large conch shell to rub the pots and explained that her father had found it on the beach and had brought it home.

Bertha Harris then made a small bowl with three rolls and a canoe.

Louise Bryson: "When we burn them, we don't know what color they'll burn out. I like mine black. Some like reds and some whites.

A student then asked if the pipes could be smoked, and Louise Bryson explained that her husband smokes one but that the reed stem had to be replaced after a while.

Louise Bryson: "Lots burn them in a hole in the ground. If I had a fireplace, I'd burn them inside. I don't know of anyone who has a kiln. We use a fire.

Bertha Harris then began to make a turtle ashtray: "First you make a cylinder like a chunky stone. Insert your thumb and hollow it out inside. Make a hat-like piece. You attach the head by making the head with an extra piece to be inserted into the pot.

Louise Bryson: "Now she has to wait until it dries a bit before she can attach the legs to the turtle. See, it goes in stages. I would make the bowl today, and the next day I would put the legs on, and the next day the head would be put on. The body must be wet so the pieces will stick together."

Bertha Harris made legs for the turtle ashtray.

A student then asked if the legs could just be stuck on, rather than inserted into the bowl.

Louise Bryson: "That is just not the Catawba tradition. We bore holes. You have to bore a hole or they will pop off in the fire. After the leg is inserted, a little roll is worked around the leg to add strength. We always save the scrapings. We try not to lose any clay because it is so hard to get the clay. Maybe you all would like to feel the clay? [Some is passed around the room.] I strain mine through a window screen. I dry mine in a bowl with a cloth liner. Then I work it into balls and put it into plastic bags. It will keep for a month or two that way—won't dry out.

"If the pot cracks after it is rubbed, it cannot be fixed. If the pot should crack after it is newly made, I can fix it, patch it. I haven't learned to make mine thin yet. If the pot is thick, then you have to trim it down until you get the size you want. I don't get mine thin enough.

"It takes years to make a rubbing rock smooth enough to rub a pot well."

The students who had worked clay and knew good clay when they felt it pondered getting some Catawba clay. Some of them expressed

their desire to obtain a quantity of clay, and Louise Bryson responded, "It's a terrible sin to sell clay." (Blumer 1977)

The six women who conducted demonstrations at Winthrop held their audiences' attention as confidently as seasoned academics. Both the students and their professors knew they were watching masters at work.

Customarily, the potters do not seek out demonstrations but wait to be asked. As a result, they often do not have much time to prepare. Such was the case in June 1978 when a Rock Hill club contacted Georgia Harris. A two-day notice was no problem, and the comments she made after the event provide insights on how this potter handled large audiences:

I went to the Country Club Thursday evening. They fed me a scrumptious meal. It was the Rock Hill Professional and Business Women's Club. And it was really crowded. Something over 150 women there. They wanted me to tell them how our pottery is made and burned. So I gave them my version on Catawba handmade pottery. I carried a few small pieces just for show. But I did sell one, a turtle. I really enjoyed it. I answered a few questions from some who didn't know how we made our pottery. It began at 6:30 and lasted until 8:30 P.M. Lots of the ladies came up and introduced themselves after the meeting and asked more questions. (G. Harris to T. Blumer, Letter, 18 June 1978, BC)

Museums have long called on the Catawba to enrich their American Indian educational programs. The potters usually respond in teams. For instance, Georgia Harris and Nola Campbell gave demonstrations at the Fall Arts Festival, Spartanburg County Museum of Art, Spartanburg, South Carolina, in 1979 (Nola Campbell, interview, 15 March 1977, BC). As a rule, the appointment means travel and a stipend. Some years earlier, in 1975, a delegation of potters and tribal council members attended an Indian Arts Convention at the Hilton Hotel in Washington, D.C. Doris Blue and Nola Campbell were chosen to represent the potters. The event lasted two days, and the potters received a stipend of 100 dollars plus airfare and other expenses. "We went up Friday morning at 8:00. It was my first plane ride, and I prayed hard, but I said I would go, and your word is your bond. We got a bus from the airport to the Hilton Hotel, and we had our clay and tools and boards and a few pots. Doris and I sold two or three. I made some more there in my demonstrations and brought them home. I demonstrated in the morn-

ings starting at 9:00 for four hours. Doris took the booth in the after-
noon" (Nola Campbell, interview, 15 March 1977, BC).

SMITHSONIAN APPEARANCES: 1979 AND 1996

In May 1978, the Catawba Indian Potters' Association had its greatest
triumph. The fledgling group participated in a small exhibit/sale at the
Smithsonian's Renwick Gallery titled "Tribal Pottery of the Catawba
Indians." The event lasted from May 4 to 31, 1979 (Galleries File, 1978,
BC). As part of the show, Georgia Harris provided demonstrations for
three days (4–6 May) (Craft Demonstrations, 1978, BC). The demon-
strations opened the show and were designed to draw those interested
in Native American pottery into the gallery. Georgia Harris hoped her
efforts would help make the sale aspect a success. She worked before
large crowds of visitors. For much of these three days, she dazzled the
crowds by making large vessels for which she was justly known. Most
were made with rolls (coils) of clay (Galleries File, BC). The majority
of the audience had never seen this technique but had read about it.
Often spectators went straight from the demonstration hall on the sec-
ond floor to the shop on the first floor to make a purchase. Georgia
Harris's reception in Washington meant a lot to the potters back home
who had already begun to emulate her. Georgia Harris's position as the
Catawba Nation's greatest contemporary potter was strengthened.

The Smithsonian called a delegation of Catawba potters back again
in the summer of 1996 for the annual Festival of American Folklife.
Nola Campbell, master potter and a demonstrator who was the best
at performing before large and small audiences, led the group. Monty
and Anna Branham accompanied her. The idea was that Monty, a new
generation master potter, would benefit tremendously from working
closely with Nola Campbell for two weeks. Anna Branham, a master
at the art of beadwork, demonstrated her beadwork and helped answer
visitors' questions regarding the Catawba Indians of South Carolina.

The trio was housed in the American South Section. They quickly
became a star attraction. For the Catawba it was the triumphs of the
1913 Corn Show all over again. Nola Campbell dazzled large audiences
with her demonstration skills. She constructed large vessels through
the use of rolls. Once she had a piece built to her satisfaction she
searched the audience for a child aged five to eight. Very tenderly, she
would call the child up to her table and say in a low voice, "Honey,
will you smash this pot for me?" The chosen child always performed
the task with vigor, and the audience always gasped in horror to see
the destruction of a masterpiece. The Branhams, along with their dem-
onstrations, also participated in Native American music programs.

Once I asked Nola Campbell why she never tried to save her demonstration pieces. She responded that she worked with greater speed than she normally would and didn't trust a demonstration piece to the dangers of the fire (Nola Campbell, interview, 4 July 1996, BC).

FILMS AND VIDEOS

The potters have also participated in the making of films. Around 1930, Frank G. Speck made a film of the Catawba at work and at play (Speck ca. 1930). Allen Stout, of the Schiele Museum in Gastonia, North Carolina, made a second film in 1978. It shows Doris Blue making a snake effigy pot. In 1989 it was transferred to video format, and a script has been written for incorporation so it can be used as a teaching tool (Stout 1979).

Since the early 1970s, the Catawba have demonstrated before video cameras. The first video was probably made by South Carolina Educational Television in cooperation with the York County Nature Museum (now the Museum of York County). It features the work of Arzada Sanders and Sarah Lee Ayers (York County Nature Museum ca. 1950, Catawba video). In 1976 this video was part of the Museum's educational Catawba program. Visitors to the Catawba gallery viewed a monitor and learned something about the Indians and their pottery. In 1976 a television news team visited the reservation to do a short commentary on the pottery classes conducted that year. Denise Nichols recalls her anxiety: "When the people came from the news, I got so nervous that I rubbed right through the pot I was working on" (Denise Nichols, interview, 1 March 1977, BC). Since this time, video teams have visited the reservation frequently. The potters have been interviewed for talk shows, news spots, and straight-out pottery-making demonstrations. In 1993, Cinebar Productions of Newport News, Virginia, began a major video effort with Earl Robbins and his family ("The People of the Clay"), a project sponsored by the Schiele Museum that resulted in a half-hour educational video.

While the Indians have long been willing to show outsiders how they fashion their wares, they have always been careful to avoid turning their demonstrations into pottery-making lessons. It has been, however, difficult to maintain a fine line between demonstrations and out-and-out classes.

Fred Sanders and his wife, Judy Leaming, founded the Catawba Cultural Preservation Project (CCPP) in 1987. One of its first projects was the initiation of the filming of an educational video ("Catawba: The River People," 1987; Yap Ye Iswa, 1994). The immediate goal was to help preserve the Nation's rich cultural heritage, including the pottery

tradition. The Project immediately became a focal point for those wishing information on the Catawba. In 1993 the CCPP was awarded the Governor's Folk Heritage Advocacy Award for the outstanding work it had done during its short tenure. Its major accomplishment is the annual Yap Ye Iswa or Day of the Catawba Festival. The first CCPP-sponsored Festival was held in 1991 under the direction of Wenonah George Haire. Fifty years had passed since the last Catawba Fair in 1941. The annual Catawba Festival gave the potters an opportunity to offer their wares at home in a festive atmosphere where Catawba culture and history dominate the scene.

Hopefully the Catawba tradition will not be compromised as the Indians move into a new century of working the Indian circuit. The Indians may be assured that little incentive exists for non-Indians to counterfeit Catawba pottery. Today such an act is against federal law (Public Law 101–644). Contemporary potters, while they are drawn to learn about the Catawba tradition, find it too restrictive. Although the Catawba have been signing their pottery as a response to customer demands for the last 25 years, the individual is largely suppressed. The pottery is a tribal possession and does not belong to any one potter. This is true, no matter how acclaimed that person might be. Also, modern technology, indeed all non-Indian technology, is shunned. The Indians avoid commercial clays, the potters' wheel, glazes, and the kiln, for these things are not Indian. They are not Catawba. Those who study Catawba pottery from outside the tradition, outside the tribe, come from a culture where originality is the dominating force. The Catawba remain firmly married to the concept of producing pottery like that of the old Indians in both appearance and workmanship.

During the last century, the Catawba potters adjusted well to new audiences. Where they were once curiosities reluctantly permitted to inhabit the state fair grounds, they are now sought by film and video makers. Today, when a Catawba potter participates in a television effort, millions have an opportunity to learn of this ancient tradition. The potters are well aware of the value of such promotion.

5 Teaching the Craft

The teaching of the Catawba pottery tradition is guarded jealously. The Indians have always been determined to keep their tribal possession in their hands. One of the major concerns among the potters regarding tribal-based research for this book was that non-Catawba might learn Catawba construction methods. It was finally decided that pottery making is widely taught at every educational level, and Catawba methods would be of little interest to outsiders (Samuel Beck, interview, 3 May 1977, BC).

Most Catawba live in extended families. Although pottery was seldom the only source of income, pottery making has always been of great spiritual and economic importance. At any given time, several members of a pottery-making family can be engaged in making pottery. Under ideal extended family conditions, small children watch the entire process from preparing the clay to building, scraping, rubbing, decorating, and, finally, burning the pottery. Learning to make Catawba pottery is a long process. The fixed construction methods of more than 100 shapes must be learned. At the beginning of the twentieth century, for most children their only outings were visits to the clay holes and peddling trips. Clay was an integral part of their restricted lives. Children absorbed the tradition slowly and joined in the various processes as they felt inclined or as their assistance was required. When possible, this educational pattern is followed today.

On occasion, non-Indians are permitted to join the ranks of the potters and are taught the full range of the tradition. Recent examples include Mae Blue, Hattie George, Dorothy Harris, and Maggie Harris. According to oral tradition, these four women are the only non-Indian potters of the twentieth century not censured by tribal law. Presumably, non-Indians who married into the tribe, before these women, were taught pottery making but no memory of their work remains. Today, of necessity, because some of the potters are married to non-Indians, their spouses are often knowledgeable of the tradition, especially in

digging clay and burning pottery. The cottage industry nature of the Catawba way requires that the entire family participate in digging the clay, burning the pottery, and even marketing the wares. Some of the non-Indians occasionally dabble in clay, but tribal and federal Indian law will not allow them to sign and sell their work as Catawba (Public Law 101–644).

The Catawba also carefully draw the line between demonstrations and teaching. If demonstrations come close to teaching, the potters will pull back. This happened most recently in 1994 when the Schiele Museum wanted the potters to demonstrate the burning process. The proposal made the Catawba feel cautious. They felt that if an outsider could burn a pot, such a person could also make Catawba style pots and sell them. The demonstrations were cancelled. Today, it has been reported that potters who demonstrate as artists-in-residence through the South Carolina Arts Commission teach the entire process from building to burning pottery, without dispute. This lack of a negative reaction may be tempered by the realization that it is very difficult to demonstrate the burning process in a traditional educational setting such as a school.

As a rule, the learning process is so gradual that some potters are at a loss for words to describe when and how they learned. For instance, Edith Brown declared, "No one taught me. I just sat and watched" (Edith Brown, interview, 21 April 1977, BC). Others wax nostalgic when thinking of those formative years. "We played as children, and we'd see them—how they made [the pottery]. I just picked it up. I loved to play in the dirt anyway, in red mud and stuff like that. I started off playing with red mud. I made little wee round pots about like that, and we'd try to put little handles on them and little legs. Then [later on] we got so we got clay" (Jennie Brindle, interview, 11 August 1982, BC).

Although Jennie Brindle and Edith Brown abridged their learning process to the simplest of terms, learning to make Catawba pottery is not easy. Clay cannot to be played with. Clay is too valuable, too difficult to obtain. Children, while they must learn, also must be kept from ruining the work of their elders.

> I guess [I learned] after I got up around seven or eight years old. You know something, they wouldn't let us mess with clay because we would put trash in it—dirt, and they didn't—my mama and my grandma, either one—like no dirty clay. . . . [When] I got up seven or eight years old, I made little ole things. . . . I remember I made a cat one time. I thought that was the cutest little thing. I can see that cat yet. You know how a cat will lay with its little arms folded like this. I made that little

cat, and its tail was curled around its little feet. . . . I made that little
cat, and I rubbed it and it burnt solid red. You've seen these cats that
are solid red. . . . It looked just like one of those. I kept that thing for a
long long time. I don't know what ever happened to it. . . . We used to
make little chickens, little old ducks. And we played with them after
we burned them. . . . We didn't [decorate]. . . . We were too small to fool
with anything like that. [They were] afraid we would leave the [the tools]
out and lose them. They had a set of tools, and you didn't play with
them as kids do now with things. (Georgia Harris, interview, 20 March
1980, BC)

The potters make use of every morsel of clay. Hands that were ca-
pable of making something as sophisticated as a cat effigy were put
right to work. Artemis Harris, for one, was forced to enlist the aid of
all her children as soon as they were capable of working in clay. Wesley
Harris recalled gathering wood for his mother and staying up all night
rubbing pottery for the North Carolina mountain trade (Wesley Harris,
interview, 10 May 1977, BC). Blanche Bryson, another one of Artemis
Harris's children, recalls that life at home from the age of ten was domi-
nated by rubbing pottery, and she grew to dislike the work (Blanche
Bryson, interview, 15 May 1977, BC). Frances Wade, who worked like
an adult when she was yet a child, provides yet a third example. She
gathered wood, beat the clay, and rubbed as many as a hundred pots
in one day (Frances Wade, interview, 18 January 1977, BC). Peggy Har-
ris's experience had a modern touch, for she had to rub a fixed num-
ber of pots before she could go out and play (Peggy Harris, interview,
15 March 1977, BC). All of these negative memories stem from the
stress of making pottery for the North Carolina mountain trade.

The learning process followed by some potters is well documented.
Nola Campbell, for instance, spent her early years watching her mother
Maggie Harris and others make pottery. After her brother Douglas mar-
ried, she came under the influence of Georgia Harris. Nola was a quick
learner and artistically inclined. Her teacher, Georgia Harris recalls:

She was maybe 10 years old, maybe 11. . . . Whenever I made any pot-
tery, I just let her fool on the little pieces first. Then she learned to rub
. . . and she got to playing with the clay with Floyd, making little old
pieces for him. . . . Well, I would even sell them for them when I'd go
up here to [North Carolina]. . . . I'd take these little pieces along. Maybe
she'd have five or six, and I'd get the money and give it to them. But
then Nola got to making it. . . . I used to tell her to make them. I used
to straighten them for her . . . and let her rub them, and then take them

off and sell them for her. I used to make five or six dollars going up
there for Nola. . . . She didn't get about 10 or 15 cents [each] for what
she made. They were little pieces. Sometimes I'd have five dollars and
wouldn't tell nobody, and I'd buy cloth. . . . I would make her clothes
for her. I'd buy cloth—buy a pair of shoes and things like that and bring
it back. . . . Nola went right for it. . . . Every time she knew I was going
up she'd have a little batch to give me, and I'd take them and sell them.
. . . Nola never made big pieces for a long time, a good while. (Georgia
Harris, interview, 25 March 1980, BC)

Catawba children discover quickly that pottery is a way to make
money and they are often eager to learn. Georgia Harris capitalized on
this desire in Nola Campbell, and her student saw that pottery could
be an important source of income. For this young girl, it was the only
source of money. Mrs. Harris's young son Floyd was also impressed by
this aspect of the trade and was eager to benefit. Nola Campbell be-
came his pottery source:

Well, Floyd wanted me to make some little pots so he could have some
to sell whenever she [Georgia Harris] went to sell hers, and I told him.
I said, "I can't make those things," and she said, "Yes you can. You got
to learn somewhere." She said, "Start and learn to make them." So I
did. I tried. I'd ask her to shape them up. . . . You got to learn, so I did
learn, and I made him I guess about three dozen. He had that many
little ole tiny ugly things to take up there and sell, and he sold them. I
don't know what he got for them, and then the last year in school . . . I
made enough to buy my clothes to finish school, and she [Georgia Har-
ris] bought my shoes for me, bought my dresses, things like that. . . . So
that told me. She said, "You just go ahead and make them and I'll sell
them, and I'll buy your clothes for you. She knew what size clothes I
wore anyway. (Nola Campbell, interview, 2 March 1981, BC)

Later, when Nola Campbell had her own family, her pottery-making
skills reached maturity. This transition was only made possible by
Georgia Harris's tutoring. Today the work of these two potters is re-
markably similar.

A potter like Florence Wade emphasizes the complexity of the learn-
ing experience. When asked for documentation, she brought many
people into her perspective. Perhaps this is the truest picture we can
have of the Catawba learning process. The potters like to work together
and enjoy comparing building techniques, though there is very little
variation. "I started making when I was ten years old. Daddy died

when I was eight. They showed me how and I watched too. I'd say, 'I can build them,' and then I'd try. I watched them make wedding jugs. That was my specialty. I couldn't do too much with gypsy pots. The legs wouldn't sit right. I could really make wedding jugs, and I loved to make canoes with heads" (Florence Wade, interview, 15 April 1977, BC).

During this period the David Adam Harris family was hard pressed to make ends meet. The family pooled all its resources to work for the tourist trade in North Carolina. It was only natural that young Florence was expected to help:

> Mama, Dorothy Price, did the trimming. Jennie Brindle made them. She'd turn them out like a machine. I rubbed the pottery. Jennie and Mama built and I rubbed. Then I learned. I shaped them up and they'd straighten them out for me. Later I rubbed for Georgia Harris. Her father, Jim, and my father, David, were brothers. I also watched Georgia Harris and Sallie Beck. I remember those loving cups and long necked pitchers. I was also around Fannie [Canty] and Edith [Brown]. Fannie made big scalloped bowls. I can visualize them right now. Fannie made big pots. I was in high school, and she lived on Adam Street, and she'd be working in clay. I'd watch her after school. I'd go there and wait for my ride, and sometimes I'd rub two or three before my ride would come for me. I also watched Sara Lee [Sanders-Ayers]. She lived right behind here. I practically stayed down there with her. (Florence Wade, interview, 15 April 1977, BC)

Finally assuming full responsibility for pottery manufacture often came with family responsibilities. As each potter was questioned, the story was much the same. Isabelle George, for instance, did not begin to bring the full impact of her years of learning into focus until she left home (Isabelle George, interview, 22 March 1983, BC). The same may be said of Catherine Canty, who never built pottery until she had her own family. "I did rub them. Mama never let me help to make them when I stayed at home" (Catherine Canty, interview, 2 March 1981, BC).

Although this family-based learning process continues, contemporary Catawba face a world where the family is not as closely knit as it once was. Today, children are taken to day care centers at a very young age. They have fewer opportunities to watch grandma or anyone else work in clay. Young mothers are most often employed off the reservation. These women, when they return home after hours of wage earning, face household chores. The pottery tradition suffers in such situations. Fortunately, the potters and the Catawba Cultural Preservation Project have been aware of this problem and steps are being taken to

solve it, at the family level and by the Project. From all appearances, the Catawba potters have entered the third millennium with a large number of master potters of unusual skill, and all of them teach the tradition. The modern solutions are, however, revolutionary to the Catawba way.

The teaching innovations began in 1976 when the Executive Committee, working under a state grant, offered its first formal pottery class. Although it appeared to be a new effort, this class was actually the culmination of years of research. The Catawba had long recognized the need for formal teaching. In 1962, Gladys Thomas requested that classes be held as part of the educational program linked to the division of tribal assets (Thomas 1962). This request was never acted upon. Over the years, various tribal members continued to request formal teaching, but it took almost 15 years to realize the dream. Even then many of the highly conservative potters were far from happy with the results.

In 1974, not long after Gilbert Blue succeeded Albert Sanders as Chief of the Catawba, momentum for such an effort increased. This impetus came, in part, from the 1973 pottery exposition and sale organized by Steven Baker that brought Catawba pottery prices more in line with those received by Native American craftsmen in other parts of the country. As prices rose and orders increased, the few potters who were active had difficulty meeting the demands of the new market (D. Blue to T. Blumer, letter, 1974, BC). Others saw the tradition as being cost effective and returned to building pots in their retirement. They began to see Catawba pottery in positive economic terms for their children and grandchildren.

By 1975 Chief Blue and Roger Trimnal obtained state funding for classes; however, problems abounded from the very beginning. The state of South Carolina insisted that a non-Indian teacher be employed (Virginia Trimnal, interview, 6 February 1977, BC). The Catawba balked at accepting any outsider. Their contention was that their own community possessed numerous master potters who had hundreds of years of collective experience making and selling Catawba pottery. Their argument was a good one. Only Catawba pottery methods would be taught. Eventually a compromise was reached. The state would provide one qualified non-Catawba potter, and the Catawba would provide five teachers from their own ranks (Fred Sanders, interview, 8 February 1977, BC). Unfortunately, the Indians considered the state-appointed instructor as an overseer and, therefore, an affront.

Some of the potters boycotted the classes entirely. Principle among this group was Doris Blue who, ironically, had long urged that classes be taught:

No, I didn't go up there. I just know about it. But they . . . had to have
a supervisor of something from Columbia, and this man that was over
the pottery class also taught ceramics. That was one reason I wouldn't
go teach. I didn't think an outsider should come in and tell me how to
teach Catawba pottery. He wouldn't know anything about Catawba pot-
tery. He wouldn't know how it should be made and wouldn't know any-
thing about it. But until the [Indians] agreed to let him supervise or, I
don't know exactly the word they had for it [the class would not be ap-
proved]. He came up though, and he was over the class. And they had
this one Catawba lady taught in the morning and one in the afternoon,
and about two and a half hours in the morning and two and a half hours
in the afternoon. Then later he had a ceramics class, and he taught ce-
ramics. To me that was kind of confusing—to have the class working
on two projects: the ceramics and the pottery. But like he would let
them go ahead with the pottery for a certain length of time and then
the ceramics later. They combined all of them in one day. . . . I didn't
teach. (Doris Blue, interview, 24 March 1980, BC)

Despite the controversy, a strong Catawba teaching faculty was or-
ganized. The group included some of the best potters the community
could offer: Sallie Beck, Edith Brown, Nola Campbell, Bertha Harris,
and Georgia Harris. Collectively, these potters brought over two cen-
turies of experience to their students. They agreed to participate under
the direction of Frances Wade. The controversial outsider was yet to be
selected. The Indians hoped the state of South Carolina would not hire
this unwelcome teacher. They felt that when the powers in Columbia
saw the strength of their teaching staff, the outsider would be forgot-
ten. The Indians were very wrong. Although never publicly stated, the
parties in Columbia did not have confidence in the Indians' determi-
nation to follow through with the classes. In South Carolina's eyes
someone directly responsible to the officials in Columbia was needed
as an overseer.

The state of South Carolina also promised to help the Catawba re-
vive their market. The state would sponsor demonstrations and sales
as part of an aggressive statewide promotional program (Fred Sanders,
interview, 8 February 1977, BC). Plans did not go well in Columbia.
The teacher selected by the state was a recent graduate of the School
of Fine Arts at the University of South Carolina. Complications con-
tinued, for the South Carolina Arts Commission felt that someone
with higher qualifications and more practical experience was needed
and could have been found. The Commission protested and withdrew
from the project (Edward Furschgott, interview, 1 July 1977, BC).

The art school graduate awarded the position of supervisory instruc-

tor of the Catawba Pottery Class of 1976 was Robert (Corky) Miranda. He knew nothing of the controversy. Influenced by the liberalism that shook campuses all across the country at that time, Mr. Miranda felt he could identify with the Indians and they would welcome him. In fact, he had long tried to identify with American Indians through his Hispanic heritage (John Davis, interview, 17 May 1977, BC). In the meantime the students were selected:

Keith Brown	Anne Sanders Morris
Larry Brown	Denise Nichols
Louise Bryson	Margaret Oliver
Ronald Canty	Alton Potts
Connie Collins	Randall Sanders
Peggy Harris	Jimmy Simmers
Debbie Howard	Bruce Wade
Billie Ann McKellar	

(Denise Nichols, interview, 1 March 1977, BC)

Eligibility for enrolling in the class required tribal membership and financial need. This latter requirement created additional controversy. Many interested would-be potters, such as Blanche Bryson and Caroleen Sanders to name only two, were turned away because their household incomes were too high (Blanche Bryson, interview, 15 May 1977; Nola Campbell, interview, 15 March 1977, BC). The Catawba do not have to look far for controversy when it comes to their pottery tradition.

All of the students had prior knowledge of the tradition. Most of them had been deprived of a full knowledge because of the changing Catawba lifestyle, which revolved around public work. For instance, Peggy Harris's mother, Edna Brown, worked in clay for most of her life, but Peggy Harris had only limited exposure to pottery construction methods. "When I was little, they all worked and then they just quit. At that time, I rubbed pots, but I had never finished one up. . . . The first time I actually built my own pots was when I went to the class, and I was happy to go and have the opportunity to learn because the pottery was dying out" (Peggy Harris, interview, 15 March 1977, BC).

Keith and Larry Brown claimed similar exposure, in spite of the fact that the Brown family included numerous potters. Louise Bryson's mother, Lula Beck, was a potter, and Louise grew up watching her mother prepare vessels for the North Carolina mountain trade. Connie Collins was a granddaughter of the renowned Arzada Sanders. Billie Anne McKellar had two master potters in her close family: Catherine Canty and Arzada Sanders. Anne Morris and Randall Sanders both

grew up watching their mother Eva Sanders work in clay. Denise Nichols spent her childhood with her mother Alberta Ferrell, who was very involved in the North Carolina trade.

The classes were held from June to August 1976. Robert Miranda's unfamiliarity with either the Catawba or their tradition posed an immediate problem. Rather than learn from Indian potters who had vast experience behind them, he spoke of improving the tradition. The Catawba balked at breaking the ancient Catawba way (Robert Miranda, interview, 1 July 1977, BC). Some Catawba, on the other hand, had never seen clay treated like cookie dough and were fascinated (Peggy Harris, interview, 15 March 1977, BC). They found the use of a rolling pin to produce slabs of clay comical (Billie Anne McKellar, interview, 15 March 1977, BC). Catawba techniques do not employ the use of large sheets of clay. The original intent of the project was to teach and preserve ancient Catawba techniques, and the students had enrolled to learn how to make the pottery of their ancestors. Miranda never realized that his forced presence was merely one more humiliation served on the Catawba by South Carolina officials (Frances Wade, interview, 6 April 1977, BC). Some of the potters also feared that Miranda would learn Catawba techniques and begin to make and sell Catawba pottery. As a result, an effort was made to restrict his access to clay. He was, at least officially, kept from visiting the clay holes (Billie Anne McKellar, interview, 11 February 1977, BC).

In the Class of 1976, a total of 15 young Catawba were taught the rudiments of the tradition. The results were mixed. On the negative side, some of the students did not make pottery after graduation even though the tradition needed the 15 young potters and their vitality. On the positive side, several potters of great potential emerged from the class. Louise Beck Bryson was not the star pupil in the group, but she immediately established herself as a hard-working potter. By the end of her short four-year career, she was making museum quality pieces and was counted as a master potter. She sold her work as fast as she could build it, finish it, and burn it.

Louise Bryson had a tremendous way with her customers and could sell anything she burned. For instance, on one occasion she broke a pitcher. All that remained was the handle and a reduced part of the bowl; the lip and much of the upper part of the vessel were gone. Rather than destroy the vessel, she finished off the rim and burned it. When a pothunter appeared at her door, he inquired about this particular vessel. It was well made and finished to perfection, as was typical of Louise Bryson's work. She laughed and told him it was a Catawba urinal, and he signed a check. Louise had many a laugh out of the expe-

rience, and today the man owns a signed piece of historically important Catawba pottery. Unfortunately, by 1980, the ravages of diabetes hampered her work, and Louise Bryson was forced into an early retirement.

The Class of 1976 had other success stories. Billie Anne McKellar continued to make a high quality ware. Peggy Harris continued to work with her mother, Edna Brown. By 1994, Keith Brown emerged as a pipe maker of reputation, and an occasional pot made by Bruce Wade appears on the market. In 1992, Denise Nichols sold pottery at the annual Yap Ye Iswa Festival.

Almost as soon as the Class of 1976 ended, interested Catawba began to lobby for a second series of classes. Efforts were made to obtain funding. With none forthcoming, Fred Sanders, then the Assistant Chief and the eventual founder of the Catawba Cultural Preservation Project, turned to a grass roots effort (Blumer 1987a). Volunteers dug a supply of clay, and teachers volunteered for two sets of classes for adults and children. Nola Campbell taught the adults, and Evelyn George and Catherine Canty taught the children's classes. The following Indians made up the adult class:

Gail Blue Jones	Sheryl Gordon
Jennifer Blue	Roberta Sanders Honeycutt
Travis Blue	Elizabeth Plyler
Kevin Brewton	Brenda Sanders Sigmon
Mohave Sanders Bryson	Colette Williams
Blanche Harris Bryson	Phyllis Beck Williams
Sandra Carpenter	Vivian Sanders Williford
Calvin George	

The children's class included:

Jason Beck	Erin Canty
Jennifer Beck	Jered Canty
Kim Beck	De Ann George
Andrew Blue	Shane Pittman
Chad Canty	Becky Trimnal

(Blumer 1987a)

This class produced more positive results, perhaps because the market for pottery had changed dramatically for the better between 1976 and 1987. With a better showing than the Class of 1976, six of the 15 adults continued to work in clay: Blanche Harris Bryson, Gail Blue Jones, Sheryl Gordon, Travis Blue, and Elizabeth Plyler. Of these six, Mohave Bryson, Blanch Bryson, and Elizabeth Plyler continue to work

in clay to this day. Elizabeth Plyler has emerged as a master potter. Mohave Bryson reportedly is a skilled potter but none of her work has been examined.

Andrew Blue, from the children's class, continued to work with his aunt, Mildred Blue, for a number of years. The progress of the other students from this class is unknown.

A second innovation developed out of the Class of 1987. Tutorials were funded by grant money from the McKissick Museum at the University of South Carolina. These lessons were arranged on a one potter to one student basis. This experiment proved to be very effective. Nola Campbell taught two sets of such tutorials, one with her daughter Della Harris Oxendine and another with Blanche Harris Bryson. Mildred Blue continued to work with her nephew Andrew Blue through this program. Catherine Canty taught Susan George, and Helen Beck taught Colette Williams, a great-granddaughter. Others participated in this grassroots effort. More importantly, this approach began to work on its own in a limited way. The young potters grew accustomed to approaching the senior potters and asking them for lessons regarding specific vessels. Gail Jones and Faye George Greiner, for instance, spent time with Earl and Viola Robbins. Earl Robbins also taught a number of young potters how to make pipe molds. Interestingly enough, none of these efforts involved an exchange of money between the experienced potter and the student.

Today the Catawba count a large number of active young potters who have not benefited from either formal classes or tutorials. Some have emerged as master potters in their own right. These students are making pottery on a regular basis. Their work ranges from awkward trade ware to vessels any museum would be proud to put behind glass. From all appearances, these new potters are learning by the old traditional way, which speaks well for the vitality of the Catawba tradition as it enters the third millennium. At least two of these young potters actively seek tutorials from senior potters or those who are a bit more experienced. On occasion, a senior potter will even seek advice from some of the new generation master potters.

6 Professionalism and the Catawba Potters

D ue recognition has come slowly to the Catawba potters. The sign-
ing of Catawba pottery vessels is a relatively recent practice, and
today collectors expect to see signatures on the bottom of the vessels
they purchase. As is often the case, however, even the most modern
Catawba innovations often have deep roots that reach into the past.
Some Catawba began to write on the bottom of their vessels following
the Civil War.

To date, the oldest example of a signed Catawba pot was found on
the old Head family home site by Betty Blue. The signature consists of
an awkward and misspelled attempt to put the word "Indian" on the
bottom of a small water jar. So abstract and oddly placed is the word
"INIAN" that it is difficult to decode it at first glance. Most likely the
work of Martha or Pinckney Head, the vessel dates from some time
between the Civil War and 1883 when the Heads removed to Colorado.

The signing of pottery may be directly linked to the first museum
collections that were developed in 1884 when Edward Palmer gathered
Catawba pottery examples for the Smithsonian Institution (then the
National Museum). Palmer took his work seriously, and his arrival,
with his professional interest and money to purchase, must have im-
pressed the Catawba potters. The concept of the attribution of Indian
arts was vague. The American people, including academics, had not
begun to think of the Indians as individuals, and the Catawba were
lucky to be called by their tribal tag. The Indians apparently acquiesced
in remaining nearly anonymous tribal members. The knowledge that
museum staff members collected their pottery for study has always
filled the potters with pride. At the time, much, but not all, of what
the Catawba produced was utilitarian ware that was used and dis-
carded. With this fact in mind, the Catawba may have been amused by
Palmer's purposes. The records are silent on the issue.

Unfortunately, museum documentation was in a developmental stage in 1884. For instance, at the turn of the century, Mann S. Valentine collected a number of fine utilitarian vessels for the Valentine Museum in Richmond, Virginia, from Sallie Wahoo, a Catawba potter who lived among the Cherokee. Valentine neglected to obtain the potter's name and mislabeled the vessels as being the work of "a Cherokee squaw." Similarly, when A. I. Robertson began the University of South Carolina collection in 1908 (*Fort Mill Times,* 19 March 1908:2; *Rock Hill Herald,* 6 March 1908), she probably obtained examples from the work of Sarah Jane Ayers Harris. The unidentified pottery was merely put on the shelf. Most South Carolinians could identify the wares as Catawba in origin. Eventually, the vessels collected by Robertson were stored in the attic at the Caroliniana Library, where they remained apparently neglected for almost 50 years. Fortunately, one water jug contained a scrap of paper stating that it had been collected by Robertson. No mention was made of the potter. If acquisition records exist, they were not with the vessel in 1977. The Confederate Museum in Charleston, South Carolina, possesses a small but very fine pot labeled as the work of a nameless widow of a Catawba Indian Confederate veteran. The potter's name might have been Sarah Jane Harris, Nancy Harris, or Elizabeth Harris, to name three pottery makers of the time who were the widows of Confederate veterans. Since the entire male population of the Catawba Nation (14 men) fought for the Confederacy and most of these died, there were too many possible widows to make conjecture (Lake 1955; Blumer 1995b).

W. R. Simpson started his collection early in the twentieth century when documentation was hardly considered (Williams 1928). He had a very good eye for the best of Catawba pottery and assembled a fine array. As a rule, he failed to keep acquisition records, but on occasion he wrote the potter's name on the bottom of the vessel in pencil. As a result, he documented several exceptional vessels from two important nineteenth-century potters, Mary Harris and Martha Jane Harris. Simpson began to see the individual potters as holders of unique skills; however, most of the fine vessels he collected can only be attributed to any one potter by wild conjecture. Today this interesting collecting effort can be appreciated in the Catawba Cultural Center on the reservation.

Carrie Garrison of Rock Hill documented a rare masterpiece of Catawba work, only because she remembered that the potter was Martha Harris Sanders, the wife of John Sanders. The piece, to date, is the only known vessel from the hands of this talented potter. Unfortunately such instances are rare outside the Catawba Nation. The Catawba have heirloom vessels from such potters as Emily Cobb, Emma Brown,

Margaret Harris, Rachel Brown, Billy George, Rosie Wheelock, Rhoda Harris, Epp Harris, and Elizabeth Harris, to list only a few of the greats remembered in this way. Most of these vessels, however, are family pieces documented orally.

The practice of signing vessels started with the Catawba participation in the tourist trade in the mountains of North Carolina. Sometimes the buyers wanted an indication of the origin of the piece. Nettie Harris Owl, while she did not inscribe her name of the bottom of her vessels, sometimes labeled them as coming from the Cherokee Reservation. Oddly enough, her name or her tribal affiliation were apparently not important to her or her customers. Nettie Owl did, however, take credit for her work collected during this period by the Smithsonian. Or, perhaps more correctly, those collecting for the Smithsonian had begun to see the value in knowing the potter's name, hence, Nettie Owl's pieces were attributed to her. The same was true on acquisition file cards for the Museum of the American Indian. The majority of the Catawba pieces that form this respected collection are from anonymous Catawba potters. Both museums also gave Susannah Harris Owl credit for her work. She apparently had enough respect among the linguists of her day to warrant the honor of authorship.

The first Catawba potter to systematically sign her vessels was Lillie Beck Sanders, who was not a Catawba but a Cherokee who married into the Catawba tribe and learned to make pottery from her in-laws. On occasion, Lillie Sanders included the date the vessel was made. Unfortunately, this practice did not spread to the Catawba potters who knew Lillie Sanders and her work.

The real problems of attribution began when the Catawba sold pottery in the North Carolina mountains. A shop owner's purpose in carrying the pottery was to give tourists an opportunity to purchase genuine Indian crafts. Up until 1923, the year of Nettie Owl's death, Nettie and Susannah Owl satisfied this growing market. After Nettie's death, an aging Susannah worked alone. Wisely, her husband, Sampson Owl, enlisted the assistance of related Catawba potters in South Carolina. It did not take the Catawba long to realize that the tourists were buying Catawba wares and thinking the work was Cherokee in origin. This knowledge bothered the Catawba. Signing the pots would solve the problem of attribution. The merchants who bought Catawba work, however, wanted to pass Catawba vessels off to their customers as Cherokee. This issue pushed the Catawba potters in the direction of demanding professional recognition of some sort by signing the bottom of each vessel.

Fannie Harris Canty, later George, who worked almost exclusively for the North Carolina mountain trade and only made crude trade

ware, began to sign some of her work during this period. By the 1930s, Early Brown began to sign some of Emma Brown's pottery. The real push for attribution did not happen, however, until the late 1960s. At this time, home decorator magazines began to show the non-Indian public the beauty of Indian art. Magazine after magazine pictured sophisticated homes with floors covered by Navajo rugs and shelves decorated with Indian pottery. The artisan became important. Buyers wanted signatures. The Catawba were forced to oblige if they wanted to make sales.

When I met Doris Blue in 1970, she was signing much of her work. Ironically, some potters had to be almost forced to claim their pottery with a signature. For instance, in 1976, Reola Harris flatly refused to sign her vessels. It took much coaxing but, in time, she reluctantly began to sign her pottery in 1977. The same was true for Viola Robbins, who began to sign her work in 1986. Today, all of the potters, even young children, proudly inscribe their names on their pots. The potters have learned the sales magic of putting a name followed by something like "made by a Catawba Indian" on the bottom of the vessel.

The Catawba have come a long way from incising the bottom of a pot with the word "INIAN." Even the smallest miniatures have initials and perhaps an abbreviated date incised in a discrete place. The attribution can be extensive: first and last name, full date, and tribe. Some pipe makers keep a hooked metal awl similar to a bent ice pick in their cache of tools. Such a simple device can be used to inscribe at least initials and a date inside a pipe bowl.

Professionalism is, however, more than being proud enough to sign the bottom of a vessel and thus mark it for all time as being from one's hands. Perhaps no Catawba potter has done more to bring professional recognition to her fellow potters than has Georgia Harris. Following the landmark exhibition at the Columbia Museum of Art, Georgia Harris continued to build museum-quality pieces. In 1977, Steve Richmond, of the Bureau of Indian Affairs (BIA) Arts and Crafts Board, began promotional work with Mrs. Harris. She was highly responsive to his suggestions. His goal was to promote her pottery in museum circles. One could not, however, advance the work of one potter without inadvertently helping the entire Catawba community. Mr. Richmond's first effort was made in December 1977, when he arranged a show for the Museum of Art in Spartanburg, South Carolina. Later that same year, Mr. Richmond initiated a similar effort with the Mint Museum in Charlotte, North Carolina (Steve Richmond, interview, 21 April 1977, BC). He envisioned this prestigious museum presenting a joint Catawba pottery and Cherokee basketry exhibit (G. Harris to T. Blumer, letter, 20 September 1977, BC). A final date was set for No-

vember 5, 1978. Mrs. Harris demonstrated pottery making for two hours on opening day and came away from the event feeling quite satisfied. "This display was really good—pottery and baskets were displayed in one room. Each helped to enhance the other. She [the curator] displayed the smaller pieces of pottery in a glass [cabinet] on the walls. They really looked good" (G. Harris to T. Blumer, letter, 20 September 1977, BC). For the first time, the work of a solitary Catawba potter was singled out for its excellence of form and finish and presented in a museum setting as art rather than craft. This treatment had a profound effect on the close-knit community of Catawba potters who emulated Mrs. Harris. High professional goals were set.

Most importantly, after the Mint show closed, the BIA Arts and Crafts Board continued to encourage Mrs. Harris and to make important purchases of her work. "Mr. Richmond came down on Wed. and bought $425 worth for the Indian Arts and Crafts Board in D. C. Could have sold him more if I had had some larger pieces. When he called he didn't say what kind or how many and I told him so. He said to let him know when I had some nice larger pieces" (G. Harris to T. Blumer, letter, 13 August 1979, BC). Georgia Harris's next letter provided a more detailed list of the purchase: "Mr. Richmond bought 10 pieces: the Indian face wall mask, 1 loving cup, 1 tall pitcher, 1 cupid jug, 1 turtle, 1 duck, 3 pipes, and the 4 legged crimped vase that came back from Mrs. Gambaro. He wanted your snake pitcher the worst kind. He said, 'You can make him another one.' I told him you bought it and you knew exactly what it looked like" (G. Harris to T. Blumer, letter, 2 August 1979, BC).

During the summer of 1979, the South Carolina Arts Commission and the BIA's Arts and Crafts Board slowed down their formal efforts to assist the Catawba potters in marketing their wares. By this time, however, the potters had received enough direction to continue on their own. The Indians knew what they needed to do. The people of both Carolinas had a sharpened interest in the region's surviving Catawba pottery tradition. At this time, the McKissick Museum of the University of South Carolina began its ambitious acquisitions program. Representative pieces from each working potter were commissioned. The partial list of contemporary potters so honored includes: Sara Lee Ayers, Doris Blue, Mildred Blue, Edith Brown, Edna Brown, Louise Bryson, Nola Campbell, Georgia Harris, Peggy Harris, Earl Robbins, and Viola Robbins (D. Blue to T. Blumer, letter, 6 July 1979, BC; G. Harris to T. Blumer, letter, 28 March 1979, BC). The Schiele Museum of Gastonia, North Carolina, soon followed the McKissick's lead and began an equally ambitious acquisitions program that has lasted from 1979 to the present with a promise to continue. Both museums were hon-

ored with important gifts of historic Catawba vessels. They also made major purchases of vessels that appeared on the antiques market.

The advances made during the late 1970s continue. Today the potters are eager to create pieces worthy of any museum's shelves and are doing so. They have gone beyond signing their work and often present the buyer with a business card and a short historical essay. Earl Robbins keeps a supply of photocopies of articles that have appeared in the local papers, and each of his customers goes away with a fairly good amount of written material on his career as a potter. Two Catawba potters, Faye Greiner and Caroleen Sanders, have had sales brochures professionally printed with illustrations. Each buyer takes home not only a vessel but also a handsome comment on the potter's art. As seasoned professionals, most of the potters also stand prepared to talk to what appears to be an endless parade of academics, journalists, school groups, and other interested visitors to the Nation. They are eager to participate in video presentations. A few of the potters have caught onto the idea of producing numbered editions of particular pots, an idea that collectors seem to like.

While this discussion has concentrated on the work of selected Catawba potters, the survival of the tradition and professional advances really belong to the community as a whole. The list of documented Catawba potters who dominated the last century is a long one but worthy of repeating as a sort of "Hall of Fame of Documented Catawba Potters." It is professionally significant that today the Catawba Nation has more master potters (17 in all) in the ranks of its pottery making community than at any time in the last two centuries. Indeed, the Catawba Nation counts as many potters today as they did their entire population in 1849 (Census 1849; List 1849). The list presented below is an attempt to be inclusive, but it is impossible to count today's potters without the benefit of a time-consuming and costly census. Those listed below have dominated this pottery-making community from the nineteenth century to the present:

DOCUMENTED POTTERS, 1880–2002

AYERS, AMY (1987–)
Produced small, signed pieces made under the supervision of her grandparents, Sara Lee and Foxx Ayers.

AYERS, HAZEL (FOXX) (1924–1999)
Produced small, signed pieces. Special interest in the pipe tradition.

Foxx Ayers put most of his energy into marketing his wife's pottery.

AYERS, SARA LEE HARRIS SANDERS (1919–2002)
An award-winning master potter, produced the full range of the Catawba tradition. Known for her large

vessels. Began signing her pottery in the 1970s. Large number of pieces marketed throughout the country over a long period of time.

BECK, HELEN CANTY (1920–)
A master potter who produces the full range of the Catawba tradition. Pieces signed from ca. 1976 to the present.

BECK, LULA BLUE (1905–1996)
Produced trade ware for the Cherokee trade, mostly small pieces, and abandoned this market when it failed in the 1960s. Resumed making a limited number of pieces in the early 1990s, some signed.

BECK, RONNIE (1976–)
Produces small pieces. Began work under the supervision of his grandmother, Lula Beck, ca. 1991.

BECK, SALLIE BROWN (1893–1993)
An award-winning master potter, produced the full range of pottery for the Cherokee trade probably beginning in the 1920s. Some of these vessels may have been signed because of the influence of Lillie Sanders. Several years of inactivity followed the failure of the Cherokee trade in the 1960s. She resumed making a limited number of pieces after 1976, all signed including a number of family heirloom pieces.

BLACKWELDER, LILLIAN HARRIS BLUE (1925–1991)
Produced small trade ware for the Cherokee trade. May have made a small number of pieces just before her death. No family heirloom pieces found to date. One vessel has

been located. It was signed with the initials "LHB."

BLUE, ANDREW (1977–)
Produces small pieces. Began work under the supervision of his aunt, Mildred Blue, in 1987.

BLUE, BETTY HARRIS (1934–)
Produces miniatures made under the influence of her brother, Edwin Campbell. Began work in 1993. All signed.

BLUE, BRIAN (1959–)
Produces occasional pieces.

BLUE, DORIS WHEELOCK (1905–1985)
A celebrated master potter of great skill, Doris Blue produced the full range of the Catawba tradition. Known for her pipes and small vessels. Began to sign her pieces in the late 1960s. Made a limited number of larger vessels late in life.

BLUE, EVA GEORGE (1910–1982)
Produced small pieces for the Cherokee trade. No signed pieces found to date. Family heirloom pieces are not signed.

BLUE, LOUISA CANTY (1883–1963)
Produced small pieces for the Cherokee trade and for sale at home. Reservation sales were brisk because her husband, Chief Sam Blue, entertained many visitors and many of them desired pottery. No signed pieces found to date. No family heirloom pieces located.

BLUE, MAE BODIFORD (NON-INDIAN) (1906–1993)
Learned to make pottery after her

marriage to LeRoy Blue in 1933. Abandoned pottery making in the 1960s and resumed a limited production of signed pieces in the late 1980s. Family heirloom pieces signed.

BLUE, MILDRED (1922–1997)
A master potter who worked with her mother, Doris Blue, for many years. She began to work independently in the late 1970s. All her work was signed. Known for small pieces and miniatures. Collectors made it nearly impossible for her to keep up with the demand. She was particularly fond of turtles.

BLUE, TRAVIS (1973–)
A limited number of small pieces made under the supervision of Faye George Greiner in 1993. All signed pieces.

BRANHAM, ANNA BROWN (1959–)
A limited number of small pieces produced under the instruction of her mother, Ruby Ayers Brown Vincent. Anna Branham is better known for her fine beadwork.

BRANHAM, WILLIAM (1961–)
Master potter who began to work in clay in 1994 and immediately began to produce vessels of museum quality. All signed.

BRINDLE, JENNIE CANTY SANDERS HARRIS (1905–1987)
Produced trade ware for the Cherokee trade and abandoned this business in the 1960s. Resumed production of signed pieces for a short time ca. 1978, many of which were signed and sold in the mountains of North Carolina.

BROWN, EARLY (1891–1963)
Extremely active in the pottery business for much of his life. Signed pieces for Emma Brown. To date none of his signed work has been found. Family worked at Schoenbrun, Ohio, in the 1930s. No family heirloom pieces have been found.

BROWN, EDITH HARRIS (1893–1985)
A master potter who produced the full range of traditional Catawba pottery. Filmed making pottery by Frank G. Speck in the 1920s. Worked for the Cherokee trade and quit work in clay when that market floundered in the 1960s. She resumed making pottery after 1976 and signed a limited number of pieces.

BROWN, EDNA WHEELOCK THATCHER (1911–1985)
Worked under the supervision of her mother, Rosie Harris Wheelock, during her early years of pottery making. Produced small pieces of trade ware from 1970 until her death. Some of these may have been signed.

BROWN, EMMA HARRIS CANTY (1889–1961)
This master potter produced the full range of traditional Catawba pottery throughout her life. After she married Early Brown, a limited number of her vessels were signed and sometimes dated by her husband. Worked at Schoenbrun, Ohio, during the 1930s.

BROWN, JOHN (1867–1927)
Highly active in the pottery busi-

ness throughout his life. First Indian to buy a car and used it to peddle Rachel Brown's pottery. Although he worked in clay, no vessels are attributed to him, and no such vessel has been found in any collection to date. No family heirloom pottery has been located.

BROWN, KEITH (1951–)
A master potter who began making and decorating pipes beginning ca. 1990. A limited number of small vessels produced, all signed. His demonstration work for the Catawba Cultural Center has brought him much positive attention.

BROWN, MARGARET GEORGE (1837–1922)
Produced the full range of traditional Catawba pottery at the master's level throughout her life. A limited number of these are in museum collections with acquisition records that include her name. To date, no signed pieces have been found.

BROWN, RACHEL GEORGE (1874–1960)
This master potter produced the full range of traditional Catawba pottery throughout her life. Demonstrated for Harrington in 1907, and some of the undocumented Harrington pieces in the Museum of the American Indian may be from her hand. A small number of unsigned vessels are treasured by family members. No signed pieces have been found to date.

BRYSON, BLANCHE HARRIS CAMPBELL (1926–)
Produces the range of traditional

Catawba pottery. Worked for the Cherokee trade during the 1940s and 1950s with her mother, Artemis Harris. When this market failed, she abandoned pottery making. Resumed work in the late 1980s; all of her work has been signed since that time.

BRYSON, LILLIE BECK SANDERS SAUNOOK (CHEROKEE) (1876–1951)
Pottery-making career began in 1913 when she married Catawba traditionalist Joe Sanders. Vessels have been identified with the names Sanders and Bryson. She made pottery at both Catawba and Cherokee where she was recognized as a master potter of great skill. It can be assumed that all her vessels were signed.

BRYSON, LOUISE BECK (1931–1984)
A member of the Class of 1976 and worked in clay from 1976 to 1980. Produced a steady supply of small pieces that quickly went from trade ware quality to museum quality. All of the work of this master potter was signed.

BRYSON, MOHAVE SANDERS (1937–)
Began working in clay around 2000 and reportedly is working at the master level.

BYRD, MARSHA FERRELL (1950–2003)
Began working with her mother, Alberta Canty Ferrell, in 1992. Limited number of small trade ware vessels produced. All signed.

CAMPBELL, EDWIN (1954–)
Began work in 1992 when poor

health forced him to abandon carpentry. This master potter produces a large number of miniatures that mimic the work of his mother, Nola Campbell. All signed.

CAMPBELL, NOLA HARRIS HARRIS (1919–2001)
An award-winning master potter. She produced the full range of traditional Catawba pottery for most of her life. Began signing her work in the 1970s. Known for her large vessels and her grand demonstration style.

CANTY, ALLEN (1911–1980)
One signed small bowl located to date. Probably made under the supervision of his mother, Emma Brown. Not known as a potter, and this signed vessel may be unique.

CANTY, CATHERINE SANDERS (1917–1999)
Produced the full range of traditional Catawba pottery. Worked at Schoenbrun, Ohio, during the 1930s and for the Cherokee trade until this market faltered in the 1960s. Resumed working in clay and began signing her work ca. 1976.

CHILDERS, PAIGE (1992–)
Learned from her grandparents and her mother, Earl and Viola Robbins and Margaret Tucker. Makes an occasional vessel.

COLLINS-BUCCA, CONNIE WILLIFORD (1955–)
Grew up watching her grandmother, Arzada Sanders, working in clay. Began building pottery indepen-

dently in the 1970s. Makes an occasional vessel.

ESTRIDGE, BETSY CRAWFORD HARRIS (CA. 1860–?)
Reportedly made pottery all her life but no signed pieces or pieces attributed to her have been found to date. No family heirloom vessels have been located.

FERRELL, ALBERTA CANTY (1929–1998)
Produced the full range of traditional Catawba ware for the Cherokee trade off and on throughout her life. Some pieces signed. After some years of inactivity, resumed work for a short time in 1992.

GARRIS, BECKEE SIMMERS (1947–)
Works occasionally in clay and produces a trade ware quality work of a traditional nature.

GEORGE, ELSIE BLUE (1914–)
Produced small pieces for the Cherokee trade until that market failed. No signed pieces found to date. Resumed limited production of pottery in the late 1990s.

GEORGE, EVELYN BROWN (1914–)
This master potter began work at Schoenbrun, Ohio, in the 1930s and later produced for the Cherokee trade. Some signed pieces have been located from her Schoenbrun period. Abandoned making pottery when the Cherokee trade failed and resumed work in clay in 1976. All signed after 1976. Has taught numerous classes in pottery making to tribal members.

GEORGE, FANNIE HARRIS CANTY
(1900–1951)
Full range of traditional Catawba
pottery produced for the Cherokee
trade throughout her life. Signed
some vessels. Also was known to
sign her work with the names of her
children.

GEORGE, HATTIE MILLINGS (NON-
INDIAN) (1893–1993)
Began to make Catawba pottery af-
ter her marriage to Moroni George
in 1912. None of her work has been
located in any collection to date.

GEORGE, ISABELLE HARRIS (1904–
1989)
Full range of traditional Catawba
pottery produced for the Cherokee
trade until the 1960s. Resumed pot-
tery making in the late 1970s. Some
pieces signed.

GEORGE, KRISTEN (1985–)
Inspired to make pottery for the an-
nual Yap Ye Iswa Festival and of-
fered her wares at the Festival for
several years. The author purchased
from this potter in 1996.

GEORGE, MANDY (1987–)
Began limited work in clay in 1993
under the supervision of her grand-
mother, Evelyn George. All pieces
signed.

GEORGE, REBECCA MARSH (? –1882)
The legendary creator of the Rebecca
pitcher. No pieces either attributed
to her or signed by her have been
found.

GEORGE, SUSAN (1947–)
Began work under Catherine Canty

in 1992 and occasionally works in
clay. All work signed.

GEORGE, WILLIAM (1800–1896)
Full range of traditional Catawba
miniatures produced throughout his
life. No signed pieces by this mas-
ter have been located to date but
several pieces attributed to him are
in collections. None of the museum
collections examined to date have
pieces attributed to him. Two family
heirloom vessels have been located.

GORDON, ELIZA HARRIS (1902–
1960)
A master potter of great skill. Ex-
tremely active in making museum-
quality pottery throughout her life.
Worked in Tannersville, New York,
in the 1930s. No signed work has
been found to date. One family heir-
loom vessel reportedly exists.

GORDON, SALLIE BROWN (1875–
1952)
This master potter was extremely
active in making traditional Ca-
tawba pottery throughout her life.
No signed or family heirloom pieces
have been found.

GORDON, SHERYL MACKIE (1959–)
Began to make small vessels follow-
ing her participation in the Class of
1987. All work signed.

HALL, VICTORIA SHELEE HARRIS
(1974–)
Learned to make pottery from Geor-
gia Harris. Makes an occasional ves-
sel.

HARRIS, ABSALOM (EPP) (1830–
1916)
A celebrated master pipe maker. Sev-

eral pieces attributed to him have been found in museum collections. Known within the tribe for his shoe pipe molds. No signed work has been located.

HARRIS, ARTEMIS HARRIS (1896–1959)
Produced the full range of traditional Catawba pottery throughout her life. No signed pieces have been located, but several heirloom pieces are treasured by her family.

HARRIS, BETSY (1861–1921)
Reportedly made pottery throughout her life. No signed pieces or vessels attributed to her have been found to date.

HARRIS, BERTHA GEORGE (1913–)
A master potter who produced the full range of traditional Catawba pottery for the Cherokee trade until that market failed in the 1960s. Resumed work in 1976 and began to sign her work at that time.

HARRIS, BEULAH THOMAS (1929–)
Worked to produce pottery for the Cherokee trade until that market floundered in the 1960s. Resumed working in clay in 1993.

HARRIS, CURTIS DOUGLAS (1956–)
Occasional signed pieces produced. Learned from his grandmother, Georgia Harris.

HARRIS, DONALD (1950–)
Began work in clay ca. 1993 under the influence of his mother, Beulah Harris. A master pipe maker of note who produces museum-quality vessels.

HARRIS, DOROTHY PRICE CANTY (NON-INDIAN) (1883–1961)
Produced the full range of Catawba traditional wares throughout her life. No signed pieces or family heirloom vessels have been found.

HARRIS, ELIZABETH (CA. 1830–CA. 1890)
Made traditional Catawba pottery throughout her life. No pieces attributed to her or signed by her have been found. One heirloom vessel has been located.

HARRIS, GARFIELD C. (1914–1994)
Made traditional Catawba pottery for the Cherokee trade until that market floundered in the 1960s. One small, unsigned heirloom vessel has been located. One lost squirrel effigy has been reported.

HARRIS, GEORGIA HARRIS (1905–1997)
An award-winning master potter. Produced the full range of traditional Catawba pottery until she obtained her practical nurse's degree in the early 1960s. Resumed working in clay in 1976 and began to sign her work at that time. Known for her large vessels and pipes. Georgia Harris is the only artisan to receive the National Endowment for the Arts prestigious National Heritage Fellowship Award posthumously.

HARRIS, IDA (1904–1983)
Worked for the Cherokee trade until that market floundered in the 1960s. No signed pieces or heirloom vessels have been found.

HARRIS, LORETTA (1946–)
Inspired to make pottery by the Yap
Ye Iswa Festival and has sold there
every year since 1997. Makes small
traditional pieces.

HARRIS, LUCINDA (1839–1880)
Produced traditional Catawba pot-
tery throughout her life. No signed
or attributed work has been found.

HARRIS, MARGARET HARRIS (1879–
1926)
Produced the full range of traditional
Catawba pottery throughout her life.
One family heirloom has been lo-
cated. Not known to have signed
her work.

HARRIS, MARGARET PRICE (NON-
INDIAN) (1892–1968)
Produced the full range of traditional
Catawba pottery throughout her life.
No family heirlooms or pottery at-
tributed to her has been located.
Did not sign her work.

HARRIS, MARTHA JANE WHITE
(1860–1936)
A celebrated master potter who
worked in clay all her life. Known
for her large vessels and pipes. Sev-
eral examples of her work have been
located in museum collections. Most
of the heirloom pipe molds owned
by tribal members are from her hand
as are most of the pipe molds found
in museum collections.

HARRIS, MARTIN (1941–2002)
Produced the full range of traditional
Catawba pottery. This master pot-
ter began to sign his work in the
1970s. Known for his large pieces.

HARRIS, MARY (CA. 1829–1904)
Produced the full range of traditional
Catawba pottery throughout her life.
Two examples of her work have been
located in museum collections. No
work signed by the potter has been
found.

HARRIS, MARY GEORGE (DOVIE)
(1877–1962)
Produced the full range of traditional
Catawba pottery throughout her life.
No signed work or family heirloom
vessels have been located.

HARRIS, MINNIE SANDERS (1909–
1979)
Produced the full range of traditional
Catawba pottery for the Cherokee
trade until the market failed in the
1960s. Resumed work with Martin
Harris in the late 1970s. Several
family heirloom vessels have been
located. No signed work has been
located.

HARRIS, NANCY (CA. 1829–CA. 1908)
Reportedly produced the full range of
traditional Catawba pottery through-
out her life. None of her work has
been located in museum collections
and no heirloom pieces have been
found in the tribe.

HARRIS, NANCY (OCTOBER) HARRIS
(1899–1975)
Produced the full range of traditional
Catawba pottery for the Cherokee
trade until that market floundered
in the 1960s. Not known to have re-
sumed work. No signed pieces or
family heirloom vessels have been
located.

HARRIS, NETTIE HARRIS OWL
(1872–1923)
A celebrated master potter of unusual skill. Began work at Cherokee probably under the influence of her aunt, Susannah Harris Owl. Produced most of her work at Cherokee and for the Cherokee trade. Several family heirloom vessels have been located, and her work is well represented in museum collections. Did not sign her vessels but may have written the place of origin on the bottom.

HARRIS, PEGGY THATCHER (1927–)
Began work following the Class of 1976. Made small pieces under the influence of her mother, Edna Brown. Much of her work is signed. Has not been active since ca. 1985.

HARRIS, REOLA HARRIS (1921–1991)
Produced traditional Catawba pottery for the Cherokee trade throughout her life. Began to sign her vessels ca. 1979. Known for her surrealistic animal effigies.

HARRIS, RHODA GEORGE (NON-INDIAN) (CA. 1829–1918)
A master potter who produced the full range of traditional Catawba pottery throughout her life. Remembered for her pipe molds, which are still used by her descendants. Numerous pipes from Rhoda Harris's molds have been located in private and museum collections but none have been attributed to the potter.

HARRIS, ROBERT LEE (1867–1954)
Not remembered as a potter, but during the Corn Exposition of 1913, he claimed to be a potter. Figure 1 may be an example of his work.

HARRIS, SARAH JANE AYERS (CA. 1839–1918)
The full range of traditional Catawba pottery was produced by this master potter throughout her life. Several vessels attributed to her form the nucleus of the McKissick Museum collection. Several photographs show her working in clay. No signed vessels have been located.

HARRIS, WALTER (1946–)
Inspired by the Yap Ye Iswa Festival and has sold there since 1993. Makes a full range of traditional pieces. An odd piece that he makes is a so-called buzzard pot taken from drawings and photos of archaeological pieces given to the potter by collector Larry Ware of Gastonia.

HARRIS, WILLIAM (BILLY BOWLEGS) (1857–1922)
Reportedly made horse effigies. May be the maker of a horse effigy pot in the Museum of York County collection. Two horse effigy pipes in the Simpson Collection of Rock Hill may be from his hands. No signed pieces or pieces attributed to him by museum acquisition records have been located.

HARRIS, FLOYD WILLIAM (1953–)
Made an occasional piece, beginning about 1977, under the tutelage of his grandmother, Georgia Harris, a master potter.

HEAD, MARTHA JANE PATTERSON
(1868–1970)
Reportedly made traditional Catawba pottery until her family removed to Colorado in the 1880s. One turtle effigy pipe found at her old home site has been attributed to her hands. Did not make pottery in Colorado.

HENDERSON, NICK (1978–)
Learned under the tutelage of his mother, Anita Hinson, and his great-grandmother, Catherine Canty.

HINSON, ANITA CANTY HENDERSON
(1959–)
This new potter is already making a reputation for herself. Learned from her grandmother, Catherine Canty. She also grew up watching Arzada Sanders work in clay.

JONES, GAIL BLUE (1947–)
Began to make traditional pottery following her participation in the Class of 1987. All work signed.

LEACH, MIRANDA (1984–)
Learned the rudiments of pottery making from her mother, Cheryl Sanders. The subject of a video made by the Mint Museum, Charlotte, North Carolina.

LEAR, FAYE ROBBINS BODIFORD
(1930–2000)
Worked in clay with the Robbins family until she married and left home. Made some signed vessels just before her death.

McKELLAR, BILLIE ANNE CANTY
(1945–)
Began to make traditional pottery following her participation in the

Class of 1976. This master potter worked under the influence of her mother, Catherine Canty, and Georgia Harris. All work signed.

MORRIS, ANNE SANDERS (1949–)
Began work in the Class of 1976 and produced a limited number of signed pieces for several years thereafter.

NICHOLS, DENISE FERRELL (1954–)
Began to make traditional pottery following her participation in the Class of 1976. All work signed.

OSBORNE, DAWN McKELLAR (1971–)
Began to make a limited number of vessels under the influence of her mother, Billie Anne McKellar, and her grandmother, Catherine Canty, ca. 1992. All signed.

OSBORNE, SHERRY WADE (1942–)
Produced a limited number of traditional pieces in the mid-1970s. All signed.

OWL, SUSANNAH HARRIS (1847–1934)
A celebrated master potter. Produced the full range of traditional Catawba pottery throughout her life. No signed vessels have been located but museum acquisition records show many vessels from her hands. Several heirloom pieces are treasured by her family.

OXENDINE, DELLA HARRIS (1944–)
Began to produce small traditional Catawba pottery vessels under the influence of her mother, Nola Campbell, ca. 1987. All work by this master potter is signed.

PLYLER, DONNIE (1959–)
Began to produce small traditional Catawba pottery vessels in the 1990s. All work signed.

PLYLER, ELIZABETH (1928–)
Began to produce traditional Catawba pottery vessels following her participation in the Class of 1987 and quickly moved to the rank of master potter. All work signed.

PLYLER, LEONARD (1934–)
Makes occasional pieces, especially for the annual Yap Ye Iswa Festival.

PLYLER, MARY RACHEL BROWN (1907–1955)
Produced the full range of traditional Catawba pottery throughout her life. Several family heirloom pieces have been located. Known by her contemporary Catawba to have been a master potter.

PLYLER, PHILLIP (1964–)
Makes occasional vessels, especially for the annual Yap Ye Iswa Festival.

ROBBINS, EARL (1921–)
A celebrated master potter known for very large vessels and pipes. Made pottery for the Cherokee trade until that market faltered in the 1960s. Resumed work in clay in 1987. Known for his pipe molds and sought out by the Catawba who wish to obtain molds. He has taught the making of pipe molds to a number of young potters, insuring the survival of this skill well into the twenty-first century. All work signed. Several museums have acquired his work.

ROBBINS, EFFIE HARRIS (1892–1972)
Produced the full range of traditional Catawba pottery for the Cherokee trade until that market floundered in the 1960s. Not known to have signed her work. No museum collection is known to have any of her vessels listed in its acquisition files.

ROBBINS, VIOLA HARRIS (1921–)
Produced the full range of traditional Catawba pottery for the Cherokee trade until that market floundered in the 1960s. Resumed work in clay in the early 1980s and began to sign her work at that time. Several museums have acquired her work.

SANDERS, ARZADA BROWN (1896–1989)
A celebrated master potter. Produced the full range of traditional Catawba pottery throughout her life. Began to sign her work in the 1970s. Several museums have acquired her work. She is the only contemporary Catawba potter with examples of her pottery in the Smithsonian collection.

SANDERS, BRIAN (WARREN) (1951–)
A master potter who produces both museum quality pieces and vessels of trade ware quality for quick sale. Learned from his grandmother, Arzada Sanders.

SANDERS, CAROLEEN (1944–)
This master potter began work ca. 1992. Gaining a reputation as a sculptor of note with a concentration on busts of historic Catawba figures. Also produces traditional Catawba vessels. All work signed. Caroleen Sanders is the first Catawba potter to have a Website.

SANDERS, CHERYL HARRIS LEACH
(1958–)
The wares of this master potter are
exceedingly thin and of exceptional
grace. Her work is much sought af-
ter by both collectors and museums.
Learned from a number of master
potters including Nola Campbell
and Earl Robbins.

SANDERS, CLARK (1947–)
Began work ca. 1992. Small signed
pieces produced.

SANDERS, E. FRED (1926–)
Learned pottery making from his
mother, Arzada Sanders. Produces
an occasional signed vessel.

SANDERS, FREDDIE (1958–)
A master potter who began by carv-
ing traditional Catawba shapes in
stone. He produces a regular suc-
cession of high quality ware.

SANDERS, MARCUS (1960–)
This master potter works in medi-
ums other than clay including wood.
He has never sold at any market.
His work is in great demand among
the Catawba.

SANDERS, MARTHA HARRIS
(CA. 1859–CA. 1900)
A celebrated master potter who pro-
duced the full range of traditional
Catawba pottery throughout her life.
One vessel has been documented
as hers. No heirloom or museum
pieces attributed to her through ac-
quisition records have been located.

SANDERS, VERA BLUE (1909–1990)
Produced small vessels for the North
Carolina mountain trade. Probably
stopped making pottery in the 1960s.

Made a limited number of pieces for
family members in the late 1980s.
No signed pieces have been located.

SANDERS, VERDIE HARRIS (1902–
1996)
Produced pottery for the North Caro-
lina mountain trade until the 1960s.
Resumed making pottery again in
the late 1980s. All late pieces were
signed.

SIMMERS, JAMES (1950–)
Produces an occasional vessel. His
work is praised by his fellow Ca-
tawba.

STRICKLAND, PEARLY AYERS HARRIS
(1907–2001)
Produced pottery for the North Caro-
lina mountain trade until the 1960s.
No signed pieces have been located.
No family collections have been lo-
cated.

THOMAS, GLADYS GORDON (1921–
1972)
Worked with her mother, Eliza Har-
ris Gordon, for many years. The
Thomas family may have examples
of her work. No signed pieces or
pieces attributed to her have been
located.

TUCKER, MARGARET ROBBINS (1957–)
This master potter has always worked
with her parents, Earl and Viola Rob-
bins. Began to sell her wares in the
early 1990s. All work signed.

TUCKER, MATTHEW (1979–)
Began working with his mother and
his grandparents, Earl and Viola Rob-
bins, as early as 1987. Began to pro-
duce more serious efforts in 1994.
All work signed.

TUCKER, SHANE (1982–)
Began working with his mother and his grandparents, Earl and Viola Robbins, as early as 1987. Began to produce more serious efforts in 1994. All work signed.

VINCENT, RUBY AYERS BROWN (1928–1997)
Produced pottery for the North Carolina mountain trade until the 1960s. Resumed work in clay ca. 1989. All work signed from this point on.

WADE, FLORENCE HARRIS GARCIA (1922–)
Produced pottery for the North Carolina mountain trade until the late 1950s. Resumed work in clay in 1989. All work signed from this point on. Extremely active in school demonstrations.

WADE, FRANCES CANTY (1924–)
Worked with her mother, Fannie Canty, as a child. Began some serious work in clay as early as 1975. Produces a limited number of signed pieces.

WADE, SALLIE HARRIS (1895–1990)
Produced small pieces for the North Carolina mountain trade. Stopped working in clay in the 1960s and did not resume. Several damaged discards are treasured by tribal members. No signed pieces located and no vessels have been found attributed to her in museum collections.

WAHOO, SALLIE (CATAWBA SURNAME UNKNOWN) (CA. 1810–CA. 1889)
Married into the Cherokee tribe and continued to make very traditional Catawba pottery throughout her life. Mann S. Valentine collected a number of her large cooking pots for the Valentine Museum in Richmond, Virginia. Today these vessels are divided between the Museum and the Department of Archaeology at the University of North Carolina at Chapel Hill. Sally Wahoo did not sign her work, but it is distinctly noticeable for its lack of European influences.

WHEELOCK, ROSIE HARRIS (1880–1935)
Began serious work in clay ca. 1900 and maintained a pottery trade until her death. No signed pieces have been located, but a large number of vessels by this potter are in museum collections. Family members treasure several examples of her work.

WHITESIDES, CHARLIE (1976–)
This beginning potter learned to work in clay under the watchful eye of his grandmother, Ruby Vincent.

WILSON, CLAIRE SANDERS AMANES (1941–)
Makes pottery on occasion. Learned from her mother, Sara Lee Ayers.

7 A Native Resource, Clay

The Catawba potters use two types of clay, pipe clay *(wimisûi"to)* and pan clay *(i"toitús)*. Although the original Catawba-language terms are no longer common knowledge, the clays retain their separate identities. Pipe clay is often used alone but only to make small objects like pipes, hence the term pipe clay. It must be mixed with pan clay to make large vessels like pans, hence the term pan clay (Harrington 1908).

Both clays are dug from pits that have been in use for a very long time, probably centuries in the case of the pipe clay holes located in Nisbet Bottoms. From about 1960 to the present, these clays came almost exclusively from two single locations separated from each other by several miles. At one time, however, the Catawba drew from much wider resources. When their land base included parts of the two Carolinas and they hunted as far away as Ohio (Brown 1966:13–16, 191), and went to war against the Iroquois Confederation in New York (McDowell 1958), the Catawba most likely knew of clay resources in much of the east. Although the Catawba traveled less after the American Revolution, those Indians who peddled the plantation circuit early in the nineteenth century knew of clay resources within much of South Carolina. They definitely used clay holes between the Nation and Charleston. William Blanding documented one such location in the 1840s when he described the Catawba's interest in Pine Tree Hill, modern-day Camden. Blanding declared that, "a very fine description of clay is found at this spot, which is resorted to by the Catawba Indians every spring and autumn, for the purpose of manufacturing pottery from it" (Blanding 1848). Blanding did not know that the Catawba King Hagler had once lived at Pine Tree Hill (*South Carolina Gazette*, 3 May 1760a:2; Bull 1771), and that the Catawba had a long political interest in the place (Waddell 2001). Today, as a result of difficulties surrounding the settlement of the Catawba land suit in 1993, the Catawba have expanded their knowledge of local clay resources.

As the Catawba world was reduced in both land holdings and population, the Indians' knowledge of clay resources away from their immediate community diminished. The potters active in the last quarter of the twentieth century seemed to know of far fewer clay holes than the potters who were active at the end of the nineteenth century. For instance, according to Harrington, the Catawba were using eight clay deposits in 1907. Pipe clay was taken from King's Bottoms, then called Johnston Bottoms (Nisbet Bottoms), and four holes on the reservation: the Ben Harris, Brady, Deerlick, and Patterson Bottoms clay holes. All the Indians considered the reservation resources as inferior. These were used only when clay was needed and King's Bottoms was not accessible. In addition, three equally fine pan clay holes were visited. One was located on the Collins farm adjacent to the reservation. The second was the Blue Clay Hole near the ferry landing on the east side of the Catawba River. The third clay hole cannot be identified today (Harrington 1908).

The Catawba are secretive about their clay sources. Few outsiders interested in the tradition are taken to the clay holes. Fewkes, for one, was never shown the pan clay source (Fewkes 1944:73). According to Carrie Garrison, who had a long interest in the Catawba dating from the early 1900s, the clay holes have always been a carefully guarded secret (Carrie Garrison, interview, 27 January 1977, BC). In the mid-1970s, when Allen Stout of the Schiele Museum shot a documentary film on Doris Blue's work, he wanted to show the potter digging clay. Doris Blue was keenly interested in helping Stout, yet she was reluctant to divulge the location of the clay holes. As a result, Doris Blue took the camera crew to the river bottoms by a long and deliberately confusing route (Allen Stout, interview, 1977, BC; Stout 1989). Today, when photographs of the Indians digging clay appear in the press, these still shots are actually staged at locations far from the clay source. The real clay holes, as a rule, are not shown to outsiders. A fear that a particular clay resource might run out causes this secretiveness. Twice, at the beginning of the twentieth century and again in the 1930s, the Catawba experienced very real threats to their clay resources from the outside world.

NISBET CLAY HOLES

The preferred primary pipe clay source and that of most historical importance is located on the east side of the Catawba River near the village of Van Wyck. The place is central to the Waxhaw Old Fields, and the Catawba have a long attachment to it. The Treaty of Pine Tree Hill (1760) provides a clue to the solution of this contemporary attitude to-

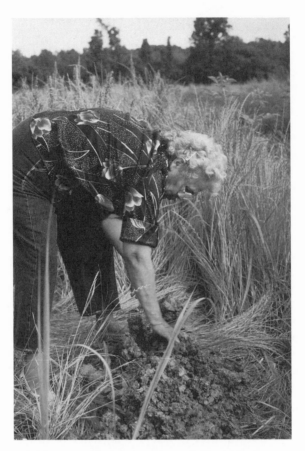

Figure 4. Evelyn Brown George picking clay in
Nisbet Bottoms. (Photo by Thomas J. Blumer)

ward the river bottoms where the Catawba clay is found. The Treaty
called for the Catawba to remove from Pine Tree Hill, formerly called
Cofitachiqui or Canos (Waddell 2001) and called Yupaha by the Catawba
(Blair Rudes, interview, 2001, BC). Today the place is known as Camden.

The new location called for by the Treaty, centered around modern-
day Rock Hill, was acceptable to the Indians for one basic reason.
When they moved near the clay holes, they were removing to the graves
of their ancestors (Treaty of Augusta, 1763) located in the heart of the
Waxhaw Old Fields. Following the Treaty, the Catawba villages were
clustered as close as possible to the most sacred ground.

The clay holes in this area are of paramount importance to the pro-
duction of Catawba pottery, but these bottoms contain the most fre-
quently threatened clay source. The Indian paranoia concerning this
site has been heightened several times during the last century.

In 1905, an alarm went up among the Indian potters who had learned that Wedgwood Pottery was visiting the bottoms in search of clay (*Rock Hill Herald*, 25 October 1905b:3). In reality this plan never materialized, yet it left a lasting impression on the potters. While it made them ever more keenly aware of the quality of their clay, the episode made them realize that others knew of their clay's fine quality. Why would foreigners cross the ocean in search of clay? If foreigners would do this, so would others (Doris Blue, interview, 21 January 1977, BC). Also during this period, the Ashe Brick Company began operations in the bottoms not far from the clay holes (Lindsay Pettus, interview, 8 January 2003, BC). This commercial operation dug more clay in an hour than the Indians took in years. Almost a century later, this commercial effort continues to thrive and is a constant reminder to the potters that their clay resource could be exhausted in a short time.

In the 1940s, yet another threat to the clay holes materialized. Soon after the Cherokee educated a number of Cherokee potters in the art of making Catawba wares, the Cherokee reservation clay source located at the Macedonia Church was exhausted. The tourist trade and the pottery business were at their height, and in response to a need for clay, the Cherokee acted with speed. A team of men obtained a truck and visited Lancaster County with the intent to carry as much Catawba clay home to North Carolina as possible. The Catawba potters learned of this Cherokee goal and petitioned the landowner, Beulah Nisbet. She ended the entire matter when she proudly declared that the clay was for "her" Catawba Indians only. The Cherokee were turned away. The Cherokee potters have resorted to commercial clay ever since (Doris Blue, interview, 21 January 1977, BC).

Another factor that contributes to Catawba fears concerning the pipe clay holes is that the Indians have not owned the bottoms since 1840. The Indians trespass to obtain their clay. The informal agreement between the Indians and a succession of landowners has been honored except for a brief period during the land suit. From 1979 to 1993, the Catawba land suit caused stressful relationships between the Indians and many of the landowners in the claim area, especially those who had large holdings. The Catawba potters lived with a fear that the clay holes might become an issue and they would be turned away. Depending on the feelings of the moment, access to the clay holes became increasingly difficult. At times the potters were forced to wait for as long as a year for tempers to cool before they were permitted to trespass and dig clay. In 1990, the long-feared landowner reaction occurred. The Catawba were barred from their most ancient clay resources in Nisbet Bottoms for almost three years. The governor of South Carolina turned a deaf ear to the Indians' pleas. Those concerned about the survival of South Carolina's most valuable folk art treasures

were rendered ineffectual (Blumer 1993b). Few South Carolina employees tried to help the potters.

The Indians met this crisis with positive action. The Catawba Cultural Preservation Project organized expeditions to locate clay pits on the reservation. The Catawba Potters' Association, under the leadership of Frances Wade, searched for clay. Individual potters intensified their efforts to find alternate clay sources. Sympathetic landowners brought clay samples from their farms for the Indians to test. The Catawba met with some success. During this period, the Robbins family located an alternate pan clay source near Camden, South Carolina, and Fred Sanders located a promising pipe clay source on the reservation. The McKissick Museum provided funding for the elder potters to employ men to go with them and dig for clay in likely places. Staff from both the Schiele Museum and the York County Museum encouraged the potters to keep looking for clay and often accompanied them on clay-hunting expeditions. Only one archaeologist in the employ of South Carolina, Chris Judge, dared to come forward in defense of this ancient art form.

During this period, the Indians gained many new non-Indian friends and learned of numerous alternative clay resources. Still, they longed to return to the clay used by the old Indians located in Nisbet Bottoms. Eventually, Earl Robbins and his sons, Bradley and Frank, located a new pipe clay resource on Bowater Company land in Lancaster County and successfully obtained permission to dig there. It was tested by the master potters and pronounced better than adequate. Some felt it was superior to the clay found in King's Bottoms, but it was not the same. Others did not agree. Any clay not coming from Nisbet Bottoms was inferior. Although the Indians were not totally satisfied with the situation, pottery production resumed once again, and the young potters continued their learning process. In 1993, after the Catawba reached a settlement of the land issue and the U.S. Congress passed the Catawba Settlement Bill, the pressure was off and tensions were eased in the claim area. The potters were soon welcome to return to their ancient clay holes. Today they gain access to the bottoms by appointments made with the Nisbet family. The Catawba seem comfortable with returning to their ancient clay holes in King's Bottoms under a new, yet traditional, informal agreement.

In March 1992, at the very time the Catawba were the most concerned about their clay holes, the Katawba Valley Land Trust was founded. This organization was established by a charter under the laws of South Carolina. Its purpose is to protect lands adjacent to the Catawba River, including the Nisbet Bottoms. Today the Trust has 3,000 acres under some form of protection (Lindsay Pettus, interview,

8 January 2003, BC). If the clay holes are ever threatened again, the Trust may become a much-needed ally for the Indians in their efforts to protect their clay holes.

In 2000, the Catawba potters were startled to find that the tribe's administrator, Chief Gilbert Blue, and his Executive Committee, not outsiders, threatened their clay holes. These latter individuals had been elected to look after the tribe's best interests. This new problem came from a Catawba-sponsored sewer line project that was to run from Charlotte to a location south of the reservation. If it became a reality, it promised to lay a huge sewer pipe through the entire length of the Waxhaw Old Fields. Nisbet Bottoms was on the list of places slated for destruction ("Alert" originally published on the South Carolina Traditional Arts Network, 28 September 2000, BC; "Nisbet Bottoms: A Catawba Treasure Trove," October 2000, BC). State archaeologist Jonathan Leader, referred to the Waxhaw Old Fields as containing the most valuable archaeological sites in South Carolina. At one meeting, he posted an archaeological map for his audience to see and declared that the map might be the closest thing to a pinup an archaeologist could imagine (Donna Lisenby, interview, 2000, BC). Fortunately, for the survival of the ancient Catawba pottery tradition, this sewer line proposal failed. At the moment, the Catawba clay holes located in Nisbet Bottoms appear to be safe.

Perhaps the greatest threat to Catawba clay resources comes from urban sprawl from nearby Rock Hill and Charlotte. The Katawba Valley Land Trust was formed as a reaction to urbanization. Every time a development becomes a reality, possible clay sources are lost to the potters.

THE BLUE CLAY HOLE OR PAN CLAY HOLE

For many years, the Blue Clay Hole was the most important resource for the only contemporary tempering medium used by the Catawba potters. This type of clay must be used if the potter is to make vessels larger than pipes and if the vessel is to remain erect during the building and early drying process. Blue clay has no elasticity and would be discarded as worthless grit by anyone not knowledgeable of clay and pottery making. It is often a rich gray color. Blue Clay Hole is located on the east side of the Catawba River, down river from Van Wyck, in Lancaster County. From testimony provided by the Indians, the hole has been in use for at least a century, but it may be much older.

The Blue Clay Hole is not far from the ferry landing once manned by John Brown. Indeed, even if the site is recent, it may have originally been found by the Indians who ran the nearby ferry. The mine itself is on a bend of a creek trapped in a gully, and the clay has apparently

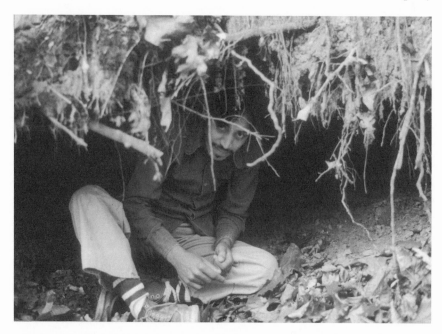

Figure 5. Larry Brown sitting inside the Blue Clay Hole, Lancaster County, South Carolina. (Photo by Thomas J. Blumer)

always been removed from the gully wall. The roof of the resulting shallow cave has occasionally collapsed. As a result, before the cave's entrance is a small shelf corresponding to the turn in the creek bed. For much of the year the creek is dry. When the roof of the cave is obviously weakened to the danger point, the Catawba dig a new secondary hole on either side of the cave's mouth. This new excavation is then used until the cave becomes dangerously unstable again.

Following Hurricane Hugo in 1989, the potters found it difficult to gain access to the Blue Clay Hole. The hurricane caused great damage to the forest in which the clay hole is located, and the potters looked for a source with easier access. This clay hole has perhaps been abandoned.

Camden/Robbins Pan Clay Hole

This clay was found by Bradley Robbins during the land suit, as an alternative to that taken from the Blue Clay Hole. It gained importance following Hurricane Hugo and today may be the potters' major source for pan clay. Since Bradley's family is deeply involved in pottery making, he is ever on the lookout for new clay sources. This was particularly true during the 1990–1993 crisis precipitated by the land suit. He

found the clay, brought a sample to his parents, and they approved its quality. Today many of the potters resort to this source located not far from Camden (Earl Robbins, interview, 1993, BC).

MINOR AND LOST CLAY RESOURCES

The Catawba still know some alternate clay holes by name or vague location. Doris Blue remembered a lost clay hole: "I remember they used to come down below Edna's to get clay below where we lived then. [Sarah Harris] was a tall lady, and all the old ladies were so thin, so slim. These old ladies would come down the hill going down below Edna's to get clay and all of them would have these skirts on and long aprons. They'd go down there and get their clay, and each of them would come back with their aprons folded up. The clay would be in their aprons, and Aunt Sarah, we always called these old ladies aunt, was one of them" (Doris Blue, interview, 20 March 1980, BC). Although this clay resource was used by the older generation, the last of whom died in the 1960s, its location is now lost. Between 1979 and 1993, several unsuccessful attempts to locate this unnamed clay hole were made.

A second lost clay hole is located below the house site now occupied by the Robbins family. Although its general location is known, this resource remains unused. Earl and Viola Robbins prefer to cross the river and dig clay at Nisbet Bottoms (Earl Robbins, interview, 13 May 1987, BC). A clay hole is easily lost in a forested area. The trees grow quickly and appearances change from season to season. A path may be altered, overgrown with weeds, and one layer of autumn leaves will easily cover a clay hole.

A pipe clay hole that is no longer used but is well documented is the Deerlick Clay Hole. It was located in a ditch along the main reservation road (now Indian Trail Road) not far below the junction of Indian Trail and Tom Steven Road. According to Edith Brown, the Deerlick Clay Hole was covered when the road was paved (Edith Brown, interview, 21 April 1977, BC). According to some informants, a side road named Deerlick Road may mark this location (Earl Robbins, interview, 11 May 1987, BC). The Ben Harris Clay Hole is another named source. This pipe clay hole was named for its owner/finder. It was abandoned in the 1960s when Ben Harris's daughters stopped working in clay. By all accounts, Ben Harris clay was of a good quality (Edith Brown, interview, 21 April 1977, BC).

Two additional pipe clay holes that have been lost in recent years are the Patterson Bottoms and Brady Clay Hole. The Patterson resource was once used by Edith Brown and was probably either owned by or

found by a member of the Patterson family (Edith Brown, interview, 21 April 1977, BC). More is known about the Brady Clay Hole, which was named for Nancy Harris Brady who went west at the turn of the twentieth century (Georgia Harris, interview, 15 April 1977, BC). Georgia Harris recalled that pieces made from this pipe clay burned a lovely red: "I visited the Brady Clay Hole as a child once. I know where it might be, but I could never find it. Edith Brown and Richard Harris say they could find it, but I doubt that seriously" (Georgia Harris, interview, 16 February 1977, BC). The problem with the Brady Clay Hole is that the clay was found in a drainage ditch in an open field (Edith Brown, interview, 21 April 1977, BC). Today this area is forested. If the bottoms are ever cleared for farming again, the Brady Clay Hole may be found.

Another major pan clay hole abandoned by the potters in recent years is the Collins Clay Hole. It was located a short walk from the reservation. All of those who used Collins clay praised its quality. Edith Brown recalled going there with her grandmother, Sarah Harris: "That was good clay. The pan was white, and it had lots of little bones in it. You had to pick them out. I don't know what they was. We called it bones. It was stiff clay" (The term "stiff" refers to the ability of the clay to stand up during construction) (Edith Brown, interview, 21 April 1977, BC).

During the 1970s, Georgia Harris located and used a vein of pan clay in a drainage ditch along the road in front of her home. Located just a few yards from her door, this source solved some problems in obtaining pan clay. It is similar to Blue pan clay in quality. Mrs. Harris preferred to take her pan clay from the Blue Clay Hole in Lancaster County (Georgia Harris, interview, 24 March 1977, BC). She was also concerned that this hole might become known and the potters would come digging clay in her yard.

VISITING THE CLAY HOLES

Catawba digging methods also illustrate how clay sources are easily kept hidden and even lost. Today, that section of Nisbet Bottoms of interest to the Indians is a large cultivated field, and each potter has favorite digging areas within the bottoms. These locations constantly shift. The potters dig clay and fill in the hole. It is not likely that they will even tell other potters of a particularly good find. It stands to reason, if a potter finds a new source, its location may never be divulged. Not knowing the extent of the vein of clay, the potter's fear is that a limited supply might be quickly depleted.

Changes have come about in visiting the clay holes in the last cen-

tury. Before the introduction of the automobile in the 1920s, all the Indians visited the bottoms by boat or occasionally by wagon. Both methods had advantages and disadvantages. "We used to cross the river in a boat—go to the clay hole and dig our clay and put it on our backs and carry it back to the river. That wasn't no short walk from the clay holes to the river either. . . . We'd carry and sometimes we'd have to make two or three trips back. The clay was damp and wet, and you couldn't carry a lot" (Georgia Harris, interview, 20 March 1980, BC). To make this approach easier, the Indians sometimes left a mule and a wagon on the reservation side so the clay would not have to be carried the last stage in the trip on their backs. The only alternative to this laborious method was to use a wagon. "We would have to go then clear around by the old ferry where John Brown's ferry would be. It was an all day trip, and we'd have to take lunch, and we'd get a bunch of people. We'd have three or four wagons, and we'd go all the way . . . up by Van Wyck, back up to that place" (Doris Blue, interview, 20 March 1980, BC).

Some potters have always worked at a great disadvantage. Individuals who have few family members to help have difficulty visiting the clay holes and often have no one to send in their place. This is true of the elderly and those who live alone. Such was the case with Edith Brown. When she first began to make pottery, she relied on clay provided by her in-laws, Rachel and John Brown (Edith Brown, interview, 21 April 1977, BC). She had fortunately married into a family that was very involved in pottery making. Other potters, particularly those who married out of the tribe, had more serious problems obtaining clay. Lula Blue married Major Beck who was from a Cherokee family in northern Georgia, which had strong affiliations with the Cherokee at the Qualla Boundary. Major Beck gained his appreciation for the Catawba tradition after he married. This fact may or may not account for his reluctance to dig clay for his wife. "Well, Daddy never would go get none for Mama. What little bit she'd get, she'd get from somebody. She'd go over here to this Collins place; . . . I remember her and Eliza Gordon going over there and getting it. But I don't know why Daddy didn't go and get her clay. But she didn't ever let us fool with clay because she never did have a lot of clay like some of them would. Just have a tub full at a time. And she'd just have a little bit, so I figured that's why she never let me fool with it" (Louise Bryson, interview, 15 June 1985, BC). The situation experienced by Fannie Canty was also unique. For much of her life, this potter had to either dig her own clay or depend on others to get clay for her. It is not surprising that she treasured what clay she had, and all of her children remember clay as a precious commodity. Alberta Ferrell was most graphic:

"Mama [Fannie Canty] would not let us kids fool with her clay. She would not waste it. It was too hard to get. We went for the clay in boats. Once she got to the other side of the river, she could only carry so much back at a time. We were not allowed to play with it at all" (Alberta Ferrell, interview, 22 February 1977, BC).

The potters are also quite particular about the quality of their clay. For instance, Doris Blue spoke of her mother's attitude: "Rosie Wheelock knew good clay and did not want any dirt in her clay" (Doris Blue, interview March 20, 1980). Georgia Harris is more emphatic when she talks of her grandmother, Martha Jane Harris. This potter would not entrust this crucial task to anyone other than herself. She alone knew what quality clay she needed and acted accordingly:

> We'd take some man along or sometimes Jesse would go. He'd dig the clay a lot of times, but my grandmother, you never could please her about her clay. She'd have to dig that clay. She'd let them clean the hole out. Then, when it got down to digging the clay out of there, she got down and dug it herself. Nobody could dig clay to suit her. It had to be right when she got it. It couldn't have no grits in it, and it didn't. It had to be free of all the dirt. She even picked it before she put it in the sack. And if there was any dirt in it, she'd pick it and throw it away. Had to be pure clay when she got it. (Georgia Harris, interview, 20 March 1980, BC)

In ancient times, the Catawba depended on fire-hardened digging sticks and shell and stone implements. In many cases the clay holes were no doubt visible outcroppings that were left open. As soon as iron tools became available, the Catawba pragmatically shifted to shovels and discarded their digging sticks. Today, the Catawba use garden tools to dig clay. Once the men have reached acceptable clay, a quantity is thrown out of the hole. The waiting potters then pick the clay, remove veins of dirt and any large impurities. Martha Jane Harris called this "picking the gold" (Georgia Harris, interview March 1977). The selected clay is then loaded into sacks and buckets and taken home.

Before the development of the North Carolina mountain trade in the 1920s, the Indians seemed to prefer clays that burned a mottled red color. Today the potters seek clay that will burn a mottled gray, sometimes nearly white. The apparent reason for this shift from red to gray clay is a matter of taste. Contemporary potters will use red clay. Knowledge of this trend often helps in dating a vessel.

PROCESSING THE CLAY

As already pointed out, obtaining and processing the best clay has always been a problem for the potters. Changes are reluctantly made.

During the early part of the twentieth century, the Indians were still beating their clay and thus removing impurities exactly as their ancestors had done for centuries. The Brown family demonstrated this method for Harrington. "When the material had been brought in, John placed some of the moist pipe clay upon a little platform of boards, and began to pound it with his pestle. . . . As the clay flattened and spread under this vigorous treatment his wife turned it back toward the center of the board, deftly picking out bits of stick and stone the while. As the pounding continued, dry pan clay and water were added until the proper proportions—about two parts of pan [pipe] clay to one of pipe [pan] clay—were reached, and the mass had attained the proper consistency" (Harrington 1908:403).

Although the Indians abandoned beating their clay shortly after Harrington's visit, many of them recall the process with nostalgia:

> Back when I was little, we didn't have no cars, and I went with my grandma Sarah Jane Harris. We would get our clay on the reservation, and we took a knife and sat at the hole and picked it out and put it in a sack and carried it home. It was not sifted and mixed with pipe clay. We beat it on a board with a maul. It was rounded on the ends and a little in the middle to fit the hand. You could beat with either end. Then we put the clay in a cloth and sat in the shade and picked it. Took out all the roots, gravel, strings. I can see my grandmother where Frances [Wade] lives. It was a log house then where the frame house is. There were two big cedar trees and a big sycamore tree. We never sifted or strained at all. (Edith Brown, interview, 21 April 1977, BC)

In Doris Blue's childhood home, a similar process was followed, but the Wheelocks had a "board which was like a large tray." The clay was beaten on this tray and its sides kept the clay from spreading to the ground and picking up dirt and other impurities. The two kinds of clay were beaten together. The pipe clay was beaten and picked fresh from the clay hole while it was still elastic. The dry pan clay was slowly added to the pipe. The beating continued until the clay reached the proper consistency (Doris Blue, interview, 15 March 1977, BC).

Harrington was possibly around too early to record an innovation that would eventually do away with the time-consuming process of beating the clay, but the transition from the old method to the new began early in the twentieth century. Almost as soon as window wire became available the potters began to soak and strain clay through a wire as an alternative to beating. The Catawba are not able to point to a date for this occurrence because the actual transition from beating to straining was slow, probably due at least in part to the cost of window wire. Also, window wire does not last long once it is exposed to

wet clay and hence has to be replaced frequently, adding cost to the process. It is quite conceivable that a family might use the two methods interchangeably depending on the availability of wire, at least until window wire became a universal part of the average Catawba home. Martha Jane Harris is recognized as the potter who discovered this labor-saving method (Furman Harris, interview, 19 April 1977, BC).

> Originally the Indians started out with one kind of clay and used the pipe clay for pipes only and added the pan clay for big pieces. My grandmother, Martha Jane Harris, said the old method was "too shorty," and she went to combining the two right away. She mixed them. The pieces stood up better, stronger, and she passed the idea on to all the people. Then we used to beat the clay, and Epp Harris made a hickory log maul for grandmother to beat her clay and pick out the gravel and roots. Again grandmother looked for a better way to do it, so she soaked it in a tin tub, say for several days or a week, then she got a wire from a window screen, dug out a hole in the ground in the yard, lined the hole with rags and oil cloth—denim to protect the clay from getting dirt in it and poured the clay over the wire and strained it out and all the trash came out. She let it dry right there, and if a rain came she would cover it right up. She was pretty good at new things. (Furman Harris, interview, 19 April 1977, BC)

Furman Harris divides his grandmother's contributions into two distinct parts. Evidently, at the end of the nineteenth century the Catawba only added pan clay if and when they planned to construct large vessels. Otherwise, they worked exclusively with pipe clay. Martha Jane Harris saw the futility of halting the building process to mix the clay and mixed all her clay by the same formula. Then, as soon as window wire became available, this inventive potter eliminated the exhausting method of beating the clay. Once she poured her clay into her makeshift strainer, the sun and the cloth liner did the work. The water left the clay both by seeping into the ground and evaporating. Martha Jane Harris saved her energy for building pottery.

Today the straining process still follows Martha Jane Harris's method. Georgia Harris learned to strain clay from Martha Jane. She first allows the clay to dry. Then the proper proportions of the two clays are measured and submerged in a tub of water. In May 1977, Mrs. Harris strained a large batch of clay. One portion had already been processed and had dried. It was ready for use. This clay was placed in a plastic bag where it would retain its moisture and elasticity. The potter then prepared a makeshift wooden frame to both support some old sheets and provide a sort of primitive container large enough to hold the drying clay. The sheets rested on the ground so the water would leech out.

The frame consisted of pieces of firewood laid out in a rough square. It was leftover wood I had cut for a burning. Over this frame, Mrs. Harris had placed a double thickness of white sheets. The cloth was shaped into a tray-like affair and was ready to take the straining of clay. The clay was strained with a makeshift fragment of window wire which was placed over the frame and supported on one side by a board. The clay had been soaking in a large tin tub, and Mrs. Harris mixed the solution to make certain the pan and pipe clays were thoroughly mixed. She then scooped up the liquid with a tin can and poured it over the wire. The clay's impurities gathered on top of the wire. When the whole process was completed, the impurities were strained a second time to make certain no usable clay was wasted. After the second straining, the impurities were tossed aside on the grass. This process was continued until the tin tub could be lifted and its contents poured out onto the strainer. (Field Notes, 11 May 1977, BC)

The only real difference in this process as it is practiced is in the quantity of clay handled at any given time. Martin Harris mixed his clay in a 50-gallon drum (Martin Harris, interview, 21 April 1977, BC). Lula Beck had a simple approach to constructing a makeshift frame to hold the straining: "I sift my dry pan clay into my pipe clay and mix them together. I then soak the clay for from several hours to several days, and I strain it through a piece of window wire. I put the wire on top of an old automobile tire, and I have a cloth under it to catch the clay and to keep the clay from getting dirt in it. After it is strained, I roll up the cloth and keep it moist until I use the clay. If the clay will not stand up, it is not ready to work. If it is too soft, it must dry for a couple days longer" (Lula Beck, interview, 17 March 1977, BC).

Some of the potters seldom or never use pan clay since they only make small vessels for the tourist trade. These individuals, of course, know the formula for mixing the two clays (Mae Blue, interview, 21 April 1977, BC). Jennie Brindle was one such potter (Jennie Brindle, interview, 21 April 1977, BC). Although she only customarily used pipe clay, she followed the same general straining process to remove the impurities. As a result of using only pipe clay, her larger vessels often did not stand up well while drying. Collected examples of her work are very light and porous when compared to the sturdy wares made with the two clays.

The actual mixing of the clays follows a nearly fixed formula that is roughly one-third pan clay to two-third's pipe clay. The majority of potters use this recipe. Edith Brown explained her procedure as follows: "You mix so much of pipe and so much of pan clay. I mix a tub full at a time. The pipe clay is soft when I measure it, and I use a gallon of pipe to a half gallon bucket of pan clay. I wait until it is stiff before

I use it (Edith Brown, interview, 21 April 1977, BC). If the potters use more than one-third pan clay the pieces will crack. According to Evelyn George, a potter can tell "by the feel of the clay" if the mixture is not correct" (Evelyn George, interview, 25 March 1977, BC).

Once the clay is mixed and strained, it is left in the open to dry to the proper consistency. In warm weather, this process can take about a week depending on the humidity. If rain threatens, the clay must be covered to protect it, or the potters must be prepared to lengthen the drying period. From time to time, the potter must check the clay to see if it is ready to work. This is done in a fashion similar to a baker working up a batch of yeast dough. In May 1977, Georgia Harris had a large pottery order and was eager to build the needed vessels. When she checked her clay, it was too wet. Rather than wait a day or two, she took some of the clay from around the edges of the batch. This part of the mass was usable. Since the day was hot, as the potter worked, she visited the drying clay and found that more clay could be removed from around the edge of the batch. Toward the end of the day, she declared that the clay was on the verge of becoming too dry. It was then covered to slow down the process (Field Notes, 9 May 1977, BC). During the drying, the potter must watch the clay, for a batch can be rendered unusable quickly under the hot South Carolina sun. "I'll have to say one thing about my grandmother, looking back and knowing the kind of clay she used. I'll have to say she was an expert in knowing clay. She never used but the best clay. She rarely used that which was found on the reservation, because most of the clays made only small pieces and she rarely made small pieces with the exception of pipes and ones that people ordered. She always said making small pieces was like playing. She used only the best clay, and that was the Johnston pipe clay and the blue pan clay from across the river (Georgia Harris, interview, 15 April 1977, BC).

8 Tools

Ancient and Modern Adaptations

The pottery tools currently in use among the Catawba reflect an interesting mix of the ancient and the modern. Some of these objects, simple as they are, have a history of their own, are treasured as heirlooms, and can even be the subject of a family dispute. When a potter dies, the tools are divided among the survivors. Hopefully the potters are considered first, but this is not always the case.

When Harrington visited the Catawba, the tools he selected to discuss were nearly all of ancient origin. He listed them and their Catawba names: wooden pestle *(yēbi"tu)*, mussel shell *(nuteē')*, gourd modeler *(wade)*, wooden modeler *(yēbitûsikawa)*, cane knife *(wasa')*, borer *(simpa)*, rubbing rock *(inthri'* or *turhrt')*, bone awl *(nusap)*, and squeeze mold *(wīmīsûmpadē'a)* (Harrington 1908). Harrington neglected to mention lap boards, some incising utensils, and corncobs. More serious is his neglect of tools of a recent origin. During his study period, the Catawba were also using steel knives, coconut shell modelers, tin spoons, buttonhooks, twisted wire, coins, snuff box lids, hairpins, and many other everyday objects found in the home. For simplicity's sake, these tools will be discussed in order of use.

AT THE CLAY HOLES

Today the Indians dig their clay with common garden tools. It is relatively certain that this has generally been the case since iron tools became available in the sixteenth century. Edith Brown recalled digging clay with a knife, and Wilburn Harris used any metal object, not necessarily a shovel, found in the yard (Edith Brown, interview, 21 April 1977, BC; Wilburn Harris, interview, 9 May 1977, BC). Harrington

mentioned the use of a hoe, which hardly seems an efficient tool for
taking clay from the ground. Today the shovel is the universal tool.
Once the clay is extracted, it is stored in metal or plastic buckets or
any bags strong enough to hold damp clay.

PREPARING THE CLAY

STRAINING

The wooden pestle once used to beat the clay was abandoned in the
first quarter of the twentieth century. The boards and shallow traylike
receptacle used for beating clay, photographed by Harrington in 1903
and recalled by Doris Blue, have also gone the way of the pestle. The
old beating process was replaced by window wire used to strain the
clay and thus remove impurities. Some of the Indians stretch this
wire on a wooden frame. Fletcher Beck made such a frame for his wife
Sallie Beck. It was about two-and-a-half feet square (Sallie Beck, inter-
view, 21 April 1977, BC). Earl Robbins uses a similar wooden frame
with window wire stretched over it. Many of the Indians do not bother
to build a wooden frame but resort to a loose piece of window wire
bent to hold a rough bowl shape to strain the clay.

BUILDING POTS

When Harrington worked with the Brown family, the potters worked
while sitting on the ground. They built their vessels on squares of
board held on their laps. These are called lap or pan boards. Doris
Blue explained their use: "We have never used a wheel. . . . We just use
a—shape them up with our hands. We just use little boards—square
boards or round. Whatever we find made out of a plank and we call
them pan boards. Some of the Indians call them lap boards that you
put your pottery on and shape it up. That's easy to set someplace to
dry, and when that piece of pottery is dry you just lift it off and use
the piece of board for another piece of pottery" (Doris Blue, interview,
5 March 1981, BC). The lap board has survived because it is technically
necessary. It allows the potter to turn the vessel and inspect its shape.
The vessel can also be left on this board until it is strong enough to
be moved without distorting its shape. Today the Catawba usually
work sitting on a chair rather than on the ground when they make pot-
tery, but the lap board has survived this change in work habit. The lap
board still rests on the potter's lap or even on a low tabletop. The num-
ber of lap boards vary according to the volume of pottery produced by
the potter. In 1977, Georgia Harris had eight pine lap boards roughly
one foot square. Reola Harris had three pine boards roughly the same

size. Almost any square of any wood, even plywood, is acceptable, and the potter will make additional boards as they are needed.

Tools used in building pots are simple. Those that have not retained their aboriginal substance have at least retained their aboriginal shape. For instance, originally the Indians modeled the inside of the vessel with freshwater mussel shells that Harrington mentioned (Harrington 1908). Today the potters continue to use shells, but these are often clam shells found on ocean beaches. When the Catawba gained access to coconuts, they found a natural use for the sturdy shell. Martha Jane Harris cut a modeling tool from such a shell, and Georgia Harris used it. She inherited the coconut shell modeler from her grandmother in 1936 (Georgia Harris, interview, 1977, BC). This same general shape may be improvised from a number of contemporary kitchen tools and other objects found in the home. Jennie Brindle liked to model her pottery with snuff can lids. Many Catawba pottery tool collections contain such lids. Another favorite is any large spoon. It is common for the potters to use corncobs to roughly obliterate the rolls on their vessels before they actually begin the modeling of the interior.

When Harrington observed the Brown family, they employed river cane knives to cut the paste and do some preliminary scraping on a pot that had not set completely. In the 1930s, F. G. Speck presented such a knife to Joffre Coe (Joffre Coe, interview, 1984, BC). No Catawba potter has been observed using a cane knife during the last 25 or more years, and no examined contemporary potter's tool kit contained such a knife. Instead, the potters use case knives and small pen knives to trim or scrape a rough vessel. Knives or simple sticks are used to bore holes for appendages.

RUBBING ROCKS

Perhaps no Catawba tool is treasured more than rubbing rocks. Many of these burnishing tools can be traced through several generations of owners. Most of the potters proudly recite the histories of their favorite rocks. When Douglas S. Brown interviewed Sallie Gordon, this potter claimed that one of her rocks was 600 years old (Brown 1956:217). While the potter was undoubtedly pulling a number out of her hat, some of her rubbing rocks had probably been in her family for several generations, for Sallie Gordon had most certainly inherited some tools from her mother, Margaret Brown. In turn, Margaret may have inherited at least some of her rubbing rocks from her mother and grandmother.

Doris Blue traced her most treasured burnishing stones from her great-grandmother, Rhoda Harris, and her mother, Rosie Wheelock. Doris Blue also had some rocks she had found (Doris Blue, interview,

Figure 6. Rubbing rocks used by Doris Wheelock Blue. (Photo by Thomas J. Blumer)

5 March 1981, BC). In general, each potter's collection of tools can be documented by the potter/owners. When Rhoda Harris died in 1918, her tools were divided between her surviving daughters, Susannah Owl and Betsy Harris (Doris Blue, interview, 5 March 1981, BC). Then when Betsy Harris died, her tools went to Rosie Wheelock and eventually to Doris Blue (*Evening Herald,* 29 October 1921:1). In 1985, Mildred Blue, of the fifth documented generation, inherited these tools. When Mildred died in 1997, these same tools were distributed within the family. In all likelihood, some of Rhoda Harris's tools came from her mother and grandmother (eighteenth-century Catawba), but this information has not been preserved in family tradition.

Some potters do not have rubbing rocks of any great historical value. One such potter was Catherine Canty. All of her tools, including her rubbing rocks, were those she had obtained herself (Catherine Canty, interview, 28 January 1977, BC). Louise Bryson was also in this category. There is a modern twist to obtaining rubbing rocks. Today it is not unusual for a potter to find a good stone in a rock shop, tourist shop, or even among the pebbles used to landscape a bank or restaurant garden. Georgia Harris obtained one of her rubbing rocks in a tourist shop in California, and she also purchased some on the Cherokee Reservation (Georgia Harris, interview, 19 March 1980, BC). Faye Greiner's rocks also originated in rock shops.

Some new rocks can also have interesting histories, and their stories are told with pride. For instance, Arzada Sanders often told how she found one of her best rubbing rocks when she "was 10 years old. I went down on a horse to the river bottoms and found it. I was terrible to ride a horse" (Arzada Sanders, interview, 25 January 1977, BC). Bertha Harris was given some treasured rocks by Martha Jane Harris, but she also fondly recalled hunting rocks with Martha Jane: "We used to go fishing on the sand bars—places where the water would go down. Martha Jane Harris would be along and she'd say, 'This will be a good rubbing rock'" (Bertha Harris, interview, 12 March 1981, BC).

Rubbing rocks often become central to family disputes. These problems stem from a desire to possess heirlooms of historical importance. Under the best of conditions, families manage to avoid these problems through cooperation. When Margaret Harris passed away, her daughters Eliza Gordon and Georgia Harris simply divided her tools without dispute (Georgia Harris, interview, 19 March 1980, BC). Then when Martha Jane Harris died in 1936, the same two potters divided their second inheritance of tools (Georgia Harris, interview, 19 March 1980, BC). However, problems arose when both Eliza Gordon and her daughter Gladys Thomas died. Unfortunately a large and historically important cache of tools became the property of a non-Indian who had no appreciation for them. To this day the family laments the loss of Eliza Gordon's tools (Georgia Harris, interview, 19 March 1980, BC). It is not uncommon for family members to put pressure on elderly potters to make decisions regarding the disposition of their pottery tools.

All is not seriousness with Catawba rubbing rocks. The potters tell some charming tales about particular rocks. Georgia Harris relates one such story:

> Bill [Harris] wants that rock. He says, "Grandma, that rock has history behind it, and I want that rock." I've got it yet. It was a rock, I guess it was about that [six inches] long. I believe my sister [Eliza Gordon] . . . had the other piece of it. . . . The chickens were fighting, and Epp Harris was sitting somewhere rubbing. . . . He hollered at them, and they didn't quit fighting, so he throwed the rock at them . . . and broke the rock half in two. It was slick on both ends. My grandmother kept it and used it, . . . and I use it. (Georgia Harris, interview, 19 March 1980, BC)

This treasured rock disappeared from Georgia Harris's pottery-making tools before she died. The family laments its loss (William Harris, interview, January 2001, BC).

The loss of a valued possession always causes consternation. Since rubbing rocks are nearly indistinguishable from other rocks, they are easily lost. Years after the event, Georgia Harris still recalled losing

one of her grandmother's prized rocks: "I had a white rock that belonged to my grandmother, and it was about this [three inches] big, and when we stayed up there where the chemical plant is, I lost it. I hated that I lost it. It was slick all over. You could take it and lay it inside of a pot like this and just work it like that with your hands, and just rub it cause it was slick all over it had been used so long" (Georgia Harris, interview, 22 March 1980, BC). In this case the rock was treasured both as an heirloom and because it had a superlative shape and fit the hand easily. Although the loss had occurred over 20 years earlier, the pain had not abated. In the wake of heightened interest surrounding the archaeological survey currently being conducted on the reservation, the Indians are increasingly watching the ground as they do their yard work. In the summer of 1994, Steve McKellar found a fine rubbing rock in his garden. Its loss must have been lamented by its former owner, possibly a member of the David Adam Harris family, for they had occupied this tribal land allotment before the McKellars obtained it.

Bone Awls

At times even the best rubbing rocks cannot be used to rub small hard-to-reach parts of a vessel, such as around handles. Originally, the potters used the smooth end of a bone or antler awl for this purpose. When Harrington interviewed the Browns, this pragmatic family was using ordinary bone toothbrush handles in the place of bone awls. Harrington failed to recognize these tools for what they were. Today, since toothbrush handles are no longer made of bone, some of the younger potters, in following the tradition, resort to the use of plastic toothbrush handles. The end burnishing results seem to be the same. Also, some of the potters have recently turned to deer antlers; this has happened out of availability rather than an attempt to make the tool kit appear more Indian in its contents. More recently, Earl Robbins discovered that fine bone awls can be fashioned out of the leg bone of a cow. These bones are easily obtained from local butcher shops. He has since become a tribal source for such awls, which may very well become tomorrow's heirlooms.

Incising

The Catawba often incise designs on their vessels. The best known but not the only tool used for this purpose is the shoe buttonhook. Other tools used are the ridged edges of large coins, twisted wire, knives, nails, or hairpins. Any sharp object found about the house will suffice. Once used for incising, these items usually become a regular part of the potter's tool kit. The importance of the designs used are discussed in chapter 10.

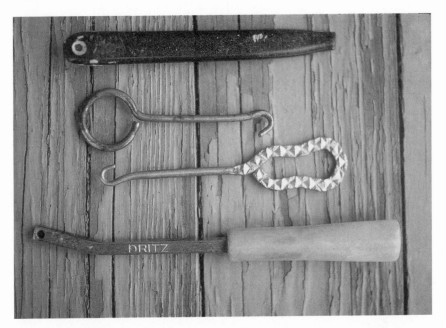

Figure 7. Incising tools used by Doris Wheelock Blue. (Photo by Thomas J. Blumer)

Storing Tools

The potters keep their pottery tools in a variety of containers including coffee cans, tin canisters, shoe boxes, cigar boxes, cloth bags, and, of course, tool boxes purchased in hardware stores. Sarah Harris used a river cane basket to store her tools (Acquisitions File, 1980, BC).

Miniature Tools

Those potters who occasionally make miniatures use the tools they have at hand. Edwin Campbell, who works almost exclusively in miniatures, relies on very small tools that enable him to make his very small pieces. His tools are merely small versions of the large tools used by his fellow potters.

Squeeze Molds

Non-Indians seldom see the squeeze molds. Most of these are used in making pipes. The origin of this interesting device is hazy at best, and the full story will probably never be known except in very general terms. An indication that the squeeze mold is of long use among the Indians is the Catawba word *wīmīsûmpadē'a*. Pipe molds certainly entered the Catawba tradition while the Catawba language had the vi-

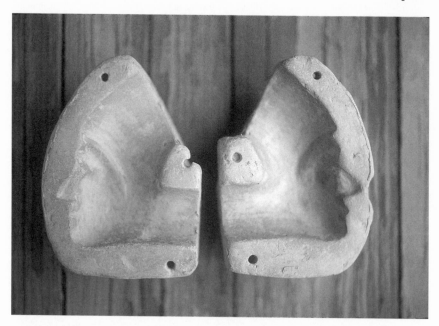

Figure 8. Squeeze molds made by Rhoda Harris in the nineteenth century. Property of the Doris Blue family. (Photo by Thomas J. Blumer)

tality needed to create a new word. Linguistic evidence points to a date well before the 1840 Treaty of Nation Ford (Barbara Heinemann, interview, 1994, BC).

There was a possibility that Harrington could have shed some light on the subject, but the ethnologist simply remarked that they were of "doubtful origin," that is not Indian. If he made any attempt to solve the mystery, he did not leave a record to this effect. This discrepancy is unfortunate. The older generation of potters, those born early in the nineteenth century, whom Harrington could have interviewed, certainly knew more about the antiquity of the squeeze molds than contemporary potters. It is possible that Harrington could have spoken to the very potter who introduced the squeeze mold to the Catawba tradition because the best-known and oldest mold makers were active at the time: Epp Harris, Martha Jane Harris, and Rhoda George Harris. As far as we know, Harrington had no contact with these potters, though they were alive when he visited the Nation.

Today, Catawba squeeze molds are regarded as authentic Catawba in design and manufacture. None of the potters are aware that they are adaptations of European models. In spite of the age of any molds currently in use, well-documented Indians made all but one-half mold found on the Betty and Bobby Blue allotment.

The origin of the squeeze mold remains a mystery. The most likely source of the Catawba pipe mold is the great clay pipe industry, which flourished from the Colonial period to the end of the nineteenth century. The manufacture of such pipes was first hurt by the unbreakable briarwood pipe and then ruined by the cigarette. With this shift in smoking habits, similar molds used by potteries throughout the country were stored away in attics or donated to museums, but the Catawba squeeze mold survived and is still in use. While it is true that the volume of the Catawba pipe trade was affected, the Catawba pipe tradition endured because the Indians have long catered to a large number of Indian arts and crafts collectors. These vessels are more Indian than a well-decorated pipe. Pipes are also expensive.

The best place to see the precursor of the Catawba squeeze mold is at Old Salem in North Carolina, or in Pamplin, Virginia. The oldest Catawba pipe molds currently in use differ from those of Pamplin and Old Salem only in their material of manufacture. The traditional commercial mold is made of pewter or brass, and the Catawba mold is made of Catawba clay. The Indians' molds are, however, exact copies of the parent molds. The earliest nineteenth-century Catawba squeeze molds even retain the holes that pierce the molds on the corners. In the original, these holes secured the molds in the pipe press. Although the holes were retained, the Catawba have never had a use for them. The Catawba equivalent of the pipe press is a pair of strong hands. In an effort to explain the existence of the holes, some of the Indians claim that the holes may be used to secure the molds in position while the molded clay sets up. This was supposedly done by putting sticks through the holes. In practice, however, the Indians immediately remove the pipe lugs from the mold and set them to one side to firm up. An experienced potter can produce many pipe lugs in one hour.

Historically, it is probably too late to determine precisely when and where the Catawba learned to make and use the squeeze mold. Pipes were of immense importance in early Colonial trade. After the founding of Charleston, the Indians had numerous opportunities to observe such molds in use. As non-Indian settlements approached and surrounded the Catawba Nation, such opportunities multiplied. Since the introduction of the molds to the Catawba tradition certainly occurred before 1840, Old Salem and Bethabara in North Carolina may be the place where the Indians first saw and learned to make squeeze molds.

The Moravian potteries date from the middle of the eighteenth century, a time when the Catawba were rapidly losing their political and military clout (Bivens 1972). It is well known that the Catawba were frequent visitors in the Moravian communities and were well received among the settlers there (Fries 1922). While the evidence gathered from

these potteries is tempting, the oldest Catawba molds in use can only be dated from the last quarter of the nineteenth century. The molds used by Doris and Mildred Blue have been in the family for five generations, but these molds are a little over a century old. One can only observe that Rhoda Harris's oldest molds look like clay copies of the Moravian brass molds.

It is entirely possible that Rhoda Harris introduced the squeeze mold to the Catawba tradition. She was an adult at the time of the Treaty of Nation Ford, and it is conceivable that her first molds were made before the Treaty was signed in 1840. Family tradition has it that Rhoda's molds were made before the potter went blind, and this occurred in the 1890s (Doris Blue, interview, 21 March 1980, BC). The linguistic evidence points to an earlier date, probably before 1840. Another separate family tradition claims that Martha Jane Harris's mother had molds. These molds would have predated the Treaty of Nation Ford by many years and would also account for the Catawba language term.

Some technical evidence points to Rhoda Harris. She made a greater variety of pipe molds than any other potter. In addition to the standard shapes (Indian head, tomahawk, chicken comb, and plain pipe), she constructed technically complicated molds for the Catawba peace pipe (Doris Blue, interview, 24 March 1980, BC). The complexity of these latter molds assures Rhoda Harris's part in mold making.

The origin of the squeeze mold is enriched by those molds found by Betty and Bobby Blue. These molds were originally discarded by those who occupied the Blues' house site in the nineteenth century and the first half of the twentieth century. Some are definitely the work of Martha Jane Harris. One part of a set of molds is much older and possibly was made by one of the Head family. This particular mold was made before 1883 when the Head family migrated to Colorado. This might be the oldest extant Catawba mold.

The only other Catawba molds that date from the nineteenth century are some of those made by Martha Jane and her husband Epp Harris (Furman Harris, interview, 19 April 1977, BC; Georgia Harris, interview, 19 March 1980, BC). These molds are interesting in that they show an evolution in style. The earliest molds are exact duplicates of those used at commercial potteries, such as that at Old Salem. However, Martha Jane Harris was a prolific mold maker, and she took shortcuts. As she grew more proficient in this exact craft, she realized that her molds did not have to mimic the parent molds in every way. For instance, her later molds do not have the pottery press holes in them, and she gradually abandoned the square shape made necessary by the pipe press. The new convex form created by Martha Jane Harris fit more easily in the potter's hands.

Most of the antique pipe molds in use today among the Indians can be attributed to Martha Jane Harris. To date, all the molds found in museum collections are also her work. According to Georgia Harris, all the Indians went to Martha Jane Harris if they needed a pair of molds. "Yes, she made a lot of molds for people. . . . She was the only one who made molds. I never did hear of anybody else making molds. They always asked Aunt Jane. That's what everybody called her. . . . She didn't charge them but a dollar for them" (Georgia Harris, interview, 30 March 1980, BC).

Making pipe molds is not difficult, but requires patience, as Harrington first described: "For making pipe molds an original model is shaped by hand, and after being burned in the usual way is greased and forced down into a flattened cake of fresh clay until half imbedded; then the surface of the cake is also greased to prevent sticking, and another cake is laid over and pressed down, forming a complete mold of the original pipe. When dry these half molds are removed from the model and burned; then they are ready for use" (see Figure 8) (Harrington 1908:405–406). These directions are accurate except for the use of grease. It is not known if Harrington's description is the result of demonstrations. According to Marvin George, making molds also requires far more devotion to detail than Harrington indicated. The most comprehensive description of this technical process is provided by Marvin George:

If you make up dough a long time, you can make good biscuits. If you work in pottery all the time and you get the knack of it, you can just make them. I made a set of headpieces—molds—for Edith [Brown] one time. I said, "I'm going to see if I can make them." I took me, well I had me a head made, a head burned. I took me a piece of clay about that big [pint], and I flattened it down [two inches thick]. I had two of them. I started working that head in there on both sides, and I got it half way, just where it would set up down to the nose, and I molded it. I made that mold. I kind of scraped it out and made it a little better, and I think I punched a hole through it and let it dry. . . . I stuck a hole down through two places in these, and I told Edith. I said, "Now here you have the head molds. You just burn them," and the last time I seen them she still had them. (Marvin George, interview, 23 March 1983, BC)

Following the death of Martha Jane Harris in 1936, it looked for a time as though the skill of mold making might become extinct among the Catawba. However, several young potters tried to produce their own molds and, in effect, planted the seeds for events that would occur many years later. Jennie Brindle made a set of molds for the plain pipe,

and Earl Robbins made two sets of Indian head pipe molds when he
was yet a teenager around 1920.

As has been the case since the Colonial period, the tradition is
linked to making money. If pipes can be sold, the easiest way to pro-
duce them is with the squeeze mold. Sara Lee Ayers was reportedly an
accomplished mold maker. All of her molds were made in support of
her pottery business. The same is true of Earl Robbins, who possibly
owns more molds than any other potter. He has also provided many of
his contemporaries with molds. In the late 1980s, Georgia Harris also
made a number of molds. And in 1993, Mildred Blue made several
sets of miniature pipe molds. These enabled her to manufacture very
small pipes quickly and efficiently. In anticipation of profiting from
the rapidly growing market for Catawba pottery, several young potters
have learned to make molds from Earl Robbins, including Gail Jones,
Elizabeth Plyler, Faye Greiner, Donald Harris, and Monty Branham, to
name a few.

9 Building Pots

Woodland and Mississippian Methods

The beginning Catawba potter faces many problems, one of which is learning a wide variety of construction techniques that follow a fixed number of steps. So well established are the methods followed by the Catawba that the Indians refer to the work as *building pots*. Those familiar with aboriginal American pottery-making methods and who have seen the Catawba at work are aware of the antiquity of the Catawba way. So conservative is the tradition that the results obtained today are almost identical to prehistoric burnished southeastern pottery (Fewkes 1944:108). The basic process is completed by hand through the use of three methods: coils, rings, and morsel modeling.

BASIC VESSEL—BUILDING WITH ROLLS

Recognizing its importance, Harrington recorded the cooking pot building method as practiced by the Brown family:

> This done, the clay was divided into little wads, which Mrs. Brown laid upon a plank and rolled out into long cylinders with her hand. . . . Then deftly shaping a little disk of clay to serve as the bottom of the future vessel, she laid it upon another piece of board and coiled upon it one of her clay rolls, . . . which she pinched fast with wet fingers. Another and another roll followed, each one pinched fast to the last until a rude pot form was made. . . . Moistening her mussel shell, the potter began to blend the coils on the outside, always smoothing the clay upward. . . . While smoothing any part of the wall of the embryo jar she supported it on the inside with her other hand. Still using the shell, and from time

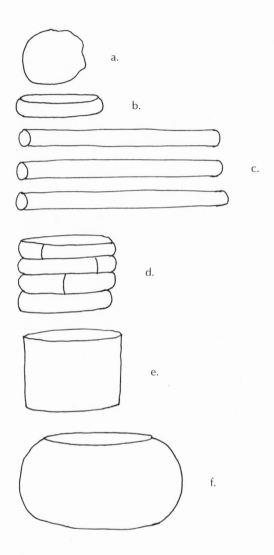

Figure 9. Basic pot made with rolls.

a. The potter takes up a morsel of clay, forms it into a ball. The potter makes certain no air holes remain in the clay.

b. The potter flattens the ball into a disk, which is to form the bottom of the vessel.

c. A number of rolls are constructed by the potter.

d. The rolls are stacked on the vessel's base. The seams are placed in different places so the potter will attain strong walls for the vessel.

e. The potter takes a jar lid or a bit of coconut shell and obliterates the exterior seams between the rolls.

f. As a last step, the potter works the interior of the pot and pushes the walls out until the vessel reaches its final shape.

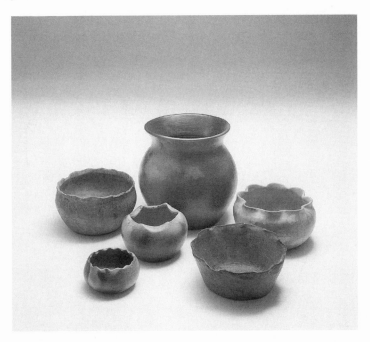

Figure 10. Typical Catawba cooking pots. *Back row, left to right:* Nola Campbell; anonymous, nineteenth century; Earl Robbins. *Front row, left to right:* anonymous milk pan, nineteenth century; Georgia Harris; Billie Anne McKellar. Pottery from the Blumer Collection. (Photo by Phil Moody)

to time a bit of gourd, both kept wet in a vessel of water standing near, she then blended and smoothed the inside of the vessel in similar fashion. . . . During these processes the jar was seen to increase gradually in size as its walls became thinner, until at last, the smoothing finished, it had attained the desired dimensions. Then Mrs. Brown leveled off the rim and bent it to suit her fancy, . . . then the vessel was set away in an airy place to dry. (Harrington 1908:403–404)

Today, almost 100 years later, the construction method for the cooking pot is exactly the same. It is to the credit of the conservative nature of the tradition that this humble vessel, such as that constructed by the Browns, has remained the mainstay for the Indian potters.

BASIC VESSEL—BUILDING WITH RINGS

Building with rings is a variation of the roll/coil method and was demonstrated by Edith Brown in 1977 (Edith Brown, interview, 21 April

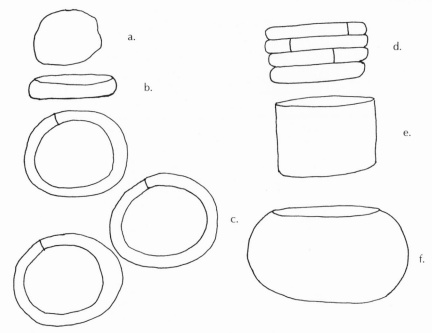

Figure 11. Basic pot made with rings.
a. The potter takes up a morsel of clay, forms it into a ball. The potter makes certain no air holes remain in the clay.
b. The potter flattens the ball into a disk, which is to form the bottom of the vessel.
c. The potter then makes rolls and forms them into rings of equal size.
d. The rings are stacked on the vessel's base. The seams are placed in different places so the potter will attain strong walls for the vessel.
e. The potter takes a jar lid or a bit of coconut shell and obliterates the exterior seams between the rolls.
f. As a last step, the potter works the interior of the pot and pushes the walls out until the vessel reaches its final shape.

1977, BC). She followed the same movements as those used in the more commonly followed coil method and created a disk to form the vessel's bottom. The rolls were constructed by the same method as the rolls for any other vessel. Edith Brown, however, took the rolls a step further and shaped them into complete rings that fit the circumference of the base. Each ring was then stacked on the disk. In this way the basic size of the vessel was attained. Once the desired height was reached, the potter took a modeling tool and smoothed the exterior of the vessel until the rings were completely obliterated. When this task was completed, she moved to the interior. While Edith Brown obliterated the

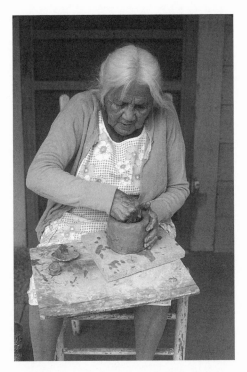

Figure 12. Edith Harris Brown building
a typical Catawba cooking pot. Potter
used the ring construction method.
(Photo by Thomas J. Blumer, 1977)

interior rings, she also pushed the walls out until the vessel took its
final form.

BASIC VESSEL—BUILDING WITH MORSELS OF CLAY

The morsel building technique is actually modeling from a single lump
of clay rather than rolls or rings. To make the traditional cooking pot
by this method, the potter first takes up a morsel of clay. This is rolled
into a ball. The ball is then placed on the lap board and rolled into a
cylinder similar in shape and size to a soft drink can. Once it is per-
fectly formed, the potter pokes the right index finger into the middle
of the cylinder. Working from the inside, the potter then widens the
interior to make a basic bowl or cooking pot. This method is generally
used for the construction of small vessels.

The three building methods produce the same result, and a graceful
cooking pot reveals the skill of the potter. The basic vessel can also be

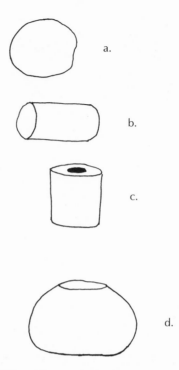

Figure 13. Basic pot made with a morsel of clay.
a. The potter takes up a morsel of clay, forms it into a ball. The potter makes certain no air holes remain in the clay.
b. The potter forms a cylinder from the morsel of clay.
c. When the cylinder is complete, the potter pokes his finger in the top of the cylinder and makes a hole, which will be the interior of the pot.
d. The potter begins to push the vessel from the inside to reach its final shape.

modified into a large corpus of shapes. The list of vessels that begin as a plain cooking pot is long:

1. plain cooking pot
2. cooking pot with lid
3. cooking pot with three legs
4. cooking pot with four legs (rare)
5. cooking pot with two handles
6. cooking pot with lug handles
7. cooking pot with Indian head lugs
8. cooking pot with crimped rim
9. cooking pot with fluted rim
10. cooking pot with two handles and three legs, gypsy pot

11. milk pan
12. snake effigy pot
13. snake effigy pot with three legs
14. snake effigy pot with two handles
15. snake effigy pot with two lugs
16. gypsy pot with snake effigy
17. water jar (vase)
18. water jar with three legs
19. water jar with two handles
20. water jar with Indian head lugs
21. water jar with fluted rim
22. cupid jug
23. wedding jug
24. wedding jug with flat Indian heads
25. wedding jug with snake effigy
26. wedding jug with one spout
27. Rebecca pitcher
28. Rebecca pitcher with snake effigy
29. water pitcher
30. bread tray
31. creamer pitcher
32. lizard vase with handles
33. alligator effigy pot
34. basket pot with loop handle
35. bowl with turtle effigies
36. water jug with turtle effigies
37. turtle effigy pot
38. peace pipe with four stems
39. peace pipe with six stems
40. peace pipe with two Indian head lugs
41. loving cup
42. loving cup without base
43. horse effigy pot
44. rat effigy pot
45. flower pot

MODIFYING THE BASIC COOKING POT

THE SNAKE EFFIGY POT

This vessel is of great importance, and its successful construction is the goal of every master potter. The snake effigy pot is also popular with collectors. In the beginning, the traditional snake pot follows the

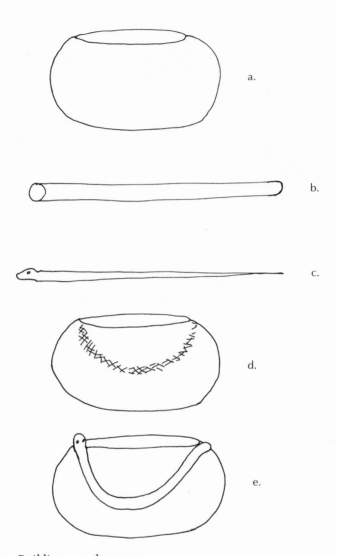

Figure 14. Building a snake pot.
a. The potter selects a vessel that is to become a snake pot.
b. A long roll is created to take the form of the snake.
c. The roll is worked into the rough shape of a snake.
d. The vessel selected to become a snake pot is then scored in the area where the snake's body is to rest. Some potters cut a channel in the vessel and place the snake in this groove.
e. The snake is placed on the side of the vessel. The potter works the area between the snake and vessel to make certain no air pockets remain.

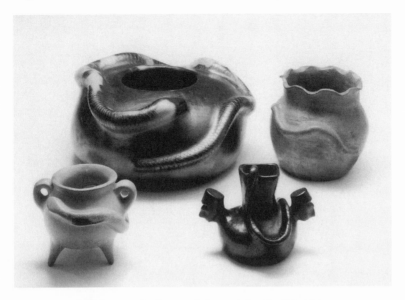

Figure 15. Snake pots. *Back row, left to right:* Earl Robbins; anonymous nineteenth century. *Front row, left to right:* Doris Blue; Denise Nichols. Pottery from the Blumer Collection. (Photo by Phil Moody)

same construction technique as the cooking pot because most, but not all, Catawba snake effigy pots are cooking pots. First, a vessel that is large enough to hold a snake effigy is built. The potter then sets the vessel aside and allows it to strengthen a bit through a partial drying period. Once the piece is strong enough to hold the snake without slumping, the potter takes a morsel of clay and rolls it into the shape of a serpent. Then the potter decides how the snake will rest on the pot. A shallow ridge is then cut into the vessel and the pattern the snake will follow is scored. This area is then moistened, and the body of the snake is secured in place (Doris Blue, interview, 24 March 1980, BC; Stout, 1978). The serpent is then worked into the vessel until the potter feels the bond is secure.

Taking a snake pot through the difficult firing process can result in a high level of breakage. While the potters work to make sure no air pockets are left between the vessel and the applied snake, this is hard to accomplish. In most of the breakage that occurs in snake pots, the serpent has popped off the vessel during the burning.

THE WATER JUG

To build a water jug, or a vase as the potters often call this vessel, the potter begins once again with a basic cooking pot. After the walls of

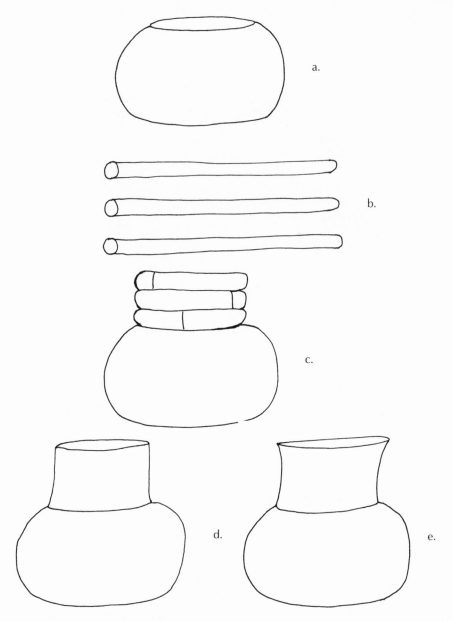

Figure 16. Building a water jug.

a. The potter selects a vessel that is to become a water jug.

b. A number of rolls are constructed by the potter.

c. The rolls are stacked on the rim of the vessel. The seams are placed in different places so the potter will attain strong walls for the vessel.

d. The potter takes a jar lid or a bit of coconut shell and obliterates the exterior seams between the rolls.

e. As a last step, the potter works the interior of the pot and pushes the walls out until the vessel reaches its final shape.

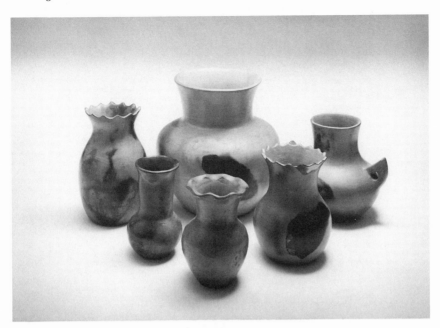

Figure 17. Water jugs. *Back row, left to right:* Nola Campbell; Georgia Harris; Georgia Harris. *Front row, left to right:* Elizabeth Plyler; anonymous, nineteenth century; Nola Campbell. Pottery from the Blumer Collection. (Photo by Phil Moody)

the parent vessel go through a short drying period to allow them to gain strength, the potter returns to the parent vessel. A number of rolls are constructed and set to one side. The potter then moistens the rim of the cooking pot and begins to add rolls for the neck. Once the desired height is reached, the exterior and then the interior of the rolls are smoothed. The rim of the finished vessel can be fluted or carved in some pleasing manner.

THE INDIAN HEAD JAR

The ability to construct large Indian head jars reveals a master potter at work. The building of this vessel follows the regular evolutionary process from the basic cooking pot to a common water jar. The jar is merely turned into an Indian head jar by the addition of heads, which are lugs. These lugs are attached through the use of a pre-Columbian Mississippian construction technique. This simple method is used to attach all appendages. When building an Indian head vase, the potters can either hand model the lugs or use pipes taken from squeeze molds. The lugs are made separately from the vessel before the process of adding them to the vessel is begun. The potter first determines where the

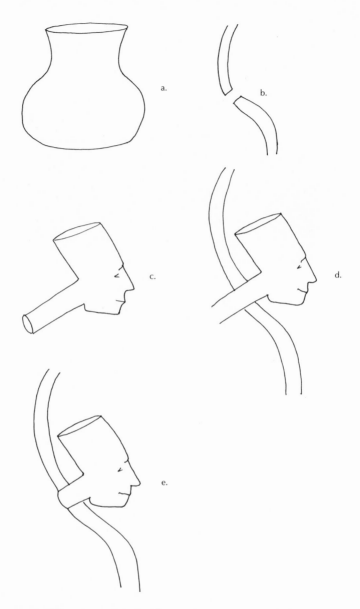

Figure 18. Building an Indian head jar.
a. The potter selects a water jug that is to become an Indian head jar.
b. Holes are cut in the side of the vessel. These are usually placed where the neck meets the body of the vessel.
c. An Indian head lug is constructed. It is usually an Indian head pipe. The stem is made long enough to penetrate through the vessel's walls.
d. The Indian head lug is forced through the hole with the stem protruding on the inside of the vessel.
e. The potter smoothes the inside where the stem protruded so that the place cannot be detected.

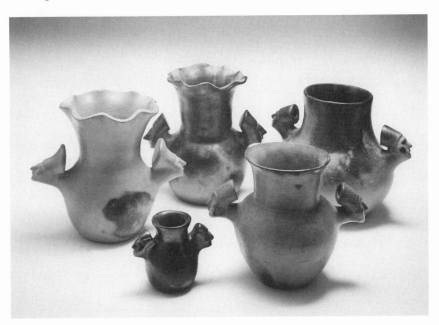

Figure 19. Indian head jars. *Back row, left to right:* Blanche Bryson; Arzada Sanders; Georgia Harris. *Front row, left to right:* Mildred Blue; attributed to Susannah Owl. Pottery from the Blumer Collection. (Photo by Phil Moody)

lugs will be placed on the vessel. The locations are marked and holes are bored through the vessel walls. The lugs are then thrust through the holes, clinched on the inside and fortified with extra morsels of clay on the exterior for a firm bond. Such lugs, however, present the potter with special problems. A pipe lug in particular is quite heavy and will not stand up well if unsupported during the early drying process. Also, it is often difficult to dry this kind of lug completely since the appendage is thick. To solve the problem of weight and drying, the potters often hollow out the bowl of the lug as they would when making a pipe. The weight of the lug is considerably reduced in this process. The pipe stem is left solid before it is inserted through a hole bored into the pot for this express purpose. Even when the lug has been carved out to make it lighter, the potters often must support the lug during at least the initial part of the drying process. The support of a towel will help keep the lug firmly in place until the vessel and the lug are strong enough to stand on their own.

THE GYPSY POT

The gypsy pot, too, begins as the versatile cooking pot. After the required drying process has been honored, the potter marks the places

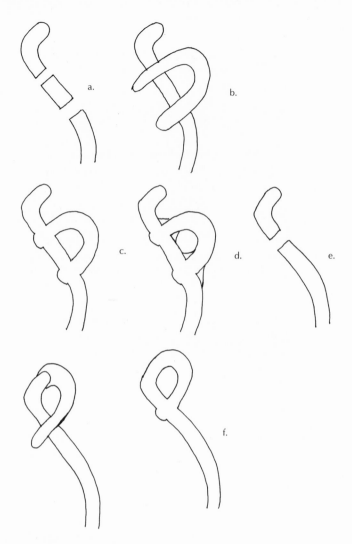

Figure 20. Building a gypsy pot.

a. The potter selects a bowl that is to become a gypsy pot. Holes are cut in the side of the vessel. These holes are placed where the handles are to be attached, near the rim.

b. The handle is forced through the hole with the stem protruding on the inside of the vessel.

c. The potter smoothes the inside where the stem protruded so that the place cannot be detected.

d. The potter then adds morsels between the handles and the walls of the pot to ensure a good bond.

e. If the potter decides the handles are to attach to the rim of the vessel, only one hole is cut in the side of the vessel.

f. The handle is forced through the hole with the stem protruding on the inside of the vessel. The free end of the handle has a fork cut into it, and the fork is made to clutch the rim. The potter smoothes the inside where the stem protruded so that the place cannot be detected.

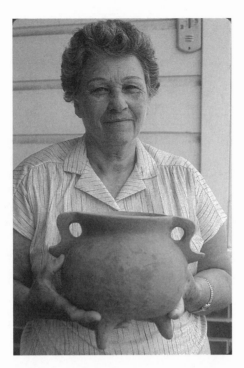

Figure 21. Portrait of Nola Campbell
holding a green ware gypsy pot. (Photo
by Thomas J. Blumer)

where the handles will be. Two sets of holes are cut in the walls of
the vessel, one for the top of the handle and the other for the bottom.
A handle is then thrust through the holes. It is clinched on the inte-
rior and strengthened on the exterior for a firm bond. On occasion the
potter will use one set of holes and fix the top of the handle to the
pot's rim.

To complete the gypsy pot, the potter must allow for a second short
drying process. The potter then flips the vessel over and sets it mouth
down on a lap board. The places where the three legs will be attached
are marked and holes are cut to take the legs. Pre-constructed legs are
then nudged through the vessel, clinched on the interior, and strength-
ened on the exterior. Gypsy pots do not vary in form from the required
two handles and three legs. The shape can, however, take on a different
personality through the hands of each potter.

The Indian head bowl follows the same basic construction technique
as the gypsy pot. Instead of handles, the potter provides Indian head
lugs. The three legs remain the same.

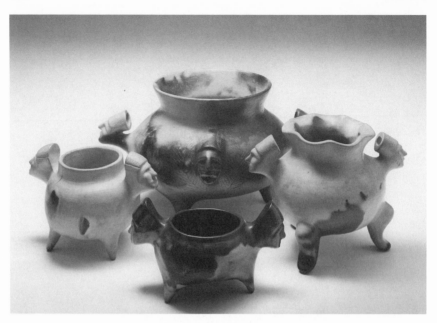

Figure 22. Indian head bowls. *Back row, left to right:* Doris Blue; Earl Robbins; Nola Campbell. *Front row:* Mildred Blue. Pottery from the Blumer Collection. (Photo by Phil Moody)

THE REBECCA

Perhaps the most elaborate adaptation of the cooking pot is a form adopted into the tradition at the turn of the twentieth century, the Rebecca pitcher. Nineteenth-century examples of this vessel clearly show that the Rebecca once began life as a cooking pot. The Rebecca is built in four stages and all parts are modeled. The potter begins by producing a cylinder of clay. If the vessel is to have an inverted cone-shaped base, the potter pinches the cylinder into two equal portions, poking a hole in the center of what will be the bowl, and modeling a small bowl. The bottom portion becomes the cone-shaped pedestal. At this point, the vessel is shaped roughly like an hourglass. After a suitable drying period, the potter bores a hole in the top rim of the bowl. A partial handle is then modeled and inserted into this hole. It is left standing as the construction continues. Next, the long neck is modeled. The lip of the neck tops off the spout. The neck is attached to the bowl, and the spout is attached to the neck and they are smoothed into each other to make a good seal. The fourth and last step is to finish the handle, which runs parallel to the entire neck from the rim to the bowl. The top of the handle is wedged into the rim of the neck and the two por-

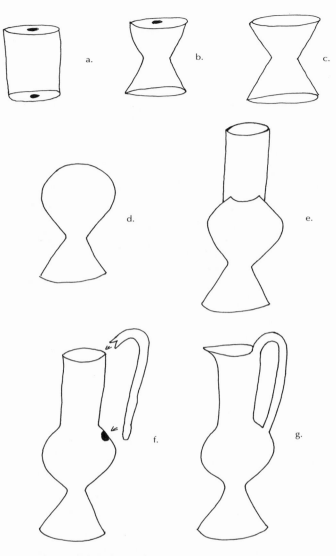

Figure 23. Building a Rebecca pitcher.
a. The potter forms a cylinder from a morsel of clay. The potter pokes a hole in the top and the bottom of the cylinder.
b. The cylinder is then pinched in the center.
c. The top is to become the base for the pitcher's body. The bottom is to become a cone shape on which the vessel will rest.
d. The top of the form is capped to form a hollow globe that will become the body of the pitcher. A hole is cut to take the neck.
e. A neck is formed of another morsel of clay and worked into the body of the vessel.
f. A hole is cut at the base of the neck. This hole will take a long handle that runs parallel to the neck to the rim. The handle is attached through the vessel at the bottom and by means of a fork of clay at the rim.
g. The spout is pulled from the neck.

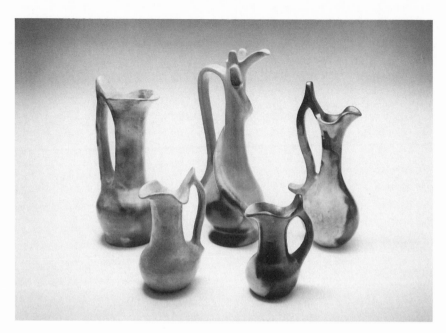

Figure 24. Rebecca pitchers. *Back row, left to right:* anonymous, early twentieth century; Georgia Harris; Nola Campbell. *Front row, left to right:* Emma Brown; Catherine Canty. (Photo by Phil Moody)

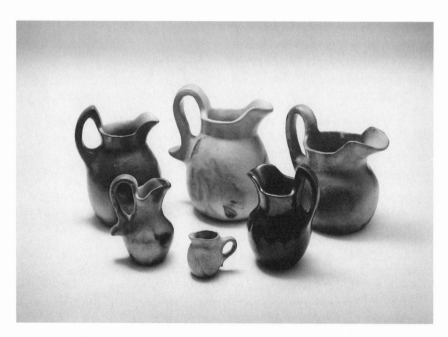

Figure 25. Water pitchers. *Back row, left to right:* Nola Campbell; Frances Wade; Martin Harris. *Front row, left to right:* Georgia Harris; anonymous, nineteenth century; Nola Campbell. Pottery from the Blumer Collection. (Photo by Phil Moody)

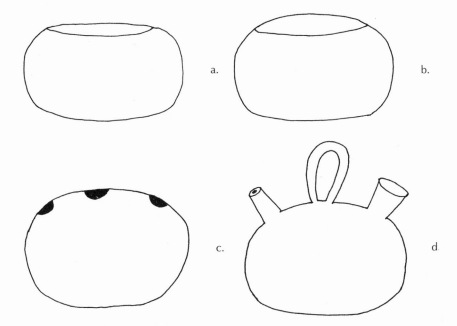

Figure 26. Building a cupid jug.
a. The potter selects a bowl that is to become a cupid jug.
b. The bowl is then capped to form a hollow globe.
c. The potter then cuts three holes in the top of the globe.
d. The center hole will take a loop handle and the two flanking holes take spouts.

tions of the handle are worked into each other to form a good seal. Today, the potters often omit the cone-shaped base.

The plain water pitcher follows a construction technique similar to the Rebecca. The neck is not as long, and the handle does not run parallel to the neck.

THE CUPID JUG AND THE WEDDING JUG

The so-called cupid jug, recently revived, begins construction as a bowl or typical cooking pot that receives a lipped lid. This cap is then smoothed onto the bowl so that a small hollow globe is formed. After this flat-bottomed globelike shape has gone through a sufficient drying period, three equidistant holes are bored in the top: one in the center for the loop handle and one for each of two spouts (Georgia Harris, Field Notes, 1977, BC).

The wedding jug was introduced to the Catawba tradition in the twentieth century. It begins as a globe similar to the cupid jug. To make a wedding jug, however, the potter cuts two large equidistant

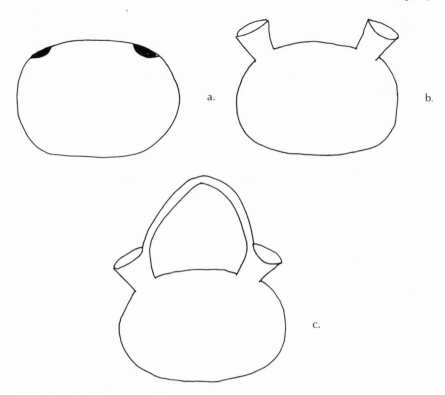

Figure 27. Building a wedding jug.
a. The potter selects a bowl that is to become a wedding jug. It is capped in
the same way the potter caps the bowl that is to become a cupid jug. This
time only two holes are cut in the top of the globe.
b. Spouts are forced through the holes.
c. A handle with forks at each end is made and worked into the interior
sides of the spouts forming a basket handle.

holes in the top of the globe and then inserts two spouts that were made
earlier. In a third step, a handle with two forked ends to wrap over the
rim of each spout is constructed. It forms a loop above the two spouts
and is wedged firmly over the inner rims of each spout.

The Peace Pipe

The ancient Catawba peace pipe is built in three stages. A small bowl,
a miniature cooking pot, is built following traditional construction
methods. It may or may not have a separate rim. After a short drying
period, the four pipe stems are measured off equidistantly around the
pot, holes are bored, and stems are inserted and clinched on the inside.
The vessel is then set aside for a second drying period. Once the peace
pipe is considered strong enough, holes for the three legs are measured

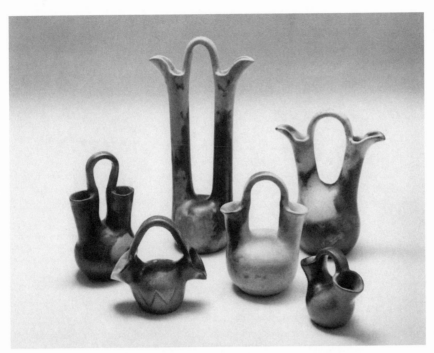

Figure 28. Wedding jugs. *Back row, left to right:* Lillie Beck Sanders; Earl Robbins; Nola Campbell. *Front row, left to right:* Louise Bryson; Evelyn George; Viola Robbins. (Photo by Phil Moody)

off. One pipe stem is used as a reference point. When the legs are made, inserted, and made secure, the completed vessel is set aside again to await the final finishing processes.

THE SWAN OR DUCK POT

One favorite modern innovation among the Catawba potters is the swan or duck pot. Nola Campbell was well known for this form. She began by building a traditional pot (see Figure 9) but made the base oblong rather than round. She then constructed a shallow bowl using two or three rolls. When this still-crude vessel had set up for a time, the potter constructed a head and neck and attached them to one end of the vessel by the use of a forked morsel of clay. The excess clay was smoothed away so the joining could not be seen. Wings were then constructed of additional morsels and secured to the side of the vessel by a deep ridge along the bottom edge of the wing. This ridge folded over the body of the bowl and made a strong bond. The tail was either pinched from the end of the bowl or added in exactly the same fashion as the wings and neck, as a forked morsel (Nola Campbell, Field Notes, 1977, BC).

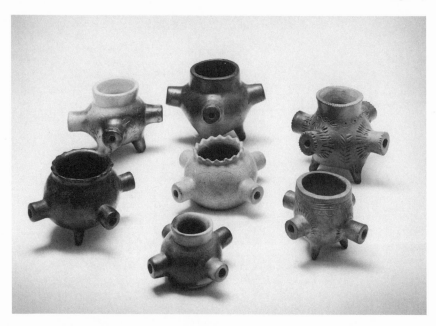

Figure 29. Peace pipes. *Back row, left to right:* Georgia Harris; Catherine
Canty; Sara Lee Ayers. Center: Earl Robbins. *Front row, left to right:* anony-
mous, nineteenth century; Mildred Blue; attributed to Susannah Owl. Pot-
tery from Blumer Collection. (Photo by Phil Moody)

SCHEDULE FOR THE DRYING PROCESS

While a vessel is in the building process it must be handled with great
care, so is usually left on the lap board. Straightening a lopsided vessel
at this point can be difficult and is best accomplished by a master pot-
ter (Sallie Beck, interview, 21 April 1977, BC). Indeed, the potter allows
the vessel to rest between stages just to prevent the possibility of a
sagging wall. Sallie Beck described a rough timetable she followed
when making Rebecca pitchers. If she constructed the body of the ves-
sel in the evening, it was ready to take the neck portion the next morn-
ing. Handles were then added toward evening of that day. In effect, the
process usually cannot be completed in one day. Once the unburned
vessel is dry, however, it is remarkably sturdy and can take some rough
treatment.

BENDING PIPES

While many Catawba pipes are manufactured with squeeze molds, the
ancient art of bending pipes by hand is still followed. The pipes pro-
duced by this method fall into two categories: traditional and fanciful.

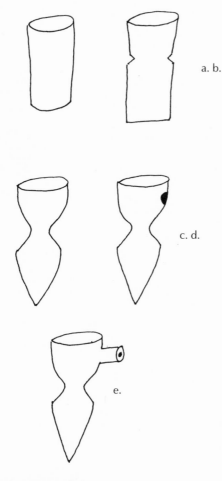

Figure 30. Bending an arrow pipe.
a. The potter takes a morsel of clay and builds a cylinder.
b. The cylinder is flattened on one end. The flattened end is to become an arrow suspended from the pipe bowl.
c. The arrow is carved from the flattened end of the cylinder.
d. A hole is cut in the side of the bowl.
e. A stem is inserted into the hole and made firm. The potter immediately cuts the hole in the stem. This hole must be large enough to take a reed stem and long enough to reach the bowl. The bowl is carved when the pipe is nearly dry.

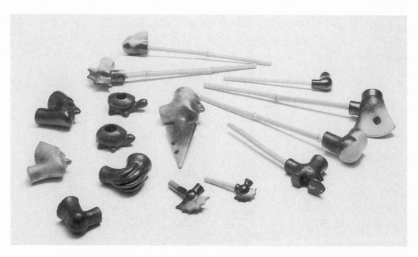

Figure 31. Pipes. *Rear with cane stems, bottom to top:* comb pipe, Doris Blue; anonymous, twentieth century. *Right side with cane stems, bottom to top:* comb pipe, Edwin Campbell; shoe pipe, Georgia Harris; plain pipe, Georgia Harris; axe pipe, Doris Blue; plain pipe, Georgia Harris. *Back row, left to right:* Indian head pipe, Billie Anne McKellar; turtle pipe, Earl Robbins; Indian head arrow pipe, Earl Robbins. *Second row, left to right:* Indian head pipe, Georgia Harris; turtle pipe, Mildred Blue; claw pipe, Foxx Ayers; comb pipe with clay stem, Edwin Campbell; plain pipe, Georgia Harris. Pottery from the Blumer Collection. (Photo by Phil Moody)

The Catawba tradition is rich in pipe shapes. The procedure followed in both cases is the same. First the potter takes up a wad of clay, works it into a ball, and then rolls the ball into a cylinder. The actual pipe lug is then molded by hand from one end of this cylinder. The other end is flattened so the potter may cut the proper comb shape or perhaps an arrow, both of which are suspended from the bottom of the bowl. If the resulting pipe is too large, the excess clay is trimmed away with a knife. The finished lug is then put aside to let the clay set up. Once the clay is ready to be taken in hand again, the potter bores a hole for the stem, models a separate stem, and inserts it in the bowl end of the lug exactly as any other appendage would be attached to a bowl. A hole large enough to hold a river cane reed is immediately bored in the stem. This hole must be deep enough to reach the bowl, which is yet to be carved in the lug. This last task is done as soon as the lug is strong enough to be carved (Billie Anne McKellar, interview, 2 April 1977, BC). The most common traditional pipe forms made in this fashion are the comb pipe, plain smoking pipe, and a curious little plain pipe with a bib of clay under the bowl. All three of these forms seem to be of ancient origin.

The most common of the so-called fanciful pipes are the arrow pipes, both single and double. The lug is made from a cylinder. One end is flattened and cut into the shape of an arrow, and the other end forms the bowl. The stem is then inserted into the bowl portion, and a pre-molded smaller arrowhead is inserted into the opposite end of the bowl. Before this pipe lug is put aside to set up, the hole intended to take a reed stem is bored out.

The Catawba pipe tradition allows for a great deal of innovation on the part of the potters. Yet though this is true, most of the Catawba who construct pipes rely on the standard traditional pipes and do not commonly vary the shape of their work. The list of pipe shapes includes:

1. plain pipe
2. comb pipe
3. arrow pipe
4. horse pipe
5. horse head pipe
6. turtle pipe
7. Indian head pipe
8. Indian head arrow pipe
9. tomahawk pipe
10. axe pipe
11. pick axe pipe
12. lathing axe pipe
13. fanciful pipe
14. teapot pipe
15. briar imitation pipe
16. pitcher pipe
17. fish pipe
18. snake effigy pipe
19. barrel-shaped pipe
20. hand pipe
21. frog effigy pipe
22. arrow pipe with second arrow protruding from front of bowl

SQUEEZE MOLD

A large number of Catawba pipes are built with the use of squeeze molds (see Figure 8). To use such molds, the potter first takes a morsel of clay and works it into a rough shape that is similar to the pipe to be taken from the mold. This morsel is then placed in the mold and squeezed into position. As excess clay emerges from between the two halves of the mold, the potter removes it with a knife. The potter may also remove the lug from the mold, trim some of the excess clay away

and place the lug back into the mold. This may be repeated several times before a suitable lug is removed. Once the potter is happy with the pipe lug produced, the product is removed for the last time. Some finishing trimming may then be done. The potter takes a stick and bores out the pipe stem before putting the lug to one side to dry. The pipe bowl will not be bored out with a knife until the pipe has gone through a partial drying process.

The Catawba construction methods are successful. The potters secure handles, lugs, and legs to their vessels carefully, yet they do recognize these appendages as possible weak points in their constructions. Even when the greatest of care is taken, the results can be disappointing. Wedding jug handles that are not properly secured can slip off in the fire (Fred Sanders, interview, 8 February 1977, BC). This happens because they are wedged over the spouts rather than attached through a hole in the vessel. Such a tragedy seldom occurs with handles attached through holes in the vessel. If the appendage is not applied with proper care, the appendage will break or even pop off in the fire.

Molds are primarily produced to assist in the manufacture of smoking pipes. In theory, any pipe in current production may be copied in a squeeze mold. Molds also come in all sizes. As a result, a potter may have two or three sizes of Indian head molds. Earl Robbins, for instance, has two sets of small Indian head pipe molds he made as a young man and numerous sets of Indian head pipe molds from various different Indian head pipes. Mr. Robbins is the most accomplished mold maker in the Nation. The list of molds commonly found at a potter's disposal is not a long one. Mr. Robbins is probably the only potter who has multiple examples of all these molds in his possession.

1. Indian head pipe
2. plain pipe
3. comb pipe
4. axe pipes of all varieties
5. arrow pipe
6. Indian head with arrow
7. tomahawk
8. face for application on side of a pot

EFFIGIES

The effigy has long been an important part of the Catawba tradition. Effigies are usually small and seldom break in the fire. For the most part effigies are inexpensive and are popular with the collector who has little money to spend yet wants something of Catawba manufacture.

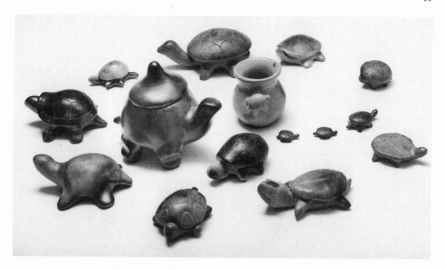

Figure 32. Turtle effigies. *Back row, left to right:* unknown, twentieth century; Earl Robbins; unknown, twentieth century; unknown, twentieth century. *Middle row, left to right:* Catherine Canty; bowl with lid, Louise Bryson; Mildred Blue; three small turtles, Earl Robbins. *Front row, left to right:* Georgia Harris; Beulah Harris; Edna Brown; Caroleen Sanders; Cheryl Gordon. Pottery from the Blumer Collection. (Photo by Phil Moody)

Only the snake and the turtle can be firmly linked to Catawba folklore and history. The most popular nineteenth-century effigies were the turtle, snake, and squirrel.

The turtle has a unique construction technique (see Figure 32). The potter first rolls a morsel of clay into a ball. This ball is then elongated to form a cylinder. Satisfied with the size of the cylinder, the potter squeezes it in the middle to make two equal portions. The top is molded into the turtle's carapace and the bottom is worked into the head, tail, and legs. The two sections are then pressed together to form a turtle.

The Catawba will make almost any kind of an animal effigy if they think it will sell. In the nineteenth century, the potters commonly made chicken effigies. Today, this shape has been discontinued. Master potter Evelyn George, however, makes a turkey effigy. Catherine Canty was known for her dog effigy ashtrays and her rat pots. The commonly made effigies are:

1. turtle
2. frog
3. owl
4. snake

5. beaver
6. bear
9. squirrel
10. horse pot

FINISHING—SCRAPING

This next step after construction is crucial, for many uneven features are repaired at this stage. "John Brown again took a hand in the work and scraped the surface of each one very carefully with iron and cane knives, reducing all irregularities and making the walls thinner. Much of the symmetry and attractiveness of the finished product depends upon the care with which this work is done" (Harrington 1908:404).

Scraping is akin to carving. The potters carefully remove the uneven places left from building the vessel. The walls are thinned down considerably. The person scraping the pot pays special attention to the handles, legs, and lugs and makes certain the vessel will show at its best. While the piece is being scraped, it is held in the potter's lap covered by a cloth. The scrapings are carefully collected in the cloth. All these bits of clay are saved for future use. No clay is wasted. Potters such as Nola Campbell preferred to scrape their pots wet, while potters such as Catherine Canty preferred to work with a fully dried pot.

FINISHING—RUBBING

The very last task is to rub the pot with a rubbing stone. This process, too, remains unchanged from prehistoric times. Archaeologists commonly find vessels in their digs that show the marks of the rubbing stone. Harrington's 1908 description is still accurate: "When he [John Brown] had finished a vessel, John handed it to his daughter, who moistened it with a damp rag and rubbed it carefully all over with the water-worn pebble kept for that purpose, removing all trace of scraping. . . . A fine polished surface may be produced, they told me, by patient use of this primitive tool. For rubbing around handles, . . . legs, and other difficult places, she used a polished bone smoother, resembling closely the blunt awl-like bone implements sometimes found in archeological excavations on the site of ancient Indian villages" (Harrington 1908:404).

The potter determines the length of time spent rubbing a pot. Those who make trade ware cut this tedious task to the minimum effort, but even then each pot is rubbed quite thoroughly. In such a case, however, the rubbing marks are easily discerned. Edith Brown rubbed her vessels only once but gave the effort a great deal of time. The best of her work

Figure 33. Earl Robbins with a water
jug, finished and ready for the fire.
(Photo by Thomas J. Blumer)

exhibited a satinlike shine, and it is difficult to see the marks of the
burnishing tool (Edith Brown, interview, 21 April 1977, BC).

Doris Blue was celebrated for the excellence of her work. She never
sold a vessel that had not been labored over for many hours. All were
finished to perfection, and she never left telltale signs of the rubbing
rock on her pottery. She claimed that a dry pot would rub to a higher
gloss. She always rubbed each vessel twice. The first rubbing was done
when the vessel was still damp. Later, when the vessel had more time
to dry, it was rubbed a second time (Doris Blue, interview, 15 March
1977, BC). Georgia Harris followed this same pattern, but she used two
different stones. The first rubbing was done with a newer, rougher stone,
while the second rubbing was accomplished with an older, smoother
stone (Georgia Harris, interview, 10 March 1977, BC).

MINIATURES

The making of miniatures is a sub-tradition among the Catawba. The
practice is an ancient one (Coe 1952). Some of the modern Catawba

potters like the challenge of constructing tiny vessels. The Catawba
potters who make miniatures may turn to any traditional shape when
producing a miniature. In spite of their size, miniatures follow the
same construction techniques used for larger vessels and are merely
tiny versions of the full-sized vessels. Today, the most accomplished
Catawba miniaturist is master potter Edwin Campbell. All of his ves-
sels, in spite of their small size, could be used if they were larger. His
work looks much like that of his mother, the late Nola Campbell. The
following 18 shapes are the only miniatures observed to date.

1. cooking pot
2. water jar/vase
3. wedding jug
4. canoe
5. snake effigy pot
6. butter churn with lid and dasher
7. loving cup
8. turtle
9. plain pipe
10. comb pipe
11. Indian head pipe
12. candle holder
13. gypsy pot
14. duck effigy
15. Rebecca pitcher
16. water pitcher
17. peace pipe
18. duck pot

10 Design Motifs

To add extra decorative elements to their wares, many Catawba potters employ incised designs. Unfortunately, while archaeologists often excavate incised Catawba pieces in their digs, to date no one has found a site that reveals the complete body of Catawba motifs. This is true even for the area within just a few miles of the Catawba Reservation and historic living sites in both York and Lancaster counties in South Carolina.

In the summer of 2002, the University of North Carolina at Chapel Hill's department of archaeology conducted surface tests of the Catawba villages of Turkey Head, New Town, Twelve Mile Creek, Old Town, Cheraw Town, Weyanne Town, and Sucah Town (Steven Davis and Brett H. Riggs, personal communication, BC). Their preliminary findings, discussed in November 2002, may help solve the mystery of the apparent break in incising between the eighteenth century and the present. To date, parts of large vessels found are most often decorated on the rim. This is especially true at the towns examined. It is not unusual to find shards decorated not with incising but with a delicate strip of red or yellow paint on the rim.

The only vessel found with incising, the feather motif, consists of two pipe fragments unearthed at the Catawba village site at Turkey Head (SOC 617, Bower's Cabin, Research Laboratories of Anthropology, University of North Carolina, Chapel Hill, 2002). Upon examining the pottery studied from the mid–nineteenth century to the present, it appears that perhaps only pipes were incised until the early twentieth century. Many of the larger vessels so decorated are the work of Susannah Harris Owl. It is possible that she may have begun decorating vessels such as pitchers and bowls in response to her efforts to provide tourists to Cherokee with American Indian art.

The Catawba potters traditionally use very simple incised line designs on their pottery. The small number of motifs include the barred oval, cross, sun circle, swastika, and the feather. Other designs merely

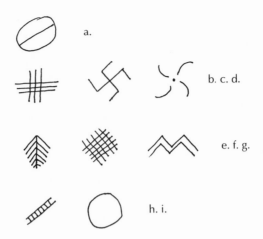

Figure 34. Common motifs.
a. Barred oval: Used by Kings Hagler and Frow to sign documents. Common motif for plain smoking pipes.
b. Cross: Used by some Catawba to sign documents. A reflection of the four cardinal directions and the four logs that feed the sacred fire.
c, d. Swastika: Used occasionally by King Hagler to sign documents. Common Catawba motif in the pinwheel version.
e. Feather: Favored motif among the Catawba potters. Used to decorate bonnets on Indian head pipes, a common motif on the peace pipe; in this century the motif has evolved to appear more like a fern than a feather.
f. Crosshatch: Used most commonly in conjunction with other motifs. Not a stand-alone motif.
g. Zigzag: Not a common Catawba motif. For the most part appears on vessels that display a multi-motif usage.
h. Ladder: A popular motif often used to make a simple line treatment more intricate.
i. Sun circle: A common motif that utilizes the other motifs in a wide variety of combinations. This motif often appears in orthodox forms that reflect the Southern Cult. This is especially true with the peace pipe.

serve to further embellish these core motifs, such as the crosshatch, zigzag, straight lines, and curves (Figure 34). All of these markings seem to be a direct reflection of the Mississippian period's love for body decoration, a fact that has been recorded among other southeastern groups. The designs either originated from or developed simultaneously with the art of body painting or tattooing. The snake in Catawba art and culture is included here because it was integral to body art and, as such, its meaning can be interpreted with some degree of accuracy.

We know the Indians of the region decorated their bodies with designs similar to those employed by the Catawba potters today. The designs also show strong Mississippian traits. The problem is we can

only document the use of such motifs from the nineteenth and twentieth centuries. There seems to be a gap in motif use between the seventeenth and nineteenth centuries. Whether this absence of information can be filled by archaeologists working in the field remains to be seen. While art historians wait for such information to come in, from all appearances the designs seem to be ancient and are very much a part of an aesthetic now almost entirely lost to the Catawba.

HISTORICAL DOCUMENTATION

Scholars have a great disadvantage when trying to make progress in researching Mississippian aesthetics. Quite often the pages are nearly blank except for the work of Le Moyne and John White (Lorant 1946). Few men during the period of great decay of native cultures felt compelled to describe the Indians in any detail. It was not rare for large parties of Catawba, Cherokee, and other tribes to send delegations to Charles Town to negotiate with the colony's authorities. Notices appeared in the *Gazette*, but descriptions were seldom provided (*South Carolina Gazette*, 19 May 1760:2).

On occasion, almost by accident, a short note was included in a commentary, yet such comments must be analyzed carefully. For instance, writing in the eighteenth century, Mark Catesby had something important to say about tattooing: "Their war captains and men of distinction have usually the portrait of a serpent, or other animal, on their naked bodies; this is done by puncture and a black powder conveyed under the skin. These figures are esteemed not only as ornamental, but serve to distinguish the warriors, making them known and dreaded by their enemies" (Catesby 1731–1743:ix). This short description is most interesting because it gives us a direct connection with contemporary Catawba art, custom, and the rank of war captain.

Some years earlier, in 1675, the Kussoe Indians ceded lands on the Ashley River to the Lords Proprietors of Carolina (Register of the Province). About 29 Kussoe Indians signed the document (Waddell 1979: 262). Most of those signing used the snake symbol and were designated as captains (war captains). Over two centuries later, Catawba chief Thomas Morrison signed an affidavit attesting to the meaning of these same signatures. That he confused Christian symbolism with traditional Catawba thinking does not diminish the importance of the signatures as marks of rank.

There is a tradition among the Indians brought down from 5,000 yrs. These are such as the serpent tempting eve our mother. The serpent is used in signing any agreement in business, and it denotes that if

the signers did not comply with the obligation punishment shall be the pay.

Chief T. Morrison
Catawba Ind.

State of South Carolina
Office of Secretary of State
I J. Q. Marshall Secretary of State do hereby certify that the foregoing signatures appear on Page 10 of Grant Book of 1675 to 1703 and that the above is a copy of a statement made by the present chief of the Catawba Indians which statement is on file in this office.

Given under my hand and seal of the State this fourth day of September in the year of our Lord one thousand eight hundred and eighty-eight and in the one hundred and thirteenth year of the Independence of the United States of America.

J. Q. Marshall
Secretary of State (Marshall)

Another brief but valuable eighteenth-century record is available to us. In 1736, a German prince/adventurer, Philip Georg Friedrich von Reck, visited Georgia and produced a small group of illustrations made during a visit to the Yuchi (Hvidt 1990). At that time the Yuchi were living near Savannah not all that far from the Catawba. Von Reck's drawing number 20 shows a woman with her left arm tattooed with a series of arrows. So impressed was von Reck by this pattern, he produced a painting and a sketch. Similarly, he produced a painting and a sketch of the *mico*, or Yuchi king. The king was painted and tattooed on both his face and his torso. It is unfortunate, for our understanding of such art in the eighteenth century, that von Reck could not stand the privations of America and soon returned home to Germany. The designs recorded by von Reck on the body of the Yuchi king are quite similar to those decorating the body of Tomo Chachi Mico of the Creek (Downs 1995:18). While it can be argued that the Yuchi were not Catawban speakers, both the Catawba and the Yuchi held the same tradition of body decorating that dominated Native American aesthetics across the region. It appears safe to assume that eighteenth-century Catawba could interpret these tattooed designs and in fact used similar body art. Unfortunately, no one interested or capable of recording similar Catawba designs visited the Catawba and left a pictorial record of the event.

During this same period, the American artist Benjamin West (1738–1820) was growing up in Pennsylvania and gathering visual impressions he would later use in his art. He most certainly had opportunities

to see frontier Indians who were painted and tattooed. When he turned to paint his now-famous *Death of General Wolfe,* in 1769, he portrayed a traditional war captain sitting at the feet of the dying general. The tattoos on the Indian's arms and legs are not far removed from those recorded on a Yuchi king around the same time by von Reck. Catesby recorded the snakes tattooed on the war captain's back (Kent, Frontispiece, 1984; Catesby 1731–1743). The serpents are from the same tradition as the snakes that Catawba war captain Pine Tree George used to decorate his prized silver gorget (see Figure 43). So close are the parallels, the Indian portrayed by West might be the recollection of a young boy's impression of a Catawba war captain observed years before. It seems most likely that the Indian portrayed by West is from the Southeast, a war captain, and perhaps even a Catawba.

In 1744, Governor Glenn of South Carolina mediated a dispute between the Catawba and the Natchez. It concerned the murder of several Catawba. As a result, the Natchez king was forced to execute the guilty parties. Glenn had their heads removed and preserved so they could be taken to the Catawba Nation. Upon inspecting the heads and their tattooed designs, the Catawba immediately were satisfied that justice had been done (XXIV S.C. Records, BPRO, 409–412, in Brown 1966:223). Unfortunately, if any descriptions of the Natchez tattoos were made they are not available.

On November 18, 1766, a notice appeared in the *South Carolina Gazette and Country Journal* describing a man and providing detail about his tattooed face: "An Indian or Mustee fellow, about 36 years of age, name Simon Flowers. . . . He is marked on the right cheek **W**, on his left with a single stroke thus **I**, which he says his father did to all his children when they were small with a needle and gunpowder" (*South Carolina Gazette and Country Journal,* 18 November 1766:1). What this notice may possibly chronicle is the survival of a family mark not unlike those recorded by Thomas Heriot in his sixteenth-century journal (Lorant 1946:271). Small clues like this are frustrating but help to develop a picture of what was happening as late as the eighteenth century.

The Indians continued to sign documents during this time, much as the Kussoe had done earlier (Waddell 1979), in ways best understood in their individual cultures. There is a marked difference between signatures done in the Northeast and those done in the Southeast. In 1764, seven Seneca headmen signed the "Articles of Peace between Sir William Johnson and the Huron Indians." The Indians drew simple animal figures, which represent clan totem signs (O'Callaghan 1855: 650–651). The southeastern Indians, including the Catawba, however, never signed a document in such a fashion. They did belong to clans

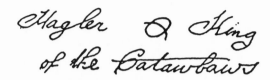

Figure 35. King Hagler signature made with the barred oval.

and these clans had totems, but apparently the southeastern Indians did not use such totems to sign documents. To date, all the signed documents uncovered by this author relate to primitive signs common throughout the Southeast: the sun circle, cross, barred oval, swastika, and serpent.

One Chickasaw document was found, and it contains numerous signatures. All are simple representations of the sun circle (Chickasaw Headmen to Governor Lyttleton, April 16, 1757, William Henry Lyttleton Papers, William L. Clements Library, University of Michigan). In 1759, the Chickasaw signed another document and used four different symbols: a barred oval, a cross, a serpent symbol, and an unidentified mark. It is impossible to determine what the Chickasaw were interpreting when they used these symbols. We might assume that if the squiggle put to the page is a snake sign, the Indian was perhaps a war captain. The cross would be in honor of the sacred fire (Howard 1968). Perhaps the signatory was connected to the fire in some official capacity. The reason for the use of the barred oval remains a mystery. To follow Warring and take the stand that this sign was the vagina or a rectum is too simple an approach (Williams 1968:11–12). As will be shown, the barred oval remains of great importance to the Catawba.

The Catawba used the very same southeastern symbols in signing their early documents. In 1757, King Hagler addressed a letter to Governor Glenn and used the barred oval for his signature (Figure 35) (Kirkland 1905:50–51). That same year King Hagler and his headmen sent a letter to the English king. Hagler signed the document with the barred oval. The second signature consists of a sun circle. The two following signatures seem to be awkward snake symbols (Petitions n.d.). On January 3, 1759, King Hagler addressed a short note to Governor Lyttleton and on this occasion signed the document with a mark that seems to be a swastika or wind symbol (Figure 36) (Kirkland 1905:52).

On January 29, 1765, the Catawba addressed a letter to Lieutenant Governor Bull in which they informed him that Frow had been chosen Catawba king by unanimous vote. King Frow, using either the sun circle or a flawed barred oval, signed this document. The three head-

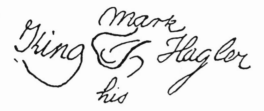

Figure 36. On occasion King Hagler used the Southern Cult swastika to sign a document.

Figure 37. Catawba signatures made in 1765 showing the full range of Southern Cult signature possibilities.

men used the snake symbol (Figure 37) (Kirkland 1905:56–57). As the Catawba learned to speak English they slowly abandoned the old symbols and began to sign with their initials. On November 24, 1792, some 31 Catawba signed a petition to the South Carolina House of Representatives. Eight used the snake symbol, six the cross, nine the sun circle, four men used their initials, John Nettles signed his full name, and three made marks, including General New River, that may be mere scribbles (Petitions n.d.). As late as 1811, the tribe sent another petition to the South Carolina House of Representatives regarding the payments of rents. Three men used the sun circle, two used a snake symbol, two apparently made an effort to use initials, General Jacob Scott used his initial "S" to sign, and John Nettles signed his full name (Petitions n.d.).

The Catawba were not alone in preserving a memory of the old designs. Although the southeastern Indians entered the nineteenth century with no hope of maintaining their once uncontested political supremacy and their cultures were on the defensive, the old heroic

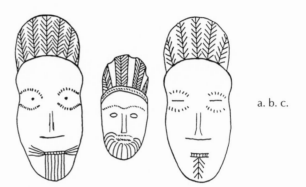

a. b. c.

Figure 38. Portrait pipes.
a. Drawing taken from an Indian head portrait pipe made ca. 1880. Shows the tattooed chin.
b. Drawing of Indian head pipe displaying the tattooed chin. Made with squeeze mold ca. 1900.
c. Drawing of a hand made portrait pipe made ca. 1880. Shows the inverted feather peace symbol on the chin.

symbols and designs were not forgotten. For instance, in 1895 the Seminole Indians of the Florida Tampa District were observed with tattoos on their hands and forearms. The simple patterns included arrows, tomahawks, and lines (Sinclair 1909:389). We don't know how the Seminole regarded these designs. They may have been read in a fashion described earlier by Heriot and Catesby. It is highly possible the Seminole had lost any ability to interpret their tattoos. Similarly, we do not know what the Catawba thought of their motifs except they were important enough to retain them as expressions from the "old Indians."

RECENT SCHOLARSHIP

In 1853, A. W. Whipple wrote his *Report of Explorations from a Railway Route, near the Thirty-Fifth Parallel of North Latitude, from the Mississippi River to the Pacific Ocean*. A German by the name of Heinrich Balduin Mollhausen was appointed draftsman for the project. Part of Mollhausen's task was to collect natural history specimens. In the course of his work, he made a painting of a Choctaw Indian whose face was either painted or tattooed. The vertical lines on the man's chin are of the same design found on Catawba portrait pipes found in several museum collections (Figure 38) (Fundaburk 1958:Figure 341).

Scholars of the nineteenth and twentieth century continue to give credence to these dim impulses from the past, and much progress has been made in the effort to understand body decoration and its applica-

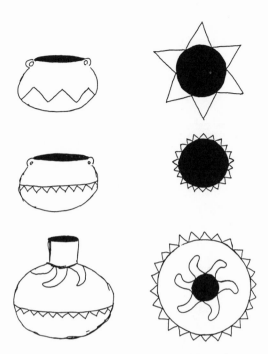

Figure 39. Three bowls taken from Willoughby showing how one usually views a vessel from the side and how one should examine a Mississippian vessel from the top down rather than from the side. In many cases this approach reveals the sun circle as the dominant motif treatment.

tion to other arts. In 1897, C. C. Willoughby published a short but very important article titled "An Analysis of the Decorations upon Pottery from the Mississippi Valley" in the *Journal of American Folklore*. In it he points out the predominance of Southern Cult symbols on pottery, some of which dominate contemporary Catawba pottery. These include the cross, swastika, and pinwheel, all of which were often combined with the sun circle (Willoughby 1897:9). More importantly, Willoughby shows us how to read such a vessel. It is not enough to look at the vessel in the usual fashion from the side. One must look down and study the design from the top (Willoughby 1897:12). Willoughby provides us with numerous examples of the results of such an approach. Even though he was not examining Catawba pots (Figure 39), the same examination method used by Willoughby may be used in reading Catawba vessels. The results are startling.

A. J. Waring and Preston Holder next took up this fascinating topic in their publication *A Prehistoric Ceremonial Complex in the Southeastern United States.* They provide numerous line drawings of Missis-

sippian motifs, including the sun circle, the cross/swastika or wind symbol, and the barred oval (Waring and Holder 1945:11, 15). Waring studied the Southern Cult and began the effort to link the Cult to contemporary Native American custom in the region. He examines this fact in such papers as "The Southern Cult and Muskhogean Ceremonial." The Catawba design motifs place these Catawban speakers in the same tradition as other tribes in the region described by Waring.

J. R. Swanton also touches upon the tattooing tradition in the Southeast in his *Indians of the Southeastern United States* (Swanton 1946). For instance, Swanton rightly links the tattooing tradition to bravery among warriors. Simple lines of red, blue, and black are placed on the stomach of the individual so honored.

More recently, James H. Howard approached the topic in his *The Southeastern Ceremonial Complex and Its Interpretation*. He takes the work of Willoughby and Waring a step further and gives graphic evidence that the Cult motifs have survived in those southeastern Indian communities he studied. For instance, his Figure 17 is a photograph of Alibamu-Koasati, a singer/dancer wearing a shoulder sash decorated with a beaded version of the flying horned snake. Howard's Figure 21 is that of a Louisiana Kosati Indian posing with a drum decorated with a repeated wind symbol or pinwheel very similar to those unearthed at Moundville, Alabama. Howard's Figure 58 is of a Creek shoulder sash decorated with a flying snake. His Figure 59 was taken from a Choctaw artisan from the Bogue Chitto community in Mississippi. It contains the cross motif and scroll designs commonly found on Mississippian pottery.

Ancient Southern Cult symbols abound in contemporary southeastern Native American art. In 1995, Dorothy Downs published *Art of the Florida Seminole and Miccosukee Indians*. Cult symbols similar to those preserved by the Catawba are frequently found on contemporary Seminole regalia. Beaded hair ornaments may consist of the cross motif surrounded by the sun circle. The treatment is very conservative (Downs 1995:148). A man's shoulder bag often has a snake motif on the flap. In effect, the snake seemed to have migrated from a tattoo on the war captain's back to his shoulder bag (Downs 1995:165). In the case of these shoulder bags (and it seems true with shoulder bags across the Southeast where they have survived as handicraft items), the strap often is decorated with a serpent pattern. With the Catawba, the snake has migrated from the war captain's back in tattoo form to the walls of a vessel.

In 1913, when a Catawba delegation attended the Corn Show in Columbia, South Carolina, the women danced with Busk turtle-shell rattles attached to their calves. Their regalia appropriately consisted of

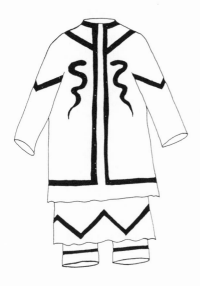

Figure 40. Catawba woman's dance dress worn at the Corn Show in Columbia, South Carolina, in 1913. Note the use of the war captain's snake insignia on the outer skirt. This dress was worn by Rosie Harris Wheelock.

dresses decorated with the honored war captain black snake insignia (Figures 40 and 41).

In 1995, this author had an opportunity to interview Chitimacha basket maker Melissa Darden at the Smithsonian Folklife Festival. When the subject of the snake image as used in art came up, Mrs. Darden reached under the counter and retrieved a Chitimacha snake basket. In this case the serpent had apparently been abandoned as a war captain tattoo motif but had survived in basketry much as had happened with the Catawba snake pot.

THE CATAWBA POTTERS

The Catawba potters are doing much the same thing as the contemporary Alibamu-Koasati, Chitimacha, Choctaw, Creek, Louisiana Koasati, and Seminole by reflecting the art of the "old Indians." The surviving art of these communities echoes the same ancient motifs to varied degrees. All of these tribes, like the Catawba, suffered the rapid decline of their native cultural environments to various degrees. In all cases it took four centuries for this to happen. For the Catawba, and most likely for the others, however, the lapse of time is not that remarkable. The oldest and finest of the documented Catawba vessels found in museum collections were made in the last quarter of the nineteenth century. The individuals who did this work, constructed and decorated these vessels, were only removed from the last glimmer of a still relatively intact Catawba way of life by two folk-life-memory generations. They looked back on the "old Indians" to a time when

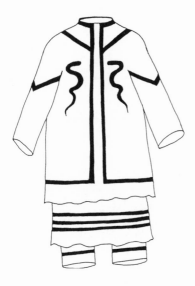

Figure 41. Catawba woman's dance dress worn at the Corn Show in Columbia, South Carolina, in 1913. Note the use of the war captain's snake insignia on the outer skirt. This dress was worn by Rachel George Brown.

the folkways were still relatively pure. For instance, the great potter Martha Jane Harris, one of the easiest potters of this generation to document, lived from 1860 to 1936. She learned her craft from her mother Peggy George Harris who learned her craft from the Revolutionary War generation of Indians. We are fairly certain that the Catawba of this period still proudly wore the old tribal designs in either tattoo form or perhaps even used them in body painting, particularly when they went off to war. Martha Jane's grandparents certainly knew Pine Tree George, either in person or through folk stories. At the same time, other than a general understanding of the peace pipe and its relation to the four cardinal directions, the contemporary Catawba have little knowledge as to what the motifs may mean. Their reason for using them remains firm: "These are the designs the old Indians used, and we use them too."

When speaking of Catawba pottery design motifs, the old and very fine nineteenth-century vessels reflect a tattooing origin or at least link to this tradition. The style of decoration found in one distinct set of nineteenth-century vessels reflects the tattoo artist's technique, which is also observable in pre-Columbian vessels found across the Southeast. The potter so marking a vessel proceeds in much the same way as a tattoo artist. First the potter makes a clean line in the wet clay. The tattoo artist does the very same thing on a person's skin. Then the potter takes a pin and punctures the line at even intervals just as the tattoo artist pushes the ink beneath the surface of the skin (Figure 42).

There exists a very small number of Catawba pipes that were hand

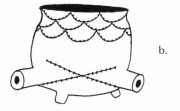

Figure 42. Tattooing technique.
a. Prehistoric usage of tattooing
technique in pottery decoration.
b. Catawba peace pipe exhibiting
the same tattooing technique. Made
ca. 1880.

bent, not made with a squeeze mold, in the nineteenth century. These pipes are more accurately termed portrait pipes, for they seem to be efforts at portraiture on a very basic level. Three of these pipes show men decorated with tattoos or with painted designs on their chins. The first pipe was discovered in the Smithsonian collection (Figure 38a). The design on this pipe is also found on the chin of the Choctaw man drawn by Mollhausen. The second pipe was found in the Simpson Collection, now housed in the Catawba Cultural Preservation Project Archives. In this case the potter added more vertical lines than required (Figure 38b). The third pipe is from the University Museum collection at the University of Pennsylvania. The man portrayed here has an inverted feather (a gesture of peace) upon his chin (Figure 38c). Other so-called portrait pipes have been located; but, to date, these are the only examples with possible tattooing or body painting on the face. The McKissick Museum collection at the University of South Carolina has an Indian head pot that displays traditional Catawba body art. This vessel is signed and can be dated. It was made by Fanny Harris Canty (1900–1951). She learned her art from her grandmother Sarah Jane Ayers Harris (1839–1918).

Another piece of evidence comes from the hand of Pine Tree George. He was one of the last documented Catawba war captains. As such, Pine Tree may have had the honor of wearing the black snake insignia tattooed on his upper back and shoulders. There is no documentation that he did, but, in the late eighteenth century, Pine Tree George was the recipient of a silver gorget for his war service. He wore this tribute of honor around his neck. The front bears his name inscribed in bold letters by the silversmith. Not satisfied with the gorget, Pine Tree George laboriously worked to engrave his rank insignia on the gorget's

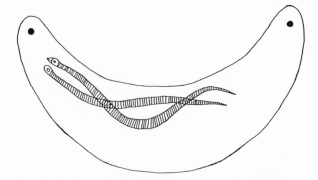

Figure 43. Drawing taken from the reverse side of the eighteenth century
Pine Tree George gorget. Displays the serpent war captain insignia.
The two snakes engraved on this silver gorget presumably by Pine
Tree George.

reverse. He obviously felt the two snakes spoke better for his accomplishments in life (Figure 43). Pine Tree George knew how to interpret the signatures on the 1764 Kussoe land cession agreement better than did Chief Thomas Morrison. He was probably present when the Natchez Indian tattooed heads were removed from the buckets of brine in which the governor of South Carolina had preserved them. He was able to read such marks. As a war captain, his advice was sought on all matters regarding war.

A brief discussion of each Catawba motif treatment in the context of Catawba usage and antiquity, primarily as Southern Cult symbols, will help put the Catawba incising tradition in its proper perspective.

SUN CIRCLE

The sun circle is perhaps the motif most commonly used in incised Catawba pottery. It can be seen if one follows Willoughby's method of observation, looking from the top down. In this way the sun circle can be analyzed in its most conservative treatment. Nearly every incised vessel exhibits a portrayal of the sun circle, sometimes in ways that are exactly parallel to examples found at the most studied Mississippian period sites. The treatment can be accomplished in a singular way. It can also be a complicated series of overlapping sun circles such as in the turtle pipe attributed to Billy George and today found in the University of North Carolina collection at Chapel Hill (Figure 44). Other more simple combinations of the sun circle motif can be just as dramatic (Figure 45). Once the Willoughby method of reading is ap-

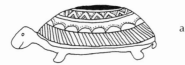

a.

b.

Figure 44. Turtle pipe.
a. Drawing of turtle pipe attributed
to Billy George (1800–1896) as typi-
cally viewed from the side.
b. Drawing is done by the Wil-
loughby method looking down on
this same pipe. This method reveals
a total of four overlapping sun circle
motifs on one very small smoking
pipe.

Figure 45. Drawing of a sun circle mo-
tif taken from a snake pot made by con-
temporary master Catawba potter
Monty Branham. The original pot was
part of a Law Library, Library of Con-
gress exhibition mounted in 1997.
(Blumer Collection)

plied to Catawba pottery, this becomes clear. This method will be used throughout this discussion of the Catawba incising tradition.

BARRED OVAL

Of all the incised designs used by the Catawba potters, the barred oval motif appears to be the most important on an individual level. Easily linked to the drawings of Le Moyne and Hagler's signature, it is tempt-ing to speculate that this design may very well represent the one motif most important to sixteenth-century Indians in general. It is not, how-ever, an exclusive Catawba motif. It appears repeatedly in the docu-mentation coming from other southeastern Indian communities. A sixteenth-century Native American presented with this motif probably would not have been able to tell that it was of Catawba origin. Such an identification depended on a combination of motifs, and this infor-mation is lost to us. Rich in possibilities, the motif is found in a large

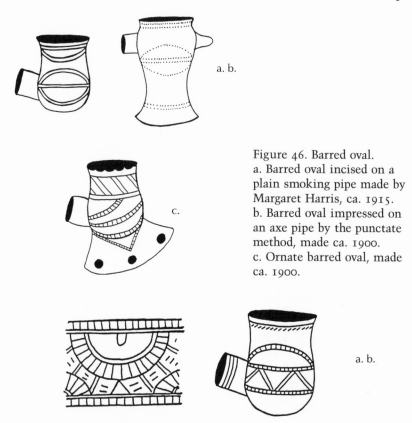

Figure 46. Barred oval.
a. Barred oval incised on a
plain smoking pipe made by
Margaret Harris, ca. 1915.
b. Barred oval impressed on
an axe pipe by the punctate
method, made ca. 1900.
c. Ornate barred oval, made
ca. 1900.

Figure 47. a. Detail of tattoo motif from Le Moyne, Figure 12 (Lorant
1946:59).
b. Drawing of a contemporary Catawba pipe displaying a similar motif.

number of variations and in numerous situations beyond the king's sig-
nature on a document (see Figures 35 and 36). For Georgia Harris, it
was a favored motif for plain smoking pipes. She learned her craft and
the use of the motif from her grandparents Epp Harris (1830–1916) and
Martha Jane Harris (1860–1936) (Figure 46).

As with the sun circle and as portrayed by Le Moyne, the barred oval
can often be part of a multi-motif treatment. For instance, the chief
pictured by Le Moyne is tattooed with the barred oval in combination
with the ladder motif (Figure 47). This is a common Catawba treat-
ment. The only surviving original painting, now owned by the new
York County Public Library, reveals that the tattoo marks Le Moyne
placed upon Chief Saturina's body are exactly the same as the barred
oval used to decorate Catawba vessels (Figure 48). It is the same symbol
used by King Hagler to sign at least one document (see Figure 35).

Figure 48. a. Detail of a tattoo motif from Le Moyne, Figure 32 (Lorant 1946:99).
b. Drawing of a contemporary Catawba pipe displaying a similar motif.

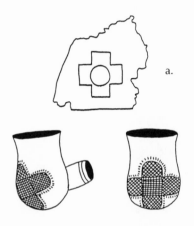

Figure 49. Cross designs.
a. Cross design from a fragment of cloth preserved through direct contact with copper. Excavated at Etowah, Georgia.
b and c. Cross incised on a plain Catawba smoking pipe, made ca. 1880.

CROSS, SWASTIKA, AND PINWHEEL

The cross and its variations of the swastika and pinwheel are well known in both North and South America. These motifs are found everywhere in ancient and modern Native American art. These important reflections of the sacred fire and the wind that feeds the fire are important to the Catawba potters (Howard 1968). The Catawba do some of their finest incising when these motifs are the subject. An example is an elbow pipe found in the Smithsonian collection. It was made in the nineteenth century by both a master pipe maker and a potter with a sure hand at incising this delicate cross symbol on such a small curved surface (Figure 49b, c).

The swastika has apparently never been a popular Catawba motif. To date, the motif has been found on only one vessel, an Indian head pot found in a Chester, South Carolina, antiques shop (Figure 50). Again the work is exceedingly well executed and shows that the potter considered the decorating task important.

Among the Catawba potters, the pinwheel variation is far more

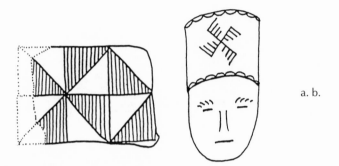

Figure 50. Swastikas.
a. Swastika incised on a prehistoric shard found at St. Johns River, Florida.
b. Swastika incised on a Catawba Indian head lug, made ca. 1880. (Blumer
Collection)

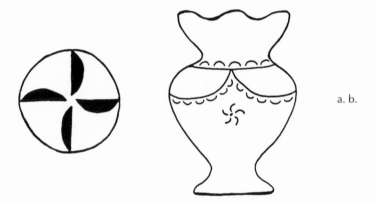

Figure 51. Swastikas.
a. Pinwheel version of a swastika motif cut into a copper gorget excavated at
Etowah, Georgia.
b. Pinwheel version of a swastika incised on a Catawba jar of a modern
shape, made ca. 1900 (Blumer Collection).

popular than is the swastika. A number of examples may be found in
the Poag Collection (Figure 51) (BC).

 In southeastern Indian art, the cross is linked to the sacred fire, the
logs of which point in the four cardinal directions (Figure 52). Keeping
the fire was a universal practice, and is reflected in much of the art
produced by contemporary southern Indians. The symbol was used in
signing Colonial documents and is still used on simple items of deco-
rative art being produced in the region.

 The most readable of all the Catawba cross treatments is found in

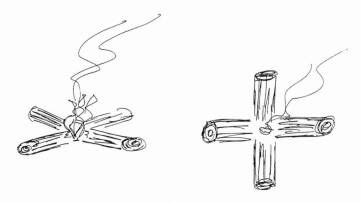

Figure 52. Sacred fire pattern
shows the four cardinal directions.

the Catawba peace pipe. This curious vessel, which has long puzzled those who have examined it and studied its construction, is in actuality a simple reflection of the sacred fire. This revelation becomes obvious when the peace pipe is seen in its ceremonial context. Also, one can only understand this little vessel when it is studied using the Willoughby method, looking from the top down. Viewed in this way, the bowl, filled with smoldering tobacco, becomes the sacred fire. The traditional four stems that point in the four cardinal directions are the four logs that feed the sacred fire (Figure 53).

Once the peace pipe is seen in its proper context, the Catawba potters' devotion to this little pipe becomes obvious. The mystery that once shrouded this vessel suddenly evaporates. The potters' stubborn refusal to abandon the peace pipe has puzzled observers for the last century. The vessel is difficult to build and has never been cost effective to make. Even at today's prices, which can top 100 dollars, the potters find it difficult to make a profit. A total of seven pieces of clay must meet on a tiny bowl in perfect harmony. The four stems must point in the four cardinal directions, a feat difficult to attain in wet clay. All this must be done to perfection before the potter begins to spend hours burnishing and incising the vessel. The pipe must at the same time be able to be smoked. Until the stems take a river cane reed, it is hard to see a situation where four people might smoke this pipe, yet when placed in a historic ceremonial context, all this become clear. Once the pipe stems are properly decorated in the four cardinal direction colors of red, black, white, and yellow the vessel needs little explanation.

The last time the peace pipe was used in a treaty ceremony can be

Figure 53. Undecorated peace pipe observed by the Willoughby method from the top down showing the clear reflection of the sacred fire.

traced to 1752. At that time the Catawba, led by King Hagler, traveled from the Catawba Nation on the South Carolina frontier to Albany on the New York frontier. They went at great hazard to themselves into enemy territory and had to be protected from possible Six Nations trickery. The peace-making ceremony is preserved in a brief description made by an eyewitness (O'Callaghan 1855). The Catawba entered the treaty grounds dancing and singing with their feathers pointed to the ground in a peaceful gesture. At the proper time, King Hagler produced a pipe, which unfortunately goes undescribed. He lit the pipe and smoked it with each of the Six Nations representatives present. The pipe was not thought worthy of description by the official witness, but since it was produced by the Catawba king, we can be fairly certain it was a Catawba peace pipe. Although the peace pipe has not been used in such a ceremony in over 250 years, the pipe still has an official position in the Catawba General Council. Peace pipes are often presented to honored government officials such as the governor of South Carolina, judges, and members of the legislature. Such pipes were presented to Senator Strom Thurmond, Senator Ernest Hollings, and Representative John Spratt in 1986.

The Catawba spend a lot of time decorating the peace pipe. But a pipe can also be undecorated and still make a statement, such as in Figure 53. The decoration can grow in complexity in accord with the potter's incising skills (Figures 54 and 55).

FEATHER MOTIF

One of the most popular motifs is the feather, which is so often connected to Indian culture by non-Indians. It is usually seen on the bonnet of the Indian head or King Hagler pipe (Figure 56). Although it is normally restricted to the smaller and more personal pieces such as

Figure 54. An incised peace pipe observed by the Willoughby method from the top down showing not only the sacred fire but also the use of a sun circle motif.

Figure 55. A more ornate incised peace pipe observed by the Willoughby method from the top down showing not only the sacred fire but also the use of a sun circle motif. This vessel is attributed to Rhoda George Harris (ca. 1818–1918). (Blumer Collection)

Figure 56. Several feather motif treatments incised on an Indian head pipe. (Blumer Collection)

pipes, it is sometimes used to decorate larger vessels as well. Georgia Harris often circled the rims of her bowls with the pattern's graceful variation. Doris Blue often used the feather motif for her smoking pipes. Peace pipes are often decorated with this motif. As a rule, the feathers point downward as a sign of peace (Figure 57).

This motif has undergone a certain evolution in the last 120 years. The oldest form of the motif is stylized and stiff and bears a striking resemblance to what archaeologists might find in a dig. Pipes attributed to Susannah Harris Owl are decorated in this fashion (Figure 58a). One of the first documented potters to begin the transition of the feather motif to that of a fern or a palm leaf was Rosie Harris Wheelock (Figure 58b). Her daughter continued the process (Figure 58c). In recent years some of the potters have tended to make their feathers graceful, more in the direction of fern fronds. In some potters' interpretation, the motif is somewhat confused between a feather and a leaf.

While Susannah Harris Owl tended to be very traditional, she sometimes decorated her larger pots with this motif. With her, the feather definitely becomes a fern symbol, which has no pre-Columbian roots that have been discovered to date (Figure 59).

THE SNAKE

The Catawba snake pot compares to the peace pipe in its importance to the Catawba potters. It is a clear reflection of the Cult of the Serpent in the southeastern Indian cultural context. The snake portrayed is the sacred black snake, which has a rich history in Catawba legend and folklore. Mary (Dovie) Harris claimed to be able to charm snakes. She often frightened children by going to the edge of the woods and putting her arms in the air and singing out, "All yee snakes and lizards come

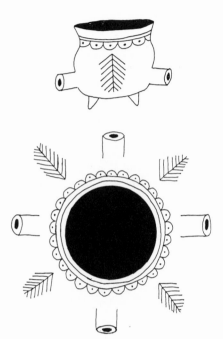

Figure 57. Peace pipe with the feather pointing down in the peace gesture and also viewed by the Willoughby method from the top down.

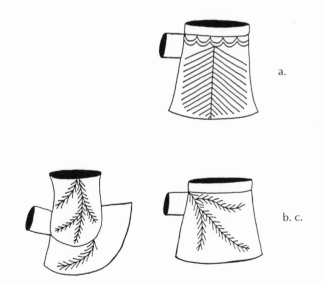

a.

b. c.

Figure 58. Axe pipes and comb pipes.
a. Axe pipe made by Susannah Harris Owl (1847–1934).
b. Comb pipe made by Rosie Harris Wheelock (1880–1935).
c. Axe pipe made by Doris Wheelock Blue (1905–1985). (Blumer Collection)

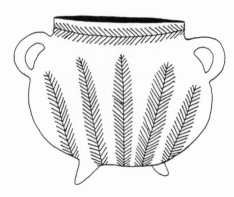

Figure 59. Gypsy or medicine
pot made by Susannah Harris
Owl, ca. 1900.

unto me." Catawba folklore abounds with snake stories such as the
giant snake that lurked in the Catawba River preying on unsuspecting
Indians fishing or going there to draw water. But the snake pot is more
than a reflection of these interesting folk tales. It is directly related to
the rank of war captain.

The war captain rank was honored throughout the Southeast (see
Figure 43). Originally, both men and women held the rank (see Figures
40 and 41), as is obvious from the Kussoe land cession document where
several female signers are designated as "captains." It was earned in
warfare. Those Catawba who gained this rank did so with scalps and
other evidence of deeds of valor. They assisted the king in convincing
tribal members to follow him in war parties and were crucial to the
success of any such venture. Although the rank died with Catawba par-
ticipation in the Indian Wars, the snake symbol survives in numer-
ous works of art. The motif is used on shoulder straps by the Creek,
Kousati, Seminole, and Yuchi; on the basket by the Chitimacha; and
on the revered snake pot by the Catawba.

The Catawba snake pot is usually but not always a humble cooking
pot. The snake traditionally appears in high relief on the side of the
vessel. It usually seems ready to crawl into the pot. It is most often
the potter's greatest accomplishment in Catawba pottery making. Not
all but most Catawba potters make the shape. Today it may be found
on vessels other than the cooking pot. These include the gypsy pot,
shallow trays, water jars, and even the Rebecca pitcher. Probably the
most triumphant snake pots ever attempted by any Catawba potter are
the monumental sculpted vessels made by Earl Robbins. Perhaps the
most sensitive versions ever made by a Catawba potter are the work of
the staunch Baptist, Susannah Harris Owl, who refused to discuss the
old religion with Frank G. Speck but was celebrated for her fine snake

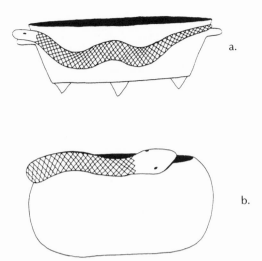

a.

b.

Figure 60. Snake pots.
a. Snake pot in the form of a tray with four legs made by Susannah Harris
Owl (1847–1934).
b. Snake pot made by Doris Wheelock Blue in 1971. (Blumer Collection)

pots (Speck 1934:xiii). Today, a number of new generation master pot-
ters are becoming known for their snake pots (Figure 60).

Secondary Patterns Used to Elaborate Primary Motifs

The Zigzag
This simple design has never been popular with the Catawba potters.
It is included here because the Catawba use it on occasion, and it is
the one pan-Indian motif most immediately identified with American
Indian art. If the zigzag is used in Catawba incising it is often part of
a multi-motif usage such as that found on the Billy George turtle pipe
(see Figure 44). The two Catawba examples provided here show that
the potters use the motif pleasingly when they do select it (Figure 61).
The Catawba have not been observed using this motif as illustrated by
Willoughby in his interesting method of study (see Figure 39). Rather
than use the zigzag, the Catawba potter will turn to the curved line.
The results of this preferred approach may be analyzed in the figures
included here.

The Ladder
This elaboration of any two parallel lines never appears alone on any
vessel. It is always done in concert with other motifs. The barred oval
is often made more complicated by this device (see Figures 46 and 47).

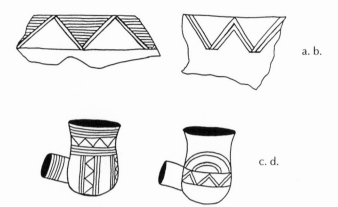

Figure 61. Zigzag motifs.
a. Zigzag motif incised on a rim shard from Etowah, Georgia.
b. Zigzag motif incised on a rim shard from St. Johns River, Florida.
c, d. Zigzag motif incised on plain Catawba smoking pipes, made ca. 1900.

The outer edge of an incised turtle effigy often shows the ladder design, probably because it seems most natural to the actual turtle shell rim pattern (Figure 62). It is very effective when used with other motifs and is often embellished with a dot appearing in each section of the ladder.

The Crosshatch
The appearance of the crosshatch on Catawba vessels has literally thousands of parallels between the prehistoric and the present. Museum collections containing southeastern materials invariably have numerous fine examples of this pattern. By nature it cannot appear without being part of another motif. It carries no meaning by itself.

Many Catawba pipes and peace pipes dating back to the late nineteenth century exhibit this pattern (Figures 49, 54, and 63). The potter credited with the survival of the crosshatch during the decline of the Catawba tradition from 1930–1970 is Doris Blue. She used it effectively, and today's new generation master potters are very apt to emulate potters like Doris Blue. Another factor in the survival of the crosshatch may be its use on the turtle effigy. The motif is not the only pattern used to decorate the turtle effigy, but it seems the most natural to the turtle shell's appearance (Figure 62). The same is true of the incising used in the snake effigy (Figure 60). To the potters, the crosshatch reflects the skin pattern of a living snake and is most often used in incising the body of a snake effigy. On occasion, however, the potters will use a series of curved lines or a series of closely placed lines, which do not reflect the pattern found on any particular snake.

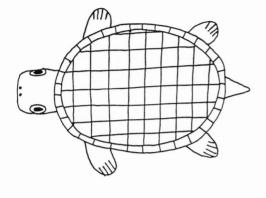

Figure 62. Crosshatch and ladder motif shown on a contemporary Catawba turtle effigy.

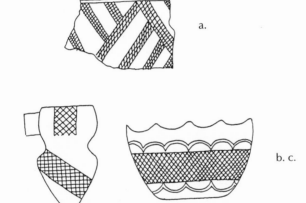

a.

b. c.

Figure 63. Crosshatch motif.
a. Crosshatch motif incised on a prehistoric shard found at St. Johns River, Florida.
b. Arrowhead pipe made in the early twentieth century by Rosie Harris Wheelock (1880–1935).
c. Small bowl (3″ × 2″) attributed to Nettie Harris Owl Harris (1872–1923), made in 1909 for the Cherokee trade. (Blumer Collection)

CONCLUSION

The Catawba incising tradition between the nineteenth and twentieth centuries remains clouded in mystery. It now seems apparent though that the nineteenth-century Catawba restricted their incising to small vessels, especially pipes. A shift in the incising tradition occurred at the end of the nineteenth century. It appears that the artistic shift may be linked to the efforts of Susannah Owl to provide the early tourists at Cherokee with examples of Indian art. She continued to decorate her

pipes in the traditional way, but she also sought to make her larger vessels more Indian in appearance through expanding the area of incising to the outer walls of large vessels.

There is little doubt that strong artistic connections remain between the sixteenth century and contemporary incised Catawba pottery. The early explorers found Indians who were content with their methods of beautifying their bodies with paint and tattooed designs, but between Le Moyne and White's artistic endeavors and the war of the American Revolution much had been lost. The Catawba is one community that has lost nearly all of its old culture, yet they have retained one wonderful glimmer of the past in their incising tradition.

The Catawba experience is not singular. Archaeologists discover new and ever more interesting perspectives as they continue the laborious task of looking into our region's prehistory. Work is being done all across the region. Artifacts of importance are being found as this book is being written. These important messages from the past must be brought together as part of a larger body of evidence. In this way we will begin to deepen our understanding of the southern Indian at the time of contact. This material provides us with a chance to grow in understanding so long after the facts of contact have been covered by the dust of time.

As agreed on by everyone who has done research with the old records, the Colonial period documents remain a weak link. Examining Colonial documents from Texas to Virginia needs to continue in a methodical way. All the citations discovered in this process need to be brought together, perhaps in one comprehensive publication.

At the same time, the contributions of existing Native American communities, including the Catawba, must be examined more closely. Every clue, every bit of important evidence should be used to its fullest potential. The three pieces of the puzzle must be brought together. The problem is that this task has been done piecemeal. The crucial work cannot be done by one discipline alone. The full range of academic scholars must tackle this issue in cooperation if progress is to be made. Anthropologists, archaeologists, ethnologists, folklorists, historians, and the Native Americans themselves must join hands in a new way and bring this important part of history to light.

The motifs preserved by the old Indians continue to decorate Catawba vessels. The catalog of such motif treatments contains a multitude of examples not used as illustrations here. Indeed, the work of today's new generation master Catawba potters looks back to the nineteenth century and seeks to rival the works of master potters such as Martha Jane Harris, Billy George, Susannah Owl, and Epp Harris, to name a few. Vitality is in the Catawba tradition. The same energy seems to be waiting to be tapped in other southeastern Indian communities.

11 The Pipe Industry

The Catawba pipe tradition traces its roots to the very origin of tobacco use and the invention of smoking paraphernalia in the Southeast. It continues to exhibit great vitality, and pipes are produced in a wide assortment of forms and styles (see Figures 29, 30, and 31). Making pipes is, in effect, a Catawba sub-tradition. Since pipe bending, as the Catawba call it, requires special skills, some Catawba excel at the craft while others do not. The current incentive to make pipes is often linked to the ownership of pipe squeeze molds, which makes pipe making easier. For instance, Doris Blue was well known for her pipes, many of which were mold made. Georgia Harris's pipes were much sought after, too. This potter used molds made by her grandparents and also bent pipes by hand. Catherine Canty did not have molds and was known for her pipes, but she did not make nearly as many pipes as she would have if she had pipe molds. Potters with an affinity for pipes, like Earl Robbins, have difficulty keeping up with the demand for them. There is a growing interest in pipe making among the male potters. Those young contemporary potters who excel in pipe making include master potters Monty Branham, Keith Brown, Edwin Campbell, and Donald Harris, to name only a few.

Of those who were working at the end of the nineteenth century and the turn of the twentieth century, perhaps the best-documented pipe makers include Epp Harris, Sallie Gordon, and Billy George. During this period, master pipe makers were held in high regard, for tobacco was either chewed or smoked in a clay pipe, and smokers always sought a well-balanced and attractive pipe.

For any pipe to be successful, it must be utilitarian. A pipe must have balance, be light in weight, and attractive to the eye. It must be easy to hold. Being a smoker is not a prerequisite to making a good pipe but it helps. Few of the Catawba potters are smokers; but as a rule, an ability to identify closely with the smoker's needs is of value.

The Catawba have been known for their pipes for centuries, and the

pipe trade itself is ancient in origin among the Catawba. The two are linked. Writing at the beginning of the eighteenth century, John Lawson emphasized the importance of smoking pipes to the contemporary Carolina/Catawba Indian trade: "At spare hours the women make baskets ... others, when they find a vein of white clay fit for their purposes, make tobacco pipes, all of which are often transported to other Indians that perhaps have greater plenty of deer and game; so they buy with these manufactures the raw skins" (Lawson 1714:316). The business records for the Colonial period also contain references to the general importance of pipes among the American Indians. For instance, when William Penn made his 1672 Indian land purchase, 300 pipes, 100 hands of tobacco, and 20 tobacco boxes were included in the purchase price (McGuire 1899:461). Five years later, another land purchase was made from a New Jersey tribe, and 120 pipes were part of this bargain (McGuire 1899:461). Although these transactions were not made in South Carolina, much-sought-after trade items were the same all along the Atlantic coast, for the trade needs of the Indians were comparable.

At this time, if one smoked, one smoked a pipe. Pipes were made of clay and because they were easily broken, required frequent replacement. The clay pipe would not decline in popularity until the twentieth century when first the briar pipe and then the cigarette became popular (Sudbury 1977:123). As late as 1890, one American pipe kiln was large enough to fire 200,000 pipes in a single firing. This particular pottery-making operation shipped 400,000 clay pipes per week (Sudbury 1977:123). Although the Catawba tradition predates the establishment of European potteries, and the Catawba had long faced this competition, the Catawba pipe tradition suffered more from the abandonment of the smoking pipe for the cigarette than it did from the factory-made clay pipe.

Following contact with European culture, the enduring popularity of the clay pipe allowed the Catawba pipe tradition to survive. The Catawba maintained a brisk wholesale trade in pipes as long as local non-Indians smoked them. The small size of the Catawba Nation and the subsistence nature of the pottery tradition also allowed the Indian pipe makers to exist on the fringes of the mammoth American pipe industry. While modern potteries produced pipes by the thousands, the Catawba sold theirs by the dozen.

Early in the twentieth century, Martha Jane Harris, a master pipe maker, provided several country stores within easy access to the Nation with pipes. According to her granddaughter's recollections, "She didn't get $1.25 a dozen for pipes" (Georgia Harris, interview, 19 March

1980, BC). All the potters of Martha Jane's generation participated in this trade.

Perhaps the last Catawba potter to make large numbers of pipes was Sallie Gordon. Georgia Harris recalled the speed with which Sallie Gordon worked:

> She made a lot of little trinkets, pipes and things. I remember when she lived right up here with Irvin, a lot of times she'd sit outside—now this was when she was real old. She'd always talk about bending pipes. . . . She wouldn't have a mold now. She'd just take her clay and she would bend them and just set out a dozen in a little while. . . . She didn't finish them off so good I didn't think—rub them so smooth because she worked them a lot when they were real damp. She didn't wait until they got a little bit dry. She'd rub them then, but they'd be a little bit rough looking, but she could make some. She could turn them out. . . . I never would have made them that fast. (Georgia Harris, interview, 19 March 1980, BC)

When MacDonald Furman visited the Catawba late in the nineteenth century, he noted the importance of the pipe-making tradition. His writings contain a description of the process as he observed it: "A short distance further on they came upon another house very much like the one just described [log construction] and another woman proved to be the only occupant. She was engaged in shaping an Indian clay pipe with the blade of an old cane knife, still busy with her work as she came to the door answering to 'Hello!'" (Furman 1890). This brief description brings us close to the advantages found in pipe manufacture in the Catawba tradition. Making larger vessels requires a block of time and a regular schedule of drying periods. The pipe maker can easily work on pipes while meeting other household obligations. Once a quantity of pipes is made, the potter can take up a pipe at any time and scrape, rub, decorate, or bore out the bowl. The making of pipes is perfectly suited to a busy homemaker. Indeed, the best pipes are made during short periods of intense labor. The nature of this fine work requires a kind of attention that is difficult to sustain for long periods.

Another built-in advantage to this tradition is standard pricing. In 1900, Martha Jane Harris knew exactly what she could expect to make from the sale of a dozen pipes, so it was easy to measure the results of her labor. In the 1980s, her granddaughter, Georgia Harris, who used the same molds and techniques, sold the same pipes for five dollars each. Again, the potter has no difficulty estimating the proceeds from

a day's labor. In 1900, pipes were sold for a dollar a dozen, and by 1994 the price had risen to 540 dollars a dozen. The prices remained competitive, and almost any visitor to the Nation was apt to purchase a pipe or two. Today the same pipes sell for 45 dollars each. If the stem is decorated, the price is higher.

Still another advantage is low breakage during the burning process. In 1978, Georgia Harris wrote of burning some pipes: "I was trying to finish the pipes my grandson had sold for me here in Ohio. Thursday I burned them, didn't lose a one. I was really proud for that. I finally got my slugs burned along with the pipes. The ones I am going to use for mold making" (Georgia Harris to Blumer, letter, 26 August 1978, BC).

The Catawba, always in tune with their market demands, are quick to see the value of an attractive pipe form and exploit it. During the well-documented nineteenth century, the potters endeavored to make true Indian pipes by slavishly reproducing the traditional shapes and decorating the pipes with ancient Catawba incised motifs. According to Harrington, the only aboriginal Catawba pipe was the so-called chicken comb pipe (Harrington 1908:402). This form is still produced in large numbers. Harrington did the Catawba a tremendous disservice, though, for the Catawba seldom depart from their customary shapes. Although the invention of the smoking pipe is American Indian, we often fail to think of the pipe as Native American, primarily because the Indians lost control of this market as soon as Europeans applied modern industrial methods to its manufacture. This happened almost as soon as tobacco smoking was introduced in Europe. As a result, first European and then American potteries produced cheap clay pipes by the millions. By virtue of the sheer number of European pipes on the market, people soon came to think of even the smoking pipe as something that was part of European culture. Even most Indian communities soon abandoned their own pipes for those of European or American manufacture. Only the Catawba of South Carolina clung stubbornly to this part of their heritage.

The Indians of the Southeast had long made effigy pipes, and the European market soon followed suit with anthropomorphic copies (May 1987). The Catawba continued to produce Indian head pipes, and well before 1880 most of the Catawba were producing the so-called King Hagler pipe. Nineteenth-century molds used to produce this pipe are still in use among the potters today, along with molds of more recent manufacture. A small number of hand bent and built Indian head pipes have always been made. Because some of these approach the likeness of individuals, they are commonly referred to as portrait pipes.

The Catawba pipe tradition has also resorted to adopting non-Indian

styles. When the briar pipe became popular, the Indians copied this pipe in clay, decorated it with traditional incised motifs, and attached a short reed stem to finish it off. Georgia Harris recalls Epp Harris's personal smoking pipe, which was a copy of a briar pipe: "He would make pipes. Well, he loved to make pipes, and he made one that he smoked his own self. . . . It had a stem. . . . The pipe was just a plain pipe, and then the stem [of clay] would run out here. Then you would have to put just a little cane, just a short one" (Georgia Harris, interview, 19 March 1980, BC).

Since the Indians had made clay pipes for many centuries, it was easy for them to lavish their creative skills on the form. Along with plain pipes, Indian heads, and the comb, they made horse, dog, snake, and turtle effigy pipes. These may or may not have pre-Columbian precursors. We can be fairly certain that the snake and the turtle pipe are very ancient among the Catawba. Evidence for the snake effigy pipe rests in a vessel found in York County by a pothunter and recorded by Tommy Charles (Charles 1981). A similar vessel made in the nineteenth century can be found in the Heye Foundation collection. Visitors to the reservation eagerly sought these pipes, and a brisk trade was maintained. Tools regularly associated with Indian culture also became suitable subjects for pipes, and one of the most popular is the axe or tomahawk pipe. These, too, can be either bent by hand or mold made. They come in as wide a variety of shapes as those found in tool sheds across the South. Only the plain axe is produced from molds dating from the nineteenth century. Earl Robbins probably makes the widest assortment of axe pipe shapes.

Another form associated with the Catawba pipe industry is the arrow pipe. The bottom of the bowl is decorated with an arrow, which hangs down from the bowl like a pendant. This form is often decorated with a second projectile point that protrudes from the front of the bowl, away from the smoker. Occasionally, a potter will go beyond tradition and take such a pipe a step in the abstract direction. Such creations are called fanciful pipes.

At the end of the nineteenth century, Epp Harris, a master pipe maker, began to produce shoe or boot pipes. A limited number of these have been located in museum collections. Most are replicas of the high-top shoes worn by women of the late Victorian period. A few are boots. So popular was the shape that Epp Harris made a set of molds so he could keep up with the market demand. His granddaughter, Georgia Harris, used these molds until her retirement in the 1990s. Epp Harris introduced the shoe pipe to the Pamunkey Indians during his late-nineteenth-century visit to that Virginia tribe. In 1993, one of Epp Harris's boot pipes was found in a collection owned by Mary Miles Bradby.

Epp Harris had apparently given the pipe to Pamunkey Chief Paul Miles, who treasured it. His daughter, Mary Bradby, finally was given the pipe; it had never been burned (Acquisition File, BC).

At times a potter will produce a unique pipe in a moment of creativity. Such pipes do not normally enter the tradition as permanent forms. A good example is the teapot pipe, which is possibly the work of Billy George. In only one aspect is it aboriginal—its construction technique. It hovers between modern innovation and the venerable tradition through the use of incised designs. Reportedly, in the late 1970s, Louise Bryson produced a number of horse saddle pipes in one of her bursts of creative energy. Other potters either never saw the form or found it uninteresting. Neither the teapot nor the saddle pipe forms became a lasting part of the tradition.

The turtle pipe exemplifies a form that is apparently very ancient, but was lost as a viable shape by the potters at the end of the nineteenth century. MacDonald Furman first recorded its existence in 1894 when he purchased a turtle pipe during a visit to the Nation (Furman 1894). Since the form had then fallen out of favor at the turn of the twentieth century, no contemporary potter had knowledge of a turtle pipe until its revival in the late 1980s.

In Catawba lore, the turtle shares a position similar to the serpent. Speck's Catawba texts preserve a small amount of this folklore, but nearly all of these fragments are examples of minor beliefs that are difficult to place in pre-Columbian Catawba religious practice. It is interesting that Susannah Owl was able to link the turtle to the creation story, precisely to the reception of life-sustaining water:

> The turtle with the big head kept back the water from the people. He sat over the spring and kept the water back. The snapping turtle was very bad. He alone kept the water back. The rabbit came up to him and said, "I want the water. Some water I need very much." "You cannot have the water," said the snapping turtle. The rabbit replied, "If you give me a drink, I'll say, 'Thank You.'" The snapping turtle refused. In the meanwhile, the rabbit scratched the ground underneath the turtle and made a ditch and the water ran out. So much ran out over the earth that it made gullies. The water flowed very well since that time. That is why water flows now. (Speck 1934:10–11)

The revival of the turtle pipe followed two recent findings. The first example of a Catawba turtle pipe was found in 1983 in the collections of the University of North Carolina (Coe, interview, 1983, BC). Although the vessel is poorly documented, it is clearly the work of a master potter of the late nineteenth century. The quality is that of either

Billy George or Epp Harris. Diagrams and photographs were circulated among the Catawba potters, but none of them had ever seen a pipe like it. None of the potters showed any interest in copying the form. In 1988 a second turtle pipe was located, this time in the Nation. It was found when Brian Blue dug a foundation for a carport. This find was the cause of excitement among the potters, and it was examined with admiration and pride. Although the piece is badly broken, possibly in the fire, and the burnished finish has been eroded by the acidic soil, it is obviously the work of a master potter. The incised pattern consists of fine curved lines. Most important of all, the house site where the turtle pipe was found can be documented. Before leaving for Colorado in 1883, Pinckney and Martha Head lived at this site. After the Head family left, the location was not occupied again until 1912 when James and Margaret Harris built a house there. The turtle pipe seems to be the work of the Head family.

By September 1989, the finding of the so-called Head turtle pipe influenced the Catawba potters. A large group had a demonstration and sale at the Schiele Museum in Gastonia, North Carolina. At this time several potters offered and sold turtle pipes, marking the reintroduction of this delightful pipe form into the Catawba tradition. Following this event, Mildred Blue made a limited but steady supply of turtle pipes. Several of the younger potters, including Donald Harris, have since followed her lead in the production of turtle pipes.

THE PEACE PIPE

Although the peace pipe is no longer used ceremonially, it typifies the tradition's tenacity (see Figure 29). This pipe remains a symbol of what it means to be Catawba, and as such it is a much sought after pipe form, particularly among collectors who know something of Catawba history and culture. All of the Catawba potters make this difficult shape, yet the versions differ somewhat from one potter to another. Some Indians make more than one style, but the basic form is a small bowl with four stems representing the four cardinal directions. The peace pipe is either supported by three legs or has no legs at all. In order to smoke the peace pipe, four river cane reeds are inserted into the clay stems. This pipe is not actually used, so the reed stems are almost never offered with the pipe. Although the four stems represent the four cardinal directions, the Indians have lost the peace pipe's ritual connection. The contemporary Catawba explanation for this pipe's existence is not very informative. "We have used the peace pipe or the pipe of peace that the Indians used instead of signing treaties. They couldn't write, and so they would smoke this pipe which had four

stems. That was the way they signed their treaties" (Doris Blue, interview, 20 March 1980, BC). While most peace pipes have four stems, it is not unheard of for the potters to make such pipes with as many as ten stems. Alberta Ferrell often made her peace pipes by special order according to the size of the family, one stem per family member (Alberta Ferrell, interview, 22 February 1977, BC).

To date, archaeologists have been able to tell us little of the curious peace pipe. George A. West called it the circular or chief's pipe. He noted, without a citation, that this pipe can have up to fourteen stems. Archaeological specimens are found principally south of the Ohio River and are made of steatite, sandstone, or clay (West 1932:225–226). None of the specimens described by West have legs. Unfortunately, all of them were from pothunter collections rather than from scientific archaeological excavations. Once found, examples uncovered by archaeologists might shed some light on the Catawba tradition. One such ancient peace pipe was reportedly found in Pike County, Illinois. It is three inches in diameter, does not have legs, and has five holes for the inserting of reed stems, which enter the bowl at its base (Thompson 1973). While the absence of legs and stems is significant, the Pike County pipe looks very much like a traditional Catawba peace pipe in both size and shape.

A second example of an excavated peace pipe was reportedly found in a mound near Edgefield, South Carolina. The Edgefield pipe is made of steatite, and nine stems surround its shallow bowl (West 1932:Plate 167). This pipe bears little resemblance to any contemporary Catawba peace pipe, except in its overall form.

Unfortunately, the Catawba peace pipe was not an object of scholarly curiosity until the twentieth century. J. D. McGuire noted that when the Catawba visited the Iroquois Confederation in 1751 a pipe of peace was smoked: "The Catawbas came down from their quarters singing, with their colors pointed to the ground, and having lit their pipes, the king [Hagler] and one more put them in the mouths of the chief Sachems of the Six Nations who smoked out of them. The chief sachems of the Senecas lit a pipe and put it in the mouths of each of the Catawbas, who smoked out of it and then he returned it among the Six Nations" (McGuire 1899:561). While we are fortunate to have this brief description of the ceremony, it is regrettable that it raises more questions than it answers. The writer apparently saw nothing unusual about the pipes used. There is no indication that the peace pipes were similar to or different from contemporary Catawba peace pipes. We are left to wonder if the pipes used were of Indian manufacture; however, the Catawba certainly would have used one of their own pipes.

The survival of the peace pipe among the Catawba is due both to

Catawba dedication and to its popularity among collectors. The potters remain determined to make this complicated vessel. Balancing a small bowl, three legs, and four stems is no easy task for a beginning potter.

The peace pipe suffered a kind of metamorphosis during the twentieth century. This occurred through a change in the environment of use, a lack of ritual and ceremonial use, and the detrimental influence of the tourist trade that dominated the tradition from the 1930s to the 1960s.

First, originally the pipe was small, just a bit larger than a regular smoking pipe—large enough to allow for the four stems. Through a lack of use and in response to a mass production need in the second quarter of the twentieth century, the tendency was to make the bowl larger, far more so than would be practical for the smoking of tobacco. Although this process has been reversed in recent years, it is still possible to occasionally find peace pipes that resemble small jardinières.

Second, the oldest examples of the peace pipe, both those found by pothunters and nineteenth-century Catawba vessels, are without legs. It is assumed that the pragmatic Catawba added the three legs in response to the demand of curio hunters and collectors who wanted to set their treasures on a table or in a china cabinet. By 1900, all Catawba peace pipes had three legs and the old form was forgotten. Today, some of the potters have returned to occasionally making peace pipes without legs.

A third factor in this metamorphosis is the migration of the stems up the sides of the bowl. Originally, as a practical matter, the stems were properly located at the bottom of the bowl so the tobacco would feel the effects of air being pulled through the stems and would thus burn evenly. In such a pipe all of the tobacco would be smoked. A lack of use and the North Carolina mountain tourist trade prompted this stem migration. It is sometimes possible to find peace pipes with stems placed so high on the bowl that the pipe could never be smoked.

The Catawba potters still construct the long-obsolete peace pipe, in spite of its difficulty, because it is so key to the Catawba tradition; it must be placed right next to the cooking pot and snake pot in ranked importance. The potters consider a well-constructed peace pipe to be a sign of a true master potter. Indeed, the peace pipe requires mature skills. The potters are rightfully proud of this ancient shape.

Although this pipe is no longer smoked, it is commonly presented to important visitors to the reservation and to politicians the Catawba wish to honor. In 1986, the Tribal Council made formal presentations of peace pipes, made by Georgia Harris, to Senators Strom Thurmond and Ernest Hollings and to Representative John Spratt on the occasion of the publication of the *Bibliography of the Catawba* (Blumer 1986).

South Carolina governors are frequent recipients of Catawba peace pipes. The peace pipe is also represented on the Catawba flag and the logo of the Catawba Cultural Preservation Project.

List of pipes known to be part of the Catawba tradition:

1. plain pipe
2. comb pipe
3. arrow pipe
4. horse pipe
5. horse head pipe
6. turtle pipe
7. Indian head pipe
8. Indian head arrow pipe
9. tomahawk pipe
10. axe pipe
11. pick axe pipe
12. lathing axe pipe
13. fanciful pipe
14. teapot pipe
15. briar imitation pipe
16. pitcher pipe
17. fish pipe
18. snake effigy pipe
19. barrel shaped pipe
20. hand pipe
21. frog effigy pipe
22. arrow pipe with second arrow protruding from front of bowl
23. rabbit pipe
24. canoe pipe

12 Burning the Pottery

The Catawba pottery tradition finishes with the firing process, or burning as the Indians call it, yet as a rule, few outsiders have watched this dramatic event. Realizing the importance of the burning, the potters describe the process for the curious and sometimes provide a video. There is no substitute though for watching the flames of the bonfire engulf the vessels. It is a beautiful sight to see a finely crafted jar nestled in a bed of smoldering coals. No matter what one's technical understanding might be, it is always a marvel that a vessel can be taken from such a violent situation ready for use. The vessels leave the fire ready to sell. It might be desirable to dust each piece lightly with a clean rag, but this step is hardly necessary. Not even the fire's soot clings to the pot. In its dramatic metamorphosis, the vessel has risen above the fire.

While the Catawba burning process can be a joyous affair, there is no more empty feeling than that experienced when the potters hear a fire-engulfed vessel crack with a metallic ping. All of the potters learn to live with the reality of the fire's dangers. Each one of them has waited patiently for the right moment to retrieve a load of wares from the coals only to discover that a prized piece is damaged. The Catawba have always been reluctant to sell broken pieces, and family members are quick to claim pottery that can be displayed but not sold. Earl and Viola Robbins cleverly save such pieces and present them as gifts to children who accompany their parents to the Robbins home to buy pottery.

The Catawba potters have shunned the European kiln for over 300 years. This device, if used, would destroy the character of their wares. The contemporary firing method, however, is a mixture of aboriginal technology and modern innovation. Harrington was first to note the rather complicated history of the Catawba burning method. To his dismay, the potters were accustomed to using the hearth. In order to meet Harrington's desires to see a purely aboriginal firing process, the

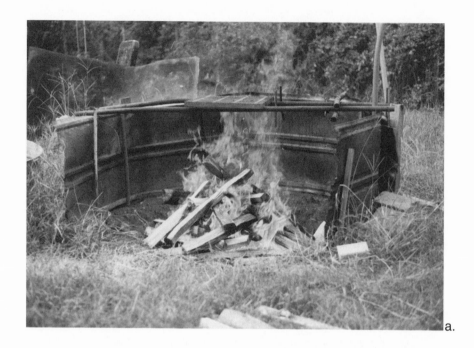

a.

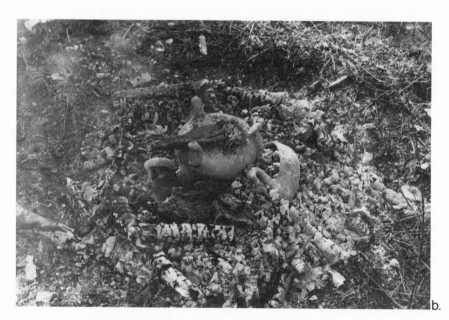

b.

Figure 64. Burning pottery. (Photos by Thomas J. Blumer)
a. *Top:* Vessels engulfed in flames.
b. *Bottom:* Vessels nestled in cooling ashes.

Brown family staged an outdoor burning (Harrington 1908). Additional changes have occurred in the Catawba method of firing in the last 90 years.

BONFIRE

The Catawba potters used a simple bonfire to burn their pottery, from the most ancient times until around 1900. The bonfire remains crucial to the appearance of Catawba pottery, but the fire has undergone some historic changes during the last century. Harrington's notes provide the only extant description of the process as recalled by John and Rachel Brown:

> The first step was to prop the vessels up around the fire, their mouths toward the blaze. . . . Here they remained for two or three hours, a peculiar black color spreading over them as they grew hotter. When this color had become uniform—a sign that they were hot enough—John [Brown] raked the blazing brands out of the fire and inverted the vessels upon the coals and hot ashes . . . which were then pushed up around them and the whole covered quickly with pieces of dry bark pulled from old pine stumps. . . . When the bark had burned away, the red-hot vessels were pulled out and allowed to cool slowly around the fire. One had cracked, as predicted, and all the pieces were more or less mottled by drafts. The black color of the first heating, however, had given place to the typical reddish yellow of Catawba pottery. (Harrington 1908:405)

THE HEARTH

Although Harrington was not interested in the contemporary Catawba use of the hearth, it was hardly a modern innovation for the Brown family. In the middle of the eighteenth century, King Hagler wrote Governor Glenn to send a man who could build a chimney (Wyle 1759:485–486). The Indians had already realized that a hearth and its accompanying chimney were preferable to a blazing, smoking bonfire in the middle of the home. While 1759 might be considered a rough date for the introduction of the fireplace among the Catawba, the date for its adoption as a tool in the pottery tradition will always remain speculative. As late as the 1840s, the Catawba were described as living in temporary camps. Such families probably continued to burn pottery in an open bonfire. However, since cabin-dwelling settlers had long surrounded the Indians, some of the Catawba certainly were accustomed to living in European-style homes and had access to a hearth. After the Catawba were fully settled on their 650-acre reservation, each

family constructed a log cabin. These homes were presumably outfitted with a stone, or stick and mud, chimney. It is likely that Margaret Brown's generation (1837 to 1922) witnessed the full transition from the open bonfire to the hearth. Both John and Rachel Brown no doubt grew up seeing pottery burned in both a fireplace and an open fire depending on the whim of the potter at the moment.

Today, the hearth as the location for the burning process has nearly followed the bonfire into extinction. There are, however, many potters who have used the hearth and can describe the method:

> [Martha Jane Harris] heated them and burned them right there in the fireplace. They'd stack them up. She had a big old fireplace from what I remember, and she'd stack them up around that fire. . . . If she had bowls, she'd stack them up on top of each other. . . . And she'd build a little fire in the center and gradually increase it so the pots got . . . hot enough to stand it. Then she'd build a bigger fire, and then when they got real white looking, she'd turn them around and let that fire burn down and then lift the pots and put them on a bed of coals and just build a fire right on top of them. (Georgia Harris, Field Notes, 1977, BC)

The major problem with using the hearth was the great heat generated by the fire and its contents and the length of time required to complete the process. "We [the Wheelock family] would start early in the morning when we got up, and she [Rosie Wheelock] always closed the doors up. She didn't want a bit of air to get to those pots. She said they would break, and the house would be like a furnace in the summer time. It would take her all day long . . . to have a burning of pots" (Doris Blue, Field Notes, 1977, BC).

The Catawba, in shifting from the bonfire to the hearth, actually made no technological changes in burning their wares. The two processes are identical except for the location. In both cases the vessels are placed in a circle around the fire to complete the drying process and heat the vessels in preparation for the fire's full force. Although the potters would argue otherwise, breakage problems resulting from drafts were not eliminated by the hearth since the chimney remained open throughout the burning. The potters did, however, effectively deal with wind and precipitation. Using the sheltered hearth, they could safely burn a load of pottery during a sudden tropical downpour.

Although the cabins were insufferably hot and the process took the better part of a day, the potters only abandoned the hearth as they modernized their homes with efficient furnaces. This process was slow, however. For instance, while most of the potters discontinued using

the hearth in the 1940s, Arzada Sanders persisted in using her hearth until she retired from pottery making in 1980.

> We always burn 35 to 37 pieces in a fire, perhaps 25 large pieces. They are stacked six or seven deep all around the edges of the fireplace. A little fire is built in the middle and kept going for about five hours. Gradually the fire is made larger until the pots are hot. If the fire touches a pot prematurely, the pot will pop like a firecracker. When the pots are hot enough, the fire is spread out and the pots are put on the coals. A bonfire is then built on top. We add wood three times and allow each fire to burn down. In the last step we add pulp wood chips that we got from a local saw mill. The color comes on at this point, as the pots glow red in color. The color depends on the smoke and how it touches the pots and how the pots are laying in the coals. We cannot control how the pots are laying in the coals. Oak is used most of the time. Pine will ruin a pot. During the summer we burn pots every Saturday. (Fred Sanders, interview, 8 February 1977, BC)

TWENTIETH-CENTURY CHANGES

Catawba pottery has survived because it remains Indian in character and marketable to non-Indians. The tradition does not, however, exist in a museum setting. Today's burning method is a masterful innovation that takes advantage of modern technology yet honors the primary requirement that the pottery remain Catawba in appearance. Fewkes was the first to note a change in the burning process: "One of the most recent innovations in firing is the use of the kitchen stove and a tin wash tub. Vessels to be fired are first placed within such a tin tub, reposing upon its bottom, some six to twelve pieces at a time. The tub is then set upon the stove, in which a moderate fire has been started in the meantime. More fuel is gradually added and the heat is increased, reaching 500 degrees to 600 degrees F" (Fewkes 1944:92).

Use of the kitchen stove allowed the potters to eliminate tending a fire for several hours while the vessels completed the drying process and were preliminarily heated. This simple innovation eventually allowed the potters to shift the drying process from a metal container placed on the stovetop to the oven where the drying and initial heating is most often conducted today. While the potters will accept changes that make life easier, they remain conservative in nature. Again, however, the acceptance of the kitchen oven was slow and did not take place until the Federal Wardship period between 1940 and 1960. Even then, some potters were forced to change their burning method because of

circumstances. For instance, Sallie Beck recalled that her family began to use the oven after the old home place burned down. The Beck's new dwelling did not have a fireplace, and Sallie Beck found it necessary to adjust to the new burning process if she were to continue her pottery making (Sallie Beck, interview, 21 April 1977, BC).

While a degree of change came to the tradition, the potters still needed the bonfire to complete the burning. Only the open fire will allow them to retain the mottled colors of their wares that are so crucial to the appearance of Catawba pottery.

CONTEMPORARY BURNING METHOD

Once the vessels are built, scraped, rubbed, and considered dry enough to begin the burning process, the potter waits for a day free of wind. The potter begins the day's tasks at dawn or early in the morning. Edith Brown described her procedure in some detail: "Today I heat them in the oven. I put it on preheat for half an hour, then up to 200 degrees for half an hour, then 250 for half an hour, then 300, 350, 400, and 500, and then you can smell them. I'll be having my fire [out in the yard] burning down to the coals (Edith Brown, interview, 21 April 1977, BC).

The potters must coordinate the vessels' heating and drying in the oven and the preparation of the final fire to which the vessels will eventually be transferred. In 1977, I assisted Mrs. Georgia Harris in the entire process. Eleven vessels, both large and small, were put in the oven at 200 degrees at 9:00 A.M. The temperature was gradually raised until the temperature at noon was 300 degrees. At 1:45 P.M. a fire was built in an unsheltered part of the yard. This fire burned heartily until the pottery in the oven turned a dark gray color. When the pottery changed color, it was judged ready to be moved to the bonfire.

Next, the fire was leveled to form a bed of coals. Then the pottery was removed from the oven: the larger pieces were placed in galvanized buckets and the smaller were placed on a cookie tin. The largest pot was put mouth down in the middle of the glowing coals, and the smaller pieces were arranged around it. All was then covered with a thick layer of wood. This transfer was accomplished in seconds to reduce the danger of shifting temperatures and any breakage that might result. So hot were the pottery and the bed of coals that the dry wood immediately burst into flames. As the fire burned, open places were quickly covered with more wood. After about an hour, the heat was so intense that we had to abandon our station close to the fire.

At 4:45 we returned to the fire again after it had burned down to a mound of ash. The legs of the largest pot protruded from the ashes. Mrs. Harris then took an iron rake and gently brushed the ashes away

and exposed the vessels. At this point, a cracked swan bowl was discovered, and it was left in the coals. When all the vessels were exposed, Mrs. Harris covered the pottery with large pieces of pine bark. This was done, she explained, to help with the mottling which is so characteristic of Catawba pottery. As the bark burst into flames, we watched the mottled places appear, grow, and sometimes fade away. After this fire died down, the vessels were removed from the coals (Georgia Harris, interview, 24 March 1977, BC). The pottery had actually been exposed to the bonfire for over three hours. The entire process had taken about six hours.

Weather conditions remain the major problem with burning outdoors, and the resulting innovations to compensate for this variable element are numerous. For instance, Effie Robbins, working in the 1940s, burned her pottery in a hole in the ground, as did Martin Harris (Martin Harris, interview, 13 April 1977, BC; Earl Robbins, interview, 13 May 1987, BC). Lula Beck and Reola Harris used an old tin tub or drum (Lula Beck, interview, 22 March 1977, BC; Reola Harris, interview, 10 May 1977, BC). During an unexpected rain shower, the potters who do not have a sheltered fire must run for sheets of tin to protect their pottery (Frances Wade, interview, 24 February 1977, BC). Most recently, Cheryl and Brian Sanders have burned their wares in an open shed. The interior is lined with tin to protect the building from catching fire during a very hot process.

The type of wood used is straightforward. Under the best of conditions, the potters use seasoned oak. Blackjack is common in the area (Georgia Harris, interview, 16 February 1977, BC; Arzada Sanders, interview, 25 January 1977, BC; Reola Harris, interview, 10 May 1977, BC). The potter must be wary of green wood. For instance, Georgia Harris noted that if sap should emerge from the burning logs and fall on the pottery, it will leave scars (Georgia Harris, interview, 16 February 1977, BC). Nola Campbell illustrated this problem in 1989 when she observed an inexperienced Indian put chemically treated wood lathing on a fire and damage an entire burning of pottery.

Some potters attribute the vessel's final color to the kind of wood used. For instance, Arzada Sanders claimed that pine will make the pots red and that oak will give a better color (Arzada Sanders, interview, 25 January 1977, BC). Fewkes was told that pine tended to make the vessels lighter in color as did oak, hickory, and dogwood (Fewkes 1944:90). Some of the potters have no theories on this matter and are content with any seasoned wood.

In the last step in the burning process, many of the potters smother the fire with bark or wood chips (Edith Brown, interview, 21 April

1977, BC; Evelyn George, interview, 25 March 1977, BC; Sallie Beck, interview, 21 April 1977, BC). In doing this, the potters hope to increase the clouding on the vessels. When Fewkes was doing his research in the late 1930s, corncobs were often used when bark was not available (Fewkes 1944:90). Today, the main difficulty seems to be in obtaining suitable material for this part of the burning process. Bark is in short supply. Few people cut wood with an axe, and wood chips are difficult to find (Bertha Harris, interview, 3 February 1977, BC).

Catawba pottery production has always been limited except among those potters who wholesale their work to shops. Georgia Harris recalls that her grandmother, Martha Jane Harris, usually burned about a dozen pots in each fire. In recalling the work of Martha Jane Harris, Jessie Harris said she would burn about two dozen pipes at a time. If she had a very large vessel, it would be burned alone (Jesse Harris, interview, 14 April 1977, BC). This kind of special attention is still given to the burning process by master potters.

BLACK WARE

Today, all the Catawba potters produce some black ware. Depending on the time spent polishing the vessels, these range from a dull but uniform black color to a high glossy black. These vessels are noted for their lack of clouding. This color is attained by completely smothering the fire so that no oxygen reaches the vessels. Some Catawba potters are happy if one or two vessels emerge from the fire with this even black coloration, and others try to burn all their vessels jet black.

When Edward Palmer of the Smithsonian visited the Eastern Band Cherokees at the end of the nineteenth century, a dwindling number of Cherokee potters were still producing a traditional black ware. According to Sally Wahoo, a Catawba potter who had married into the Cherokee Nation in the 1830s, this burning method was Cherokee in origin (Holmes 1903:53). By the 1880s, the Catawba had adopted this technique as their own and used it almost exclusively for pipes. Harrington observed such a burning: "Pipes are stacked upon between two fires to receive their preliminary heating; but after this the burning takes place as with the pottery, and the black color, which is more popular for pipes than for pottery, is produced in the same way, the pipes, after the preliminary heating, being packed into the containing vessel between layers of bark chips" (Harrington 1908:405). The containing vessel, a bucket or an iron kettle, is then inverted on a bed of coals and covered with wood that is allowed to burn away. As the bark chips in the containing vessel smolder, a black smoke is produced. (Rather than burn rapidly, this slow fire, deprived of oxygen, smolders.) The resulting thick black smoke penetrates the pipes that have been

burnished with care (Fewkes 1944:91–92). They emerge from this process with a brilliant shine and are uniformly black. According to archaeologist Brett Riggs, all such pottery was originally burned black on the inside as a method of making cooking vessels waterproof (Riggs, interview, 19 November 2002, BC).

Conclusion

The Catawba pottery tradition is alive and well. The craft remains a strong reflection of what the Catawbas' ancestors made before the coming of the white man. The pottery is still closely tied to the Indians' economy. Today, however, the potters are amazed to learn the prices demanded by their predecessors. The smoking pipe that sold for 10 cents in 1900 sells for a minimum of 45 dollars or more today. The same is true of every other shape produced by the potters. Making Catawba pottery is lucrative, and this is one key to the craft's survival into the third millennium.

The Catawba peddled pottery from the earliest historical times to the 1960s. Although they no longer go from house to house, some still visit the gift shops in the North Carolina mountains and at Myrtle Beach, South Carolina. The main emphasis has shifted from quick wholesale deals to approaching enthusiastic collectors and museum shops that carry the best in folk art. The modern Catawba potters want to see their work being exhibited behind glass.

The Indians began to attend fairs and historical events at the turn of the twentieth century, and their businesses profited. Catawba potters still attend such events, but they now expect to exhibit in a booth and they expect to be paid. If sales are not good, they do not go back. Although some follow the powwow circuit, which is known for low prices, most aim for more sophisticated events. The use of business cards, cell phones, and pamphlets that market a particular potter's wares is the growing trend.

A partial change in the teaching of the tradition has occurred. Classes have been offered to interested tribal members since 1976 because of a new scattered family lifestyle, yet most of the new generation master potters still learn in a modified traditional way. They also turn to tutorials within the community. Each potter has mentor potters who provide help in making particular shapes. The new method appears to be

working. The tradition is successfully being passed on from one generation to the next.

The Catawba stubbornly cling to their native clay. Although commercial clay is available, they continue to work with the clay of their ancestors, obtained in Nisbet Bottoms. They visit the holes in groups, usually individuals from a particular family. Once the clay is removed, the Indians carefully fill in the hole. At home, the clay is mixed by the old formula and strained through window wire to remove impurities. Since clay is so difficult to obtain, it is not wasted.

The tools the Catawba use to build their pots have changed somewhat in the last century. The Indians turn to things found in the kitchen for much of their work. The main tools remain a pair of talented hands and burnishing rocks, most of which are family heirlooms. The method of constructing each form remains fixed. If a young potter does not know how to make a wedding jug, the individual turns to a potter who will provide the necessary lessons. In this way, only the most conservative construction methods are passed to the next generation of potters.

Seldom will a Catawba potter incise a vessel with a motif that is foreign in origin. The goal is to produce pottery exactly as that of the "old Indians." Much of this incising is found on small pieces, particularly smoking pipes and the venerated peace pipe. Future work by archaeologists will perhaps give us a clearer picture of the Catawba incising tradition. Large vessels are seldom given this extended treatment. The goal seems to be to let the larger vessel's grace carry it to a successful sale.

The Catawba burning method has remained pretty much the same from ancient times to the present. Changes have occurred in the location of the fire but not in the fire itself or its results on the pottery. Today the majority of potters dry their work in the kitchen oven. Once the potter determines that the vessels are ready for the full impact of the fire, the pieces are transferred to a fire prepared in the yard. Crude efforts are made to protect the pottery during this critical stage. The major problems come from wind and rain. Some of the potters burn their pottery in a hole while others surround the fire with a barrier of sheet metal. A successful fire produces a beautiful ware with mottled colors of red, gray, black, brown, and shades that even approach white.

An important aspect of the Catawba tradition is its amazing endurance. In 1900, the tribe counted around 20 potters, total. In 2003, the tribe points to more than 75 adult potters. Today's community proudly counts approximately 20 master potters and the number is growing. These new generation master potters are determined to preserve the

pottery just as grandma made it. The trend of Catawba history from the early nineteenth century to recent times has been toward eventual extinction of this rare art form, yet from all appearances, the Catawba tradition is far from vanishing. The folk art treasure that has survived just a few miles east of Rock Hill, South Carolina, will continue to delight collectors, ethnologists, journalists, archaeologists, historians, and students at every level.

Pride is another key to the survival of the Catawba tradition. All of the Indians, those who make pottery and those who do not, are proud of their tradition. Those who do not make pottery plan to do so one day. The Indians calculate their attachment to the Catawba Nation by measuring their involvement in making pottery. Nearly all of the tribe's artistic energy flows in the direction of working in clay. Everyone is aware of one simple fact: without pottery the Catawba would not have survived the long period of social, economic, and political stress between the sixteenth century and the present. As long as the Catawba Nation continues to be a presence in South Carolina, the Indians will be known for their pottery.

References Cited

Act No. 401, An Act to Settle and Regulate the Indian Trade. March 20, 1719. *South Carolina Statutes at Large* 3:86–96.

Act No. 487, An Additional Act to an Act Entitled an Act for the Better Regulation of the Indian Trade. February 15, 1723. *South Carolina Statutes at Large* 3:229–232.

Act No. 2831, An Act to Make Appropriations . . . 1841. *Acts of South Carolina* (Columbia: Pemberton, 1842), pp. 146–149.

Act No. 393, An Act to Repeal Section 3205, Code of Laws of South Carolina, 1942, Providing Payment of Appropriations for the Catawba Indians, July 31, 1951. *Acts of South Carolina* (Columbia: Joint Committee, n.d.), p. 740.

Adams, David Wallace
 1995 *Education for Extinction: American Indian Boarding School Experience, 1875–1928.* University Press of Kansas, Lawrence.

Baker, Steven
 1972 Colono-Indian Pottery from Cambridge, South Carolina, with Comments on the Historic Catawba Pottery Trade. *Institute of Archaeology and Anthropology Notebook* 16:4.
 1973 Catawba Indian Trade Pottery of the Historical Period. Museum of Arts and South Carolina Arts Commission, Columbia.

Bivens, John, Jr.
 1972 *The Moravian Potters in North Carolina.* University of North Carolina Press, Chapel Hill.

Blanding, William
 1848 Ancient Monuments of the Mississippi Valley. *Smithsonian Contributions to Knowledge* 1. Edited by E. G. Squier and E. H. Davis. In L. Ferguson, Archaeological Investigation at the Mulberry Site. *Institute of Archaeology and Anthropology Notebooks* 56, May–August 1974, nos. 3 and 4.

Blumer, Thomas John (Blumer Collection)
 1970– Acquisition File.
 2003
 1977 Field Notes.
 1979a Price List.

1979b Renwick Gallery Notes, Smithsonian Institution, Washington, D.C.

1979c Two Points Concerning a Just Settlement of the Catawba Indian Land Suit of 1977. United States Congress. House. Committee on Interior and Insular Affairs. *Settlement of the Catawba Indian Land Claim: Hearing before the Committee on Interior and Insular Affairs, House of Representatives, Ninety-sixth Congress, First Session, on H.R. 3274.* GPO, Washington, D.C.

1980 Rebecca Youngbird: An Independent Cherokee Potter. *Journal of Cherokee Studies*, pp. 41–49.

1985 Wild Indians and the Devil: The Contemporary Catawba Indian Spirit World. *American Indian Quarterly* (spring):149–168.

1986 *Bibliography of the Catawba.* Scarecrow Press, Metuchen, New Jersey.

1987a Catawba Indian Pottery. Catawba Cultural Preservation Project, Catawba Nation, Rock Hill, South Carolina.

1987b Catawba Influences on the Modern Cherokee Tradition. *Appalachian Journal* (winter):153–173.

1987c The Snake in Catawba Art and Folklore. Lecture delivered at the Schiele Museum of Natural History, Gastonia, North Carolina.

1989 The Turtle in Catawba Art and Folklore. Lecture delivered at the Schiele Museum of Natural History, Gastonia, North Carolina.

1990 Catawba Reservation Cemetery: A Perspective and a Roster. *Journal 2.* York County Historical and Genealogical Society.

1993a Catawba Restoration of Justice Project: Comments for the records and appendices. *Hearing before the Subcommittee on Native American Affairs of the Committee on Natural Resources, House of Representatives, One Hundred Third Congress, First Session on H.R. 2399.* July 2. GPO, Washington, D.C.

1993b Comments for the Record Regarding H.R. 2399 and S. 1156, A Bill to Settle the Ancient Catawba Land Claim and to Restore the Federal Trust Relationship, submitted on July 26, 1993. *Catawba Indian Tribe of South Carolina Land Claim Settlement Act of 1993, Hearing before the Committee on Indian Affairs, United States Senate, One Hundred Third Congress, First Session on S 1156 to Provide for the Settlement of Land Claims of the Catawba Tribe of Indians in the State of South Carolina and Restoration of the Federal Trust Relationship with the Tribe,* pp. 178–221. GPO, Washington, D.C.

1994 Catawba. *Native America in the Twentieth Century: An Encyclopedia,* pp. 92–94. Edited by Mary Davis. Garland, New York.

1995a Price List.

1995b Record of Catawba Indians' Confederate Service. *South Carolina Historical Magazine*, pp. 221–229.

Blumer, Thomas John, and Janet Harris

1988 At the Gates of Winthrop: Catawba Indians and the Girls in Blue. *Winthrop Magazine*, pp. 10–12.

Brown, Douglas Summer

1956 Background Notes and Subject Bibliography for a History of the Catawba Indians. On file, Rock Hill Public Library, Rock Hill, South Carolina.

1966 *Catawba Indians: People of the River.* University of South Carolina Press, Columbia.

n.d. Catawba Crafts and Craftsmen. On file, Rock Hill Public Library, Rock Hill, South Carolina.

Bull, William

1770 A Proclamation of March 29, 1770. *South Carolina Gazette Supplement* 4 April:1

1771 A Proclamation of July 12, 1771. *South Carolina and American General Gazette* 15 July:1.

Burrell, Beth

1984 Schiele Indian Village Offers Peek into the Past. *Gastonia Gazette* 18 October:C1.

Bushnell, David J., Jr.

1920 *Native Cemeteries and Forms of Burial East of the Mississippi.* U.S. Bureau of Ethnology Bulletin. Vol. 71. Washington, D.C.

Catawba Nation

1975 Constitution and By-Laws of the Catawba Nation of South Carolina.

1987 Catawba: People of the River. Charlotte-Mecklenberg School District, Charlotte, North Carolina.

1994 Yap Ye Iswa: The Day of the Catawba. Catawba Cultural Preservation Project.

Catesby, Mark

1731– *Natural History of Carolina, Florida, and the Bahama Islands.*
1743 Self-published, London.

Census of Catawba Indians Connected to Echota Mission of Methodist Episcopal Church in North Carolina (17 September 1849). Indian Affairs, 1831–1859. Governor's Correspondence, Massey to Governor Seabrook. South Carolina Department of Archives and History, Columbia.

Charles, Tommy

1981 Dwindling Resources: An Overture to the Future of South Carolina's Archaeological Resources. *Notebook* 13. University of South Carolina Archaeological Institute.

Chickasaw Headmen to Governor Lyttleton, 16 April 1757, William Henry
 Lyttleton Papers. William Clements Library. University of Michigan,
 Ann Arbor.

Cinebar Productions
 1999 People of the Clay. Shiele Museum of Natural History. Newport
 News, Virginia.

Coe, Joffre L.
 1952 The Cultural Sequence of the Carolina Piedmont. In James B.
 Griffin. *Archaeology of the Eastern United States*, pp. 301–311.
 University of Chicago Press, Chicago.

Cutten, George Barton
 1973 *Silversmiths of North Carolina, 1696–1850*. Department of Cul-
 tural Resources, Division of Archives and History.

De la Vega, Garcilaso
 1951 *Florida of the Inca*. Translated by John Grier Varner and Jeannette
 Johnson Varner. University of Texas Press, Austin.

Dobyns, Henry V.
 1983 *Their Numbers Became Thinned*. University of Tennessee Press,
 Knoxville.

Downs, Dorothy
 1995 *Art of the Florida Seminole and Miccosukee Indians*. Univer-
 sity Press of Florida, Gainesville.

Evening Herald (Rock Hill)
 1909 Day with the Catawba Indians. 1 May:1.
 1913 Catawba Indians Arrive for Corn Show in Columbia. 25 Janu-
 ary:1.
 1918 Fifth Child of John Brown Died. 10 October:3.
 1921 Well Known Resident of Reservation Dead. 29 October:1.
 1927 Indian Ferryman on Catawba Dies. 21 June:1.
 1939 Name Winners in Catawba Fair. 22 September:5.
 1940a Children of King Hagler. 15 June:5.
 1940b Indians Will Give Demonstrations at Park Friday Night. 8 Au-
 gust:5.
 1940c Catawba Indian Fair to be Held Oct. 19. 18 October:15.
 1941 Indians Will Display Work. 4 September:1.
 1942 Study Indian Rehabilitation. 26 March:1.
 1952 Raymond Harris Ex-Catawba Chief, Died. 24 January:2.
 1959 Van Wyck Bridge May Open Soon. 23 July:1.
 1960 Mrs. Brown, Oldest Catawba Dies at 86, 133 Survive. 21 Sep-
 tember:2.
 1963 Early M. Brown. 18 March:2.
 1985a Edith Brown. 14 June:2.
 1985b Catawba Women Had a Vital Role. 8 July:4.
 1985c Indians Seek State Recognition. 5 August:3.

Fewkes, Vladimir
1944 Catawba Pottery-making, with Notes on Pamunkey Pottery-making, Cherokee Pottery-making, and Coiling. *Proceedings of the American Philosophical Society.* Philadelphia.

Fort Mill Times
1908 The Catawba Indians. 19 March:2.

Freis, Adelaide L.
1922 Records of the Moravians in North Carolina. Edwards and Broughton, Raleigh, North Carolina.

Fundaburk, Emma Lila
1958 *Southern Indians: Life Portraits—A Catalog of Pictures, 1564–1860.* Self-published, Luverne, Alabama.

Furman, MacDonald
1888 The Catawba Indians. *Yorkville Enquirer* 18 April:4.
1890 The Catawbas: The Remaining Few of a Once Powerful Tribe. *Yorkville Enquirer* 12 February.
1894 South Carolina Indians. *Rock Hill Herald* 6 June.

Gazette of the State of Georgia
1787 Savannah. 10 May.

Gordon, Sallie, and Frank G. Speck
1946 Ethnoherpetology of the Catawba and Cherokee Indians. *Journal of Washington Academy of Sciences* 36:358.

Gregorie, Anne
1925 *Notes on Sewee Indians and Indian Remains of Christ Church Parish, Charleston County, South Carolina.* Charleston Museum, Charleston, South Carolina.

Griffin, James B.
1945 An Interpretation of Siouan Archaeology in the Piedmont of North Carolina and Virginia. *American Antiquity* 10:321–330.

Hamilton, Elsie
1994 Catawba Pottery Is a Vanishing Art Form. *Gastonia Gazette* 18 August:B1.

Harrington, M. R.
1908 Catawba Indian Potters and Their Work. *American Anthropologists*, n.s., 10:398–407.

Harris, Charlotte
1893– Record No. 5461. Carlisle Industrial School. National Archives,
1904 Washington, D.C.

Harris, Nettie Owl
1921 Letter to Frank G. Speck, December 2. American Philosophical Society, Philadelphia.

Hewatt, Alexander
1961 *An Historical Account of the Rise and Progress of the Colonies*

of *South Carolina and Georgia.* Reprint Company, Spartanburg, South Carolina.

Holmes, W. H.

1903 *Aboriginal Pottery of the Eastern United States.* Bureau of American Ethnology, Annual Report, No. 20, Washington, D.C.

Howard, James H.

1968 *The Southeastern Ceremonial Complex and Its Interpretation.* Memoir. Missouri Archaeological Society, No. 6.

Hvidt, Kristian

1990 *Von Reck's Voyage: Drawings and Journal of Philip Georg Friedrich von Reck.* Library of Georgia, Savannah.

Kent, Donald H.

1984 *Early American Indian Documents: Treaties and Laws, 1607–1789.* Vol. 2: *Pennsylvania Treaties, 1737–1756.* University Publications of America, Washington, D.C.

Kirkland, Thomas J., and Robert M. Kennedy

1905 *Historic Camden.* State Company, Columbia.

Lake, William C.

1955 Catawba Indians: Monument in Fort Mill Honors "Red Confederates." *Observer* 9 October:20.

Lawson, John

1714 *The History of Carolina.* London.

Laurence, Jessie

1952 Letter to DAR Committee on American Indian Affairs of February 14. Winthrop College Archives, Rock Hill, South Carolina.

List of Names of Catawba Indians Residing in North Carolina, Haywood County, Cherokee Nation; in Chester District; in York District on Their Old Home; in Greenville District (29 September 1849), Indian Affairs, 1831–1859. Governor's Correspondence, Massey to Governor Seabrook, South Carolina Department of Archives and History, Columbia.

Lorant, Stefan

1946 *The New World: The First Pictures of America.* Duel, Sloan and Pearce, New York.

Marshall, J. Q.

1888 South Carolina Department of Archives and History, Columbia, South Carolina.

May, Alan

1987 Archaeological Excavations at the Crowders Creek Site (3IGS55): A Late Woodland Farmstead in the Catawba River Valley, Gaston County, North Carolina. *Southern Indian Studies* 28:23–50.

McGuire, J. D.

1899 Pipes and Smoking, Customs of the American Aborigines, Based on Material in the U.S. National Museum. *Report of the U.S. National Museum.* GPO, Washington, D.C.

Merrell, James H.
 1989 *The Indians' New World: Catawbas and Their Neighbors from European Contact through the Era of Removal.* University of North Carolina Press, Chapel Hill.
Milling, Chapman James
 1940 *Red Carolinians.* University of North Carolina Press, Chapel Hill.
Moore, Clarence B.
 1918 *The Northwestern Florida Coast Revisited.* Philadelphia.
Moorehead, Warren K.
 1932 *Etowah Papers.* Yale University Press, New Haven.
O'Callaghan, E. B. (editor)
 1855 *Documents Relative to the Colonial History of the State of New York Procured in Holland, England and France.* Weed, Parson, Albany.
Pargellis, Stanley (editor)
 1959 An Account of the Indians in Virginia. *William and Mary Quarterly,* 3rd ser., pp. 16:231.
Passport for 40 Catawbas, July 19, 1715. *Calendar of Virginia State Papers.* Vol. 1:182. Superintendent of Public Printing, 1875–1895, Richmond.
Petitions. Department of Archives and History. Columbia, South Carolina.
Phillips, Philip
 1975– *Pre-Columbian Shell Engravings: From the Craig Mound of*
 1982 *Spiro, Oklahoma.* 6 Vols. Peabody Museum Press, Cambridge.
Public Law No. 101–644. Indian Arts and Crafts Act of 1990. 25 U.S.C. 305a.
The Record
 1913 Catawba Indian War Dance. 12 February:12.
 1918 Indians Die of Flu. 7 October:5.
 1923 Nettie Owl Harris Dead. 12 March:1.
Records of the Owl Family. Hampton Institute, Indian School. Hampton Institute, Hampton, Virginia.
Reed, Elizabeth
 1959 The Browns Proud of Their Catawba Blood. *Evening Herald* 16 July:12.
Register of the Province. Conveyance Books. Record Group S210001. Vol. 2 (G in Green's Index) 1665–1696, p. 10.
Reina, Ruben E., and Robert M. Hill
 1977 *Traditional Pottery of Guatemala.* University of Texas Press, Austin.
Richter, Daniel K.
 2001 *Facing East from Indian Country: A Native History of Early America.* Harvard University Press, Cambridge.

Robertson, James Alexander (editor and translator)

 1993 The Account by a Gentleman from Elvas. In Clayton, Lawrence A., et al., eds. *The De Soto Chronicles: The Expedition of Hernando De Soto to North America in 1539–1543.* Vol. 1, pp. 19–220. University of Alabama Press, Tuscaloosa.

Rock Hill Herald

 1895 Indian Pipes and Pots. 6 March.

 1896 To Educate the Catawbas. 5 December:2.

 1901 Indian Village. 17 July:3.

 1905a Catawba Indians at Gastonia. 15 August:1.

 1905b Wants Potter's Clay. 25 October:3.

 1908 Indian Pottery Market Created. 23 May:1.

Simms, William Gilmore

 1859 Caloya; or Loves of the Driver. *Wigwam and Cabin.* Redfield, New York.

Sinclair, A. T.

 1909 "Tattooing of the North American Indians." *American Anthropologist* 11:362–400.

Smith, A. E.

 1890 Statement No. 8, Financial Report of the Catawba Indian Agent. *Reports and Resolutions ... South Carolina ... 1889*, p. 420. James Woodson, Columbia.

Smithsonian Institution

 1977 National Collection of Fine Arts and Its Renwick Gallery. May Calendar.

South Carolina Gazette

 1759 Charles-Town, May 21. 21 May:2.

 1760a Charles-Town, May 3. 3 May:2.

 1760b Charles-Town, May 19. 19 May:2

 1760c Charles-Town, December 15. 15 December:1.

South Carolina Gazette and Country Journal

 1766 Charles-Town, November 16. 16 November:1.

 1766 Charles-Town, November 18. 18 November:1.

Speck, Frank G.

 1934 *Catawba Texts.* Columbia University Press, New York. Reprint, 1969, AMS Press, Brooklyn.

 Ca. Untitled Film. University Museum, University of Pennsylvania, Philadelphia.
 1930

Spratt, Thomas Dryden

 n.d. *Recollections of His Family.* York Public Library, Rock Hill, South Carolina.

State

 1913a Eight Indian Braves to Attend Corn Show. 27 January:9.

1913b Red Cloud to Lead Historic Dances. 3 February:12.
Stout, Allen
1977 Doris Blue. Schiele Museum of Natural History, Gastonia, North Carolina.
1989 Doris Blue: Story of a Potter. 16 mm film. Schiele Museum of Natural History, Gastonia, North Carolina.
Sudbury, Byron
1977 The Clay Tobacco Pipe. *Pothunters* 1. Colonial Press, Covington, Kentucky.
Swanton, John R.
1945 *Indians of the Southeastern United States.* GPO, Washington, D.C.
Thomas, Gladys Gordon
1962 Letter to Thomas Arntson. 3 April 1962, File No. Acc. 67-A-721-103. File 11273-1959-077. Bureau of Indian Affairs Records, Washington, D.C.
Thompson, Ben
1973 Indian Pipes. *Central States Archaeological Journal* 20 (January).
Toole, Matthew
1958 Letter to Governor Glenn of April 30, 1751. In *Documents Relating to Indian Affairs, May 21, 1750–August 7, 1754.* Vol. 1, pp. 212–213. Ed. William L. McDowell, Jr. South Carolina Archives Department, Columbia.
U.S. Congress, Senate, Committee on Indian Affairs.
1931 Survey of Conditions of the Indians of the United States. *Hearings before a Subcommittee on the Committee of Indian Affairs, United States Congress, United States Senate, 17th Congress, 2nd Session. Part 16.* GPO, Washington, D.C.
U.S. Department of the Interior, Bureau of Indian Affairs
2000 Final Base Membership Roll of the Catawba Indian Nation (Formerly Known as the Catawba Tribe of South Carolina). *Herald* 5 October:4d.
Waddell, Gene
1979 *Indians of the South Carolina Low Country, 1562–1751.* Reprint Company, Spartanburg, South Carolina.
Warring, Antonio J., Jr., and Preston Holder
1945 A Prehistoric Ceremonial Complex in the Southeastern United States. *American Anthropologist* 47:1–34.
Washington Post
1978 Weekend. 31 March:6.
Weinland, Joseph E.
1928 *The Romantic Story of Schoenbrun: The First Town in Ohio.* Seibert Printing, Dover, Ohio.

West, George A.

 1934 Tobacco Pipes and Smoking Customs of the American Indians. *Bulletin of the Public Museum of the City of Milwaukee* 17.

Williams, Ida Belle

 1928 Collection of Catawba Indian Relics Found. *Observer* 20 July:5.

Williams, Stephen

 1968 *The Waring Papers: The Collected Works of Antonio J. Waring, Jr.* Papers of the Peabody Museum of Archaeology and Ethnology. Vol. 58. Harvard University, Cambridge.

Willoughby, C. C.

 1897 An Analysis of the Decorations upon the Pottery from the Mississippi Valley. *Journal of American Folklore* 10:9–20.

Wyle, Samuel

 1970 Letter to Governor Lyttleton of May 5, 1759. In *Documents Relating to Indian Affairs, 1754–1765.* Vol. 2, pp. 485–486. Edited by William L. McDowell, Jr. South Carolina Archives Department, Columbia.

York County Nature Museum

 ca. Catawba Video. Rock Hill, South Carolina.
 1950

Index

Harris, Floyd William (Bill): biography, 87; rubbing rock, 111

Harris, Furman: Indian circuit, 48, 49; peddling pottery, 36, 39, 41; processing the clay, 104; squeeze molds, 116

Harris, Garfield: biography, 85

Harris, Georgia Harris, 4, 11, 77–78, 84, 85, 88; barred oval motif, 164; biography, 85; building tools, 109; burning pottery, 188, 194; burning pottery in the hearth, 190; Class of 1976, 69; clay holes, 100; contemporary pottery burning method, 192–193; cooking pot, 121; demonstrations, 59, 60; economic concerns, 18–19, 20, 25, 27; feather motif, 170; Indian circuit, 47, 49, 53; Indian head jar, 131; jug, 129; lap boards, 108; learning, 64–65; peace pipe, 140, 185; peddling pottery, 32–33, 40–41; pipes, 177, 178, 179, 180, 181; Rebecca pitcher, 136; rubbing pottery, 147; rubbing rocks, 110–111; processing the clay, 104–105, 106; squeeze molds, 116, 117, 118; teaching pottery making, 65–66, 67; turtle effigy, 145; visiting the clay holes, 101, 102

Harris, Ida: biography, 85; peddling pottery, 36

Harris, James, Chief of the Catawba, 10, 67, 183; Indian circuit, 46

Harris, Jesse: burning pottery, 194; peddling pottery, 32, 35; visiting the clay holes, 102

Harris, Loretta: biography, 86

Harris, Lucinda: biography, 86; peddling pottery, 30–31

Harris, Margaret (Maggie) Price, 63, 65; biography, 86; peddling pottery, 33–34; teaching pottery making, 65

Harris, Margaret Harris, 10–11, 76, 183; barred oval motif, 164; biography, 86; economic concerns, 16;

peddling pottery, 35, 38; rubbing rocks, 111

Harris, Martha Jane White, 11, 75, 160; barred oval motif, 164; biography, 86; building tools, 109; burning pottery, 194; burning pottery in the hearth, 190; economic concerns, 27, 31; incised designs, 176; Indian circuit, 48; peddling pottery, 32–33, 36, 38; pipes, 178, 179–180; processing the clay, 104, 106; rubbing rocks, 111; squeeze molds, 114, 116, 117; visiting the clay holes, 102

Harris, Martin, 10; biography, 86; burning pottery, 193; economic concerns, 27; processing the clay, 105

Harris, Mary, 75; biography, 86; Rebecca pitcher, 136

Harris, Mary George (Dovie): biography, 86; Cult of the Serpent, 170–172; Indian circuit, 48; peddling pottery, 33–34

Harris, Minnie Sanders: biography, 86; economic concerns, 27

Harris, Nancy, 75; biography, 86

Harris, Nancy (October) Harris: biography, 86; economic concerns, 20, 26

Harris, Nettie Harris Owl. See Owl, Nettie Harris

Harris, Peggy George, 160

Harris, Peggy Thatcher, 78; biography, 87; Class of 1976, 70, 71; learning pottery making, 65, 72

Harris, Peter, 13

Harris, Raymond, 18

Harris, Reola Harris: biography, 87; lap boards, 108; peddling pottery, 33, 39, 77

Harris, Rhoda George, 5, 76; biography, 87; peace pipe, 169; rubbing rocks, 109–110; squeeze molds, 114, 116

Harris, Richard: clay holes, 100; economic concerns, 20; peddling pottery, 35–36; Indian circuit, 47

Harris, Robert Lee: Indian circuit, 47, 48; biography, 87
Harris, Ruthie Harris: peddling pottery, 33
Harris, Sarah Jane Ayers, 161; basket for storage of tools, 113; biography, 87; clay holes, 99, 100; peddling pottery, 31, 35, 75; processing the clay, 103
Harris, Theodore: economic concerns, 17
Harris, Walter: biography, 87
Harris, Wesley: learning pottery making, 65; peddling pottery, 32
Harris, Wilburn: digging clay, 107
Harris, William (Billy Bowlegs): biography, 87
Head, Martha Jane Patterson, 11, 91, 183; biography, 88
Head, Pinckney, 183
Head, Robert, 11, 91
Head family, 10–11, 91, 116
Henderson, Nick: biography, 88
Henderson, North Carolina, 40
Herbs, 1
Heriot, Thomas, 153, 156
Heritage Day, Schiele Museum, Gastonia, North Carolina: Indian circuit, 53
Heye Foundation, Museum of the American Indian, 18, 181
Hinson, Anita Canty Henderson: biography, 88
Hoe to dig clay, 108
Holder, Preston, 157–158
Hollings, Ernest, 168
Honeycutt, Roberta Sanders: learning pottery making, 72
Hoover, President Herbert, 49
Howard, Debbie: Class of 1976, 70
Howard, James H., 158
Hudson, Charles M., 54
Hunting grounds, 92
Hunting rights: violated, and result on economy, 14
Hurricane Hugh and Blue Clay Hole, 98

Incising tradition, 149–176, 197
Incising tools, 107
Indian Arts Convention, Washington, D.C.: as place for demonstrations, 59
Indian head bowl, 133
Indian head jar: building, 129–131
Indian Trail Road, Catawba Indian Nation, York County, South Carolina, 99
Iron: trade for, and economy, 13
Iroquois Confederation, 14, 184

Jacksonville, Florida: peddling pottery, 36
Johnston Bottoms, 93, 106. See also Nisbet Bottoms
Jones, Gail Blue: biography, 88; learning pottery making, 72, 73; squeeze molds, 118
Judge, Chris: clay crisis, 96
Jug: building, 127–129

Katalsta sisters: last traditional Cherokee potters, 38
Katawba Valley Land Trust, 96, 97
Kenion, Rita, 10
King Hagler. See Hagler, King of the Catawba Nation
King Hagler pipe, 180
King's Bottoms, 93. See also Nisbet Bottoms
Kings Mountain Park: Indian circuit, 49
Knife: cane, 107, 109; steel, 107
Kussoe Indians: Southern Cult signatures, 151, 153, 162, 172

Ladder motif, 150, 173–174
Lancaster, South Carolina, 35
Land base, Catawba, 13
Lap boards, 107, 108
Law, tribal, 7
Law Library, Library of Congress, 163
Lawson, John, 8, 178; economic concerns, 29; peddling pottery, 31
Leach, Miranda, 8; biography, 88

Slaves: trade in Indians, 14, 29; capture of Negroes, 14
Smith, A. E. (Agent): Indian circuit, 46
Smithsonian Institution: collection, 10, 89, 161, 165; demonstrations, 60–61
Snake effigy pot, 172; crosshatch, 174–175; films and videos, 61; building, 125–127
Snake motif, 158–160, 170–173
Snuff can lid modeler, 109
South Carolina Arts Commission: Class of 1976, 69; demonstrations, 55; teaching, 64
South Carolina Educational Television, 61
South Carolina Inter-State and West Indian Exposition, Charleston, South Carolina: Indian circuit, 46–47
Southeastern Native American Studies Program, Schiele Museum, Gastonia, North Carolina: Indian circuit, 53
Southern Cult, 4, 158; signatures, 151–155; motif treatment, 157
Spartanburg, South Carolina: as place for peddling pottery, 35
Speck, Frank G., 15, 24, 53, 81, 109, 172; films and videos, 61
Spoon modelers, 107, 109
Spratt, John, 168, 185
Spratt family, 13
Squeeze molds, 7, 9, 113–118, 177; building, 143–144; chicken comb, 116; Indian head, 116; peace pipe, 116; plain pipe, 116; tomahawk, 116
Starnes, Lucy George: Indian circuit, 48
State Fair, Columbia, South Carolina: Indian circuit, 48
Stout, Allen, clay holes, 93; films and videos, 61
Straining the clay, 108
Strickland, Pearly Ayers Harris: biography, 90

Sucah Town archaeological site, 149
Sun circle motif, 150, 154, 158, 162–163, 169
Swanton, John R., 158
Swastika motif, 150, 158, 165–168

Tannersville, Pennsylvania, 18, 84; Indian circuit, 53
Tattooing aesthetics, 150–153, 160–161
Teaching pottery making, 7, 19, 63–73
Thomas, Gladys Gordon: biography, 90; Indian circuit, 53; tools, 111; teaching pottery making, 68
Thomson, Captain: signature, 155
Thurmond, Strom, 168, 185
Tolbert, Margaret: peddling pottery, 37
Tom Steven Road, Catawba Indian Nation, York County, South Carolina, 99
Tomo Chachi Mico, King of the Creek Nation, 152
Tools: bone awls, 112–113; building pots, 108–109; Catawba language names, 107; clay preparation, 108–109; coin incising tools, 112; digging clay, 107–108; hairpin incising tools, 112; knives, 112; nails as incising tools, 112; pottery making, 5, 107–118; rubbing rocks, 109–112; shoe buttonhook incising tool, 112; storage of tools, 113; toothbrush awls, 112; twisted wire, 112
Trade: Colonial Period, 14
Trade ware shapes, 44–45
Treaty of Augusta (1763), 14, 94
Treaty of Nation Ford (1840), 15, 114, 116
Treaty of Pine Tree Hill (1760), 14, 93
Tribal Council. See General Council
Trimnal, Becky: learning pottery making, 72
Trimnal, Roger: Class of 1976, 68
Trimnal, Virginie, 68
Tryon, North Carolina: peddling pottery, 40